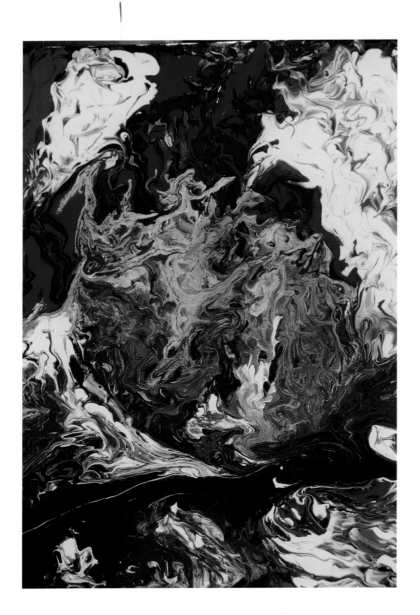

NEW ART
INTERNATIONAL

A Compendium of Recent Works
by World Contemporary Artists

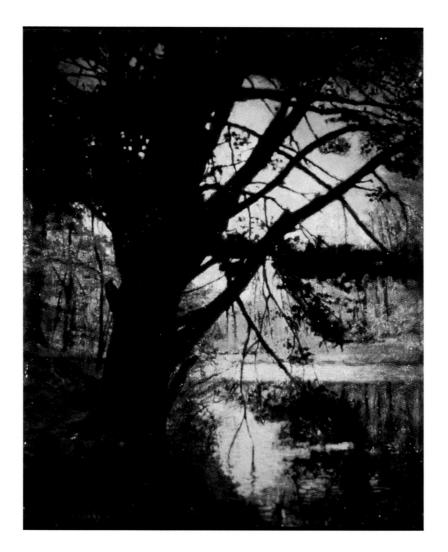

Book Art Press • Publishers • New York
Volume VIII 2003-2004

Covers:
YOLANDA KLAPPERT
PETER MITCHEV

Frontispiece:
ELLA SIPHO

Title page:
ALEX BRODSKY

Executive Editor: Jeremy Sedley
Managing Editor: G. Alexander Irving
Production: Natalie Gains
Copy Editor: Eugenia Buerklin
Graphics: Nicole Digilio
Assistant Editor: Lisa Palmgren
Assistant Editor: Brandi Budziak
Curator: William La Mond
President: Leslie McCain
Publisher: J. S. Kauffmann

Published in the United States of America
in 2003 by Book Art Press, Ltd.

New Art International
Copyright ©2003

ISBN 0-9713859-4-7 0-9713859-5-5 (pbk.)

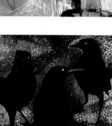

CALVIN GRIMM

21ST Century Caveman

Considerably more agile, trim and lithe than the concepts of a "caveman" ingrained into us by imaginative artists of many decades past, Calvin Grimm has nonetheless poked his way into more than his share of remote fissures, clefts and rumples of rock. An avid outdoorsman, mountaineer and qualified wilderness educator, Grimm has wandered his way through isolated terrains of the northern U.S. Rockies, coastal regions of Alaska and other areas of untamed seclusion; fording rushing waters and scaling vertiginous slopes; melding his own energies into the momentums of the environment.

As an abstract expressionist painter, such proclivities materialize on a visual plane as what has been described as "a personal collaboration with the forces of nature." One can trace lines and vitalities of a landscape in his streaming compositions of color without seeing the forest through the trees but by *feeling* it within places where trees might stand. An astute observer has noted of Grimm's work that "the beauty of nature is not so much to be found in the individual stone or tree or stream, but in the dynamic and unceasing exchange of energy between them."

Reflecting elements of landscape without formally describing them follows the mystical traditions of art favored by painters seeking a deeper reality than they perceive as available in mere physical appearance. Grimm expresses these derivative aspects with fluid urgency and taunting allusion in a style developed since his studies of fine art at the State University College at Buffalo, New York in the mid-1960s.

If the present work is deemed as a departure from his usual stylistic approach, it is one with personal roots much deeper than Grimm's formal study. In fact, he recalls an interest in cave art going back to his single digit years and an elaborative experience of working on a commercial project in a New York studio at age sixteen, wherein he was reintroduced to classical cave art images in the course of replicating them on simulated cave walls made with molded styrofoam.

"We used airbrush, things like that, on castings of cave textures, painting pretty true to the originals," he recalls.

When Grimm received a scholarship, through Bard College, to study in the south of France at the Lacoste School of the Arts in 1997, he unknowingly set himself on the path toward a fresh acquaintance with ancient images worked into and upon limestone walls.

"I wanted to take a pair of studio courses because I wanted to study printmaking and I wanted to paint while I was there," Grimm explains. "The academic (course) was going to be French Language and Culture but each instructor spoke, the night before signing up, Gustaf Sobin, an American poet living there for quite a while, said that what he wanted to discuss in an archaeology/art history course was the question of 'why does the human being make art?' He approached it from such a profound poet's view that I said this is the person I have to be with for the next six weeks."

While studying the 30,000 B.C. art of the Chauvet Caves and other sites of cave art in the context of seeking the wellsprings of artistic motivation, Grimm began working with the images.

"I was pretty much working from photographs because I hadn't been able to get into those caves, due to the fact that, in an effort to keep the Chauvet site as pristine as possible, entrance is entirely forbidden to the public I was being true to the line because I thought the line was spectacular," Grimm recalls. "Then, as an abstract painter, I was enjoying making the background illusionary. You have to have a 'loose hand' when you're making this sort of limestone appearance and I was relishing that very much.

"Starting with the athletic portions of animals, with the artists seeing lines and how observant they needed to be as hunters, I started to abstract the color; add to it and punch it up. As a painter, I felt I wanted to do that, so, that's how I first started altering them. Then, I started moving animals around on the canvas- being somewhat faithful to their animals but moving them about, taking animals from different cave panels, having them interact and adding my own beasts.

"After doing those, I started making animals that I knew- horses... I did some dogs on cave walls- schnauzers, believe it or not- that was pretty funny. Then I started feeling like, well, if the cave artists were not obsessed with animals- as they were by necessity- what else might they be thinking about? Love? Vulnerability? Things of that nature?"

One of the works in Grimm's series, "Falling Angel," transposes Rodin's sculptured image of Icarus into the caves.

"That to me represented ambition and failure; vulnerability and so on," Grimm elaborates, drifting from depictions of wildlife into more abstract terrains of concept. "We have the privilege of 30,000 years of methodology- which started somewhere after the cave artists I would think. I felt humans would start to move away from just being obsessed with animals and start into thought about other things, eventually to create a true mythology of those characters that represent our psyches and our passions..."

Grimm's speculations about the origins of myth began to emerge in the work, as in the scene of a young goat/human feeding honeycomb to bear cubs.

"I thought I have the advantage of 30,000 years of genetic transformation," he mused. "And, so, I think I'm going to put some of these mythical characters on cave walls as if this might have been something that cave artists were thinking about... If not, well, I'm thinking about it...in a primitive way. So, that's where the painting of Pan came from...mischievous, dealing with animals and he's half-animal. It seems a natural fit for a cave wall. That's how that evolved for me."

One of the works, a large shaped canvas on a stretcher, uses differently contoured branches and other braces which cause it to protrude by as much as six inches.

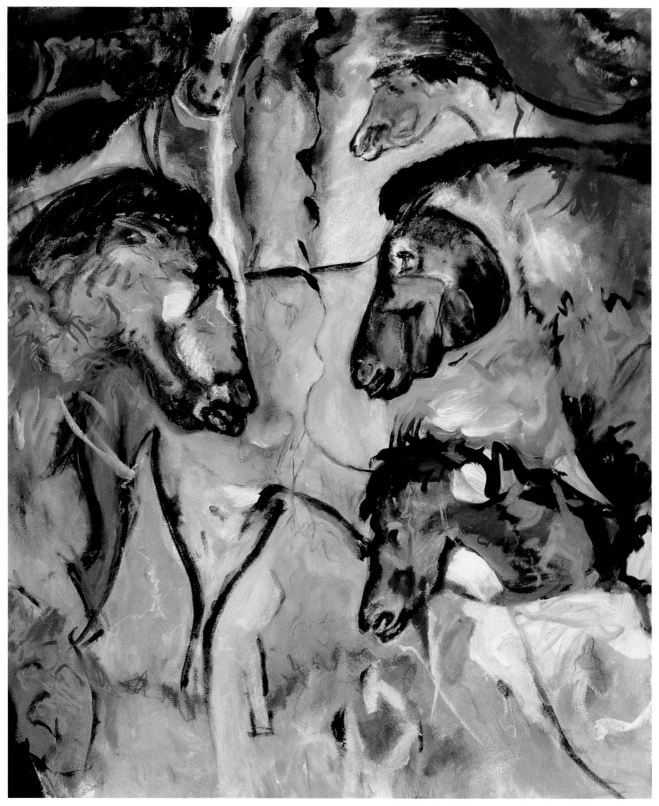

Horses, Chauvet Cave 40"x 30¼" Oil on canvas

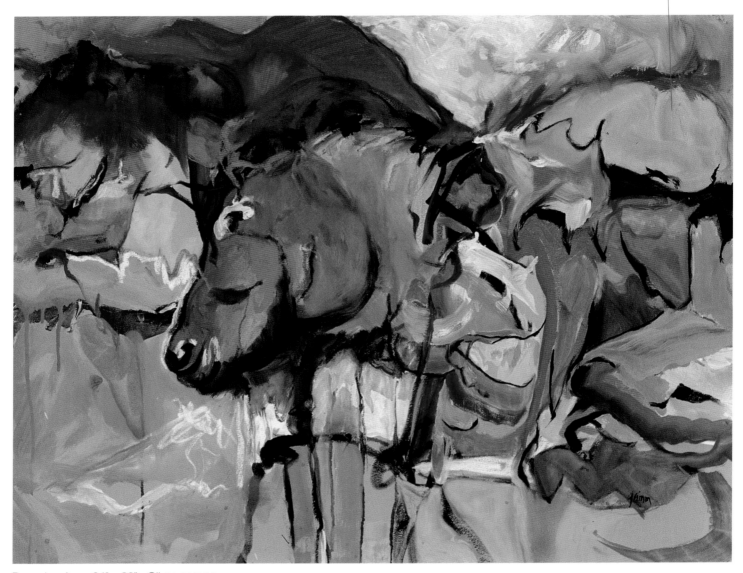

Drowning Ass 24" x 30" Oil on canvas

"In some of the Chauvet pieces, the artist used a technique where a protruding wall shape represented the shoulder of an animal," Grimm explains, "so that, if you looked at it from one side, you'd see the face but from the other side, you'd only see the body. I played with that a bit on that shaped canvas. Others are largely graphite and paint stick on paper, so they have a pastel quality...and oil, very often thinned and allowed to run as minerals would on the surface of limestone. Fairly flat, using only as much texture as it takes to make those lines. It's not *impasto* in any way; I don't use palette knives. It's all basically thin washes and whatever texture it appears to have is just the illusion of cracks in the rock and minerals washing over surfaces. If it appears to have dimension, it's just illusionary."

As departures from Calvin Grimm's customary devotion to abstraction, the pieces capture mesmerizingly magical qualities of the "discovered" ancient cave art of uncertain origin which continue to enthrall us so many thousands of years after their creation. His earlier work, which has been shown in ninety exhibitions in recent decades, including eighteen solo shows, attracted the developers of the San Francisco Giants' recently built ball park, Pacific Bell Park, to commission Grimm for a large painting which now resides on a curved wall on the AAA Club Level of the facility. It serves as an ideal example of the artist's staunch regard for expressionism.

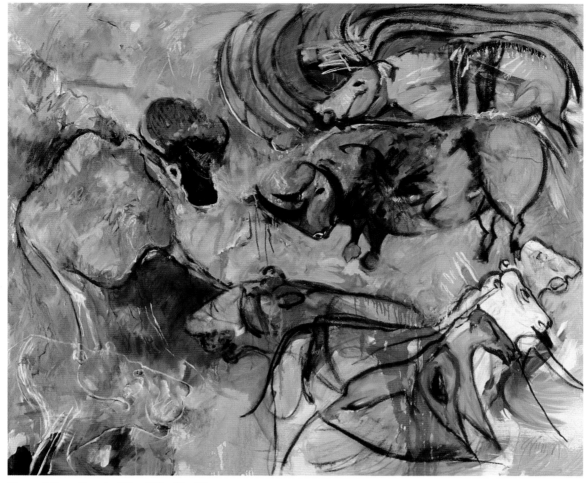

Shaped Cave Panel 60" x 70" x 6" Oil on canvas

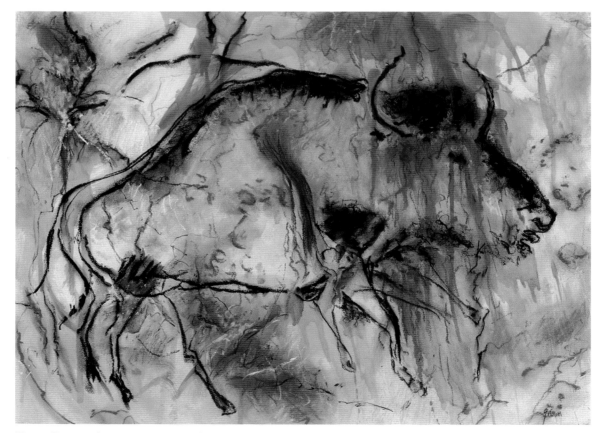

Bison, Chauvet Cave 22¼" x 30" Oil, graphite/paper

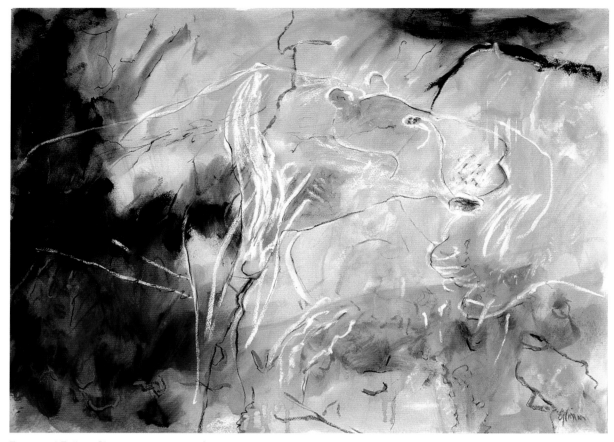

Engraved Feline, Chauvet 22" x 30 Oil on paper

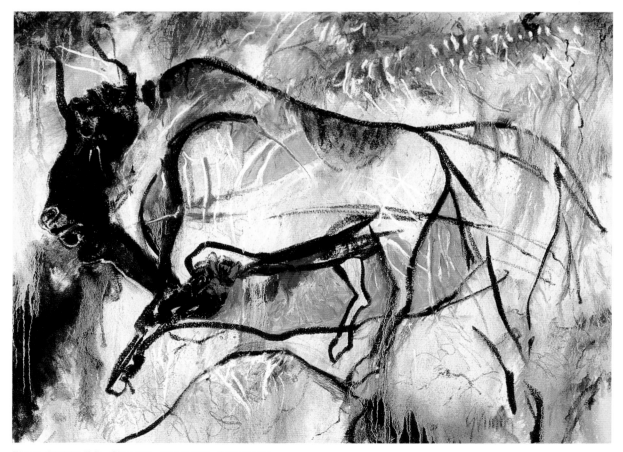

Bison, 30,000 B.B., Chauvet 30" x 40" Oil/canvas

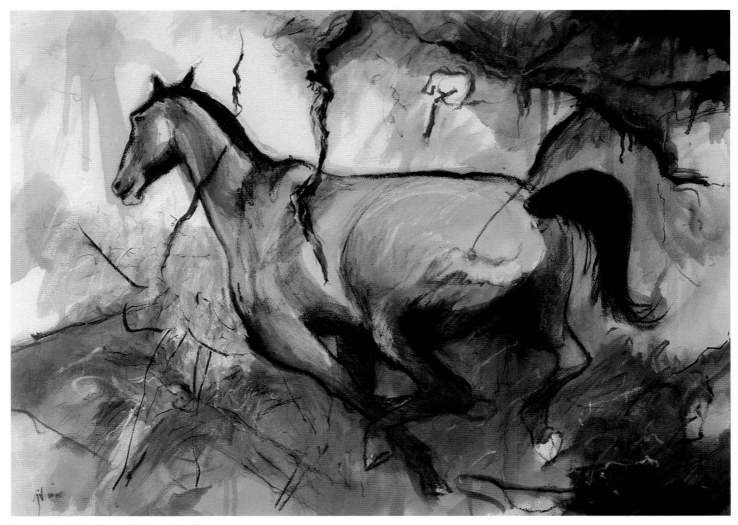

Buster, 30,000 B.C. II 22¼" x 30" Oil, graphite/pape

How does an abstract expressionist "action" painter find himself identifying with the cave art of 30,000 B.C.?

Within my primal core are universal situations/symbols found in the natural milieu and the human anatomy... Years of wilderness exploration in the U.S. Rocky Mountains and the Alaskan coastline inform my large abstract paintings... Mysteries in nature cause me to wonder, among other questions, what is within that glacial crevasse or that narrow cave entrance... How would modern homo sapiens benefit from going back though the vaginal openings in the earth into cavernous wombs?... And why would an ancient or modern person draw animals on mineral-washed limestone walls where cave bears have scratched their claw marks before them?

We lived more spiritually connected to wildlife once. We considered our own behavior while observing theirs. In time, we began to give power to thoughts of the human condition by developing symbolism to describe our feelings of vulnerability, love, compassion-thereby evolving "the arts."

While so many today see their gods in television and in war, I go back to the early musings of 'who am I'? in the organic world. And so, I paint abstract expressionist viewscapes and I make paintings depicting animals and mythological characters on simulated cave walls.

On these pages, I am sharing images of animals in my gene-pool and those I know personally, as well as creatures precious to others.

Songs of an Old Forest : Melody #2 9" X 4½" Watercolor Songs of an Old Forest : Melody #1 9" X 4½" Watercolor

VLADIMIR VASILYEV

Messages of symbolic legacy in images siphoned from the primitive past and articulated with reverent affection in subdued and intriguing hues by Vladimir Vasylyev are contrasted with emotive and otherwise primitive impacts of mythic portion in the present. Conjointly, they present an unsettling crosscurrent of tradition and conflict which urges an instructive overview of distance for adequate rumination while, individually differentiated, they insist upon close consideration of point and essence.

Born in the southern Ukraine, Vasylyev obtained his art degree from Odessa Art College prior to moving to Kiev and discovering the remarkable distillation of ancient Ukrainian folklore, mythology and philosophy to be found in the poetry of Lesya Ukrainka. Finding boundless inspiration in the poet's insights into the relationship of man and nature as exampled in such works as "The Song of the Forest," Vasylyev experienced the sway of her ideas and inherited wisdoms as he illustrated hundreds of books while in the Ukraine and continues to feel her influence after his immigration to the United States in 1998.

Songs of an Old Forest : Melody #4 9" X 4½"

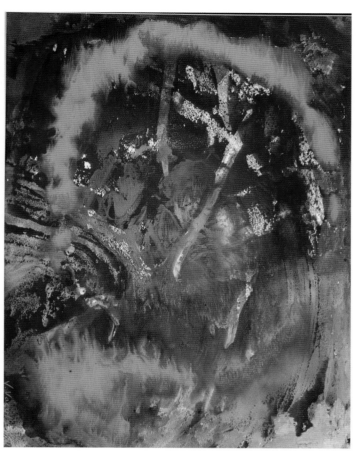

September 11, 10:28 a.m. 23" x 18" Gouache

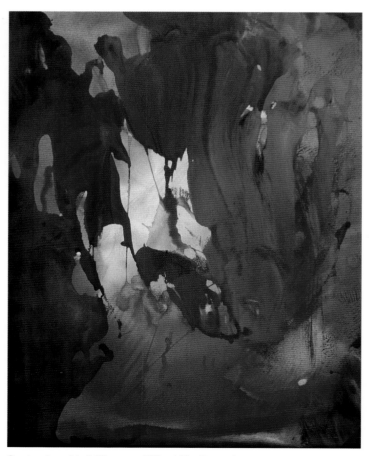

September 11, 9:00 a.m. 23" x 18" Gouache

In my art I present dramatic moments of contemporary history as well as mythological and historical themes that come from appreciation of the ancient history of my native town and Ukrainian folklore.

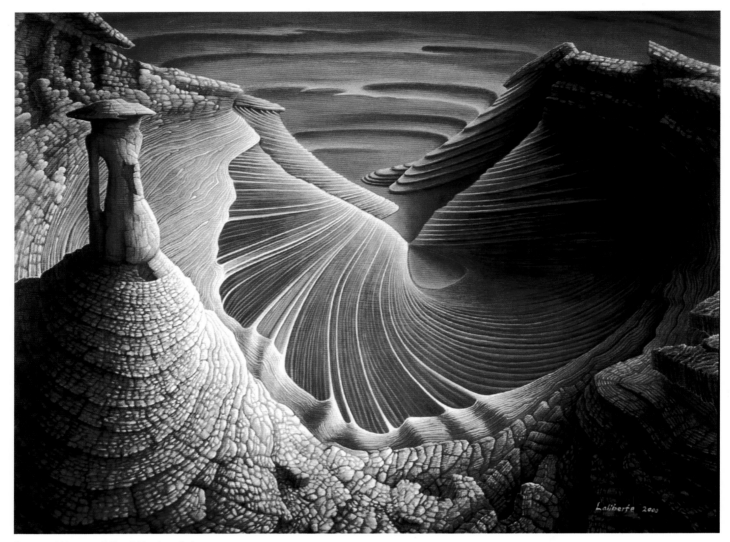

Canyon Waves 24" x 30" Acrylic/canvas

ROBERT LALIBERTE

In spectacular fashion, Robert Laliberte raises a ghost from the "bones of the earth" he finds in the wastelands of the West and engages his singular visionary prowess by granting it the privilege of walking in new flesh. The exercise of enchantment he is able to employ in permitting the viewer of his paintings to stride such sturdy steps into the same imaginary landscape is strikingly apparent in his scenes.

A native of Colorado, Laliberte studied Fine Art at the University of Colorado while earning a B.A. in Psychology and, later, a Master of Architecture degree from the same institution. Just two Art History courses short of a B.F.A. at U.C., he also garnered an Associate of Applied Science degree in Mechanical Design Technology from Pikes Peak Community College. Astonishingly, despite a lifelong interest and involvement in art, Laliberte has never before publicly exhibited his work.

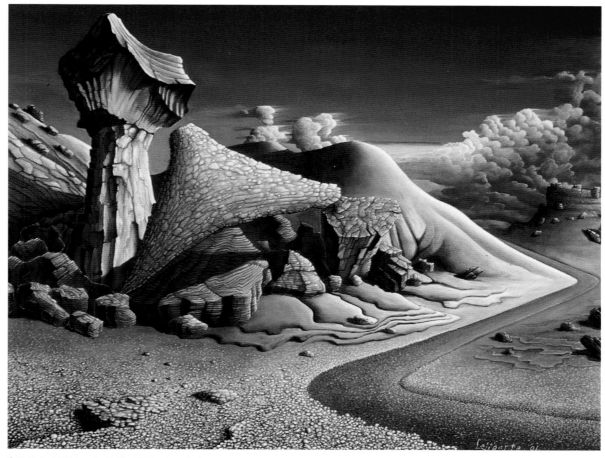

Smokey Hill Road 24" x 30" Acrylic/canvas

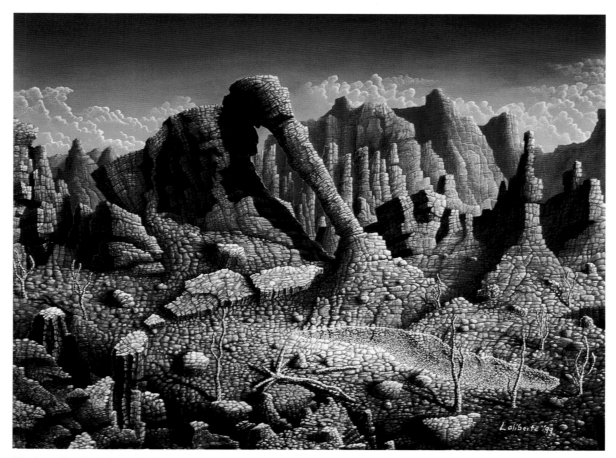

Elephant Rock 24" x 30" Acrylic/canvas

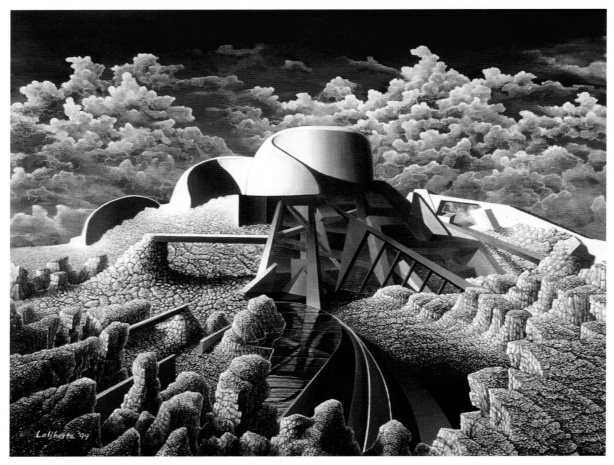

Reconstruction 24" x 30" Acrylic/canvas

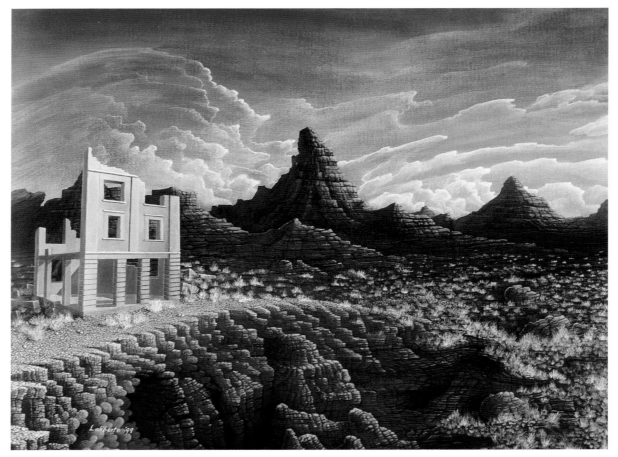

Ruins 24" x 30" Acrylic/canvas

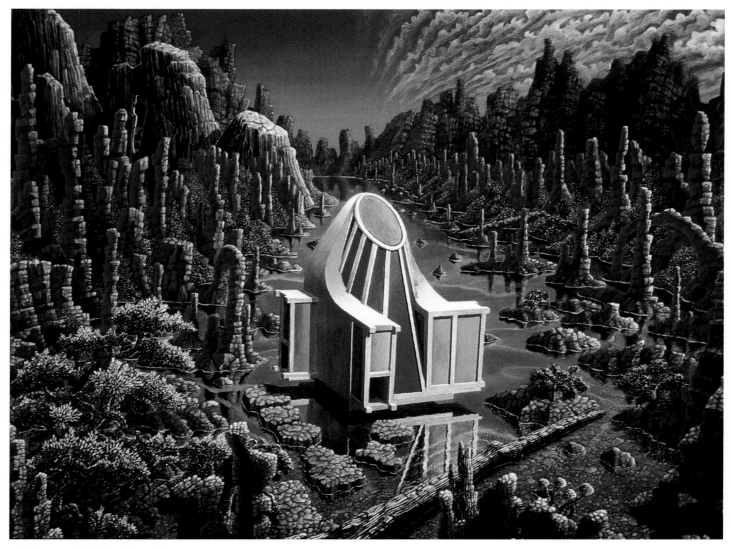

Tea House 24" x 30" Acrylic/canvas

For many years, I was inspired by surrealism and visionary art. I particularly liked the visionary landscapes of Nick Hyde, Gage Taylor and Bill Martin. In the last few years, I've become fascinated with the surreal quality of the strange but beautiful geology of the slick rock country of southern Utah and northern Arizona...The more remote and barren a landscape is, the more I like it...The contorted rock formations of arches, pinnacles, hoodoos and slot canyons have provided inspiration for many of the paintings that I've done recently... I don't feel a challenge replicating a photograph. I like to create new landscapes that don't exist anywhere on earth. I may borrow elements from some of the landscapes that I've photographed and use them as a base for a new landscape.

Although I've spent many years in the design profession, I find drawing and painting more satisfying than anything else. I can create anything I want without any constraints or budgets to worry about. I can get therapy, relaxation and inspiration all at the same time at the easel.

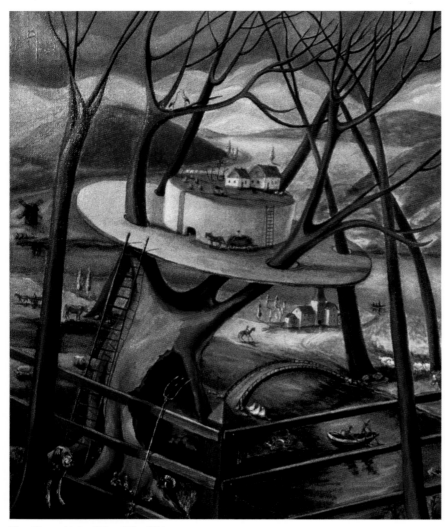

The Straw Hat 27" x 22" Oil/canvas

RAISSA LATYCH

Captivating flights of fantasy and symbolism propel the surrealism of Raissa Latych into an exhilarating plane of aesthetic regard. Her themes intermingling social circumstance and an environment of natural forces find reflection in humorous and cautionary posture.

Born at Stavropol, Russia, Latych graduated from the Industrial Art College of Moscow and received her Master's degree in Art from that city's Stroganoff Institute of Art. During her student years, she worked as a graphic artist for *Pravda* and the German newspaper *Neues Leben*; also illustrating for a film company. Latych became known for her work with the famous Moscow Doll Theatre and as a designer of camera bodies and toys. She was commissioned for a trio of 30 foot square murals by a scientific research company and for the design of the stone statuary which today graces the city of Krasnogorsk, where she presided as General Manager of that municipality's principal gallery. Presently an instructor at the School of Art in Moscow, she has presented her work at numerous exhibitions in Russia and the United States.

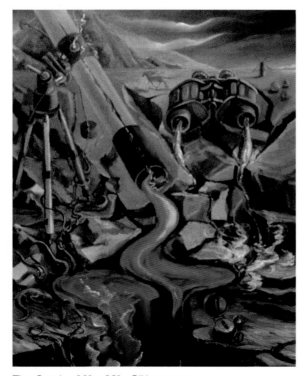

The Crack 28" x 22" Oil/canvas

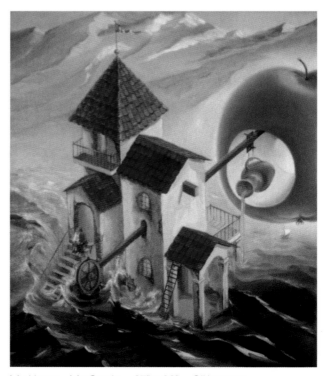

My Home - My Castle 27" x 22" Oil/canvas

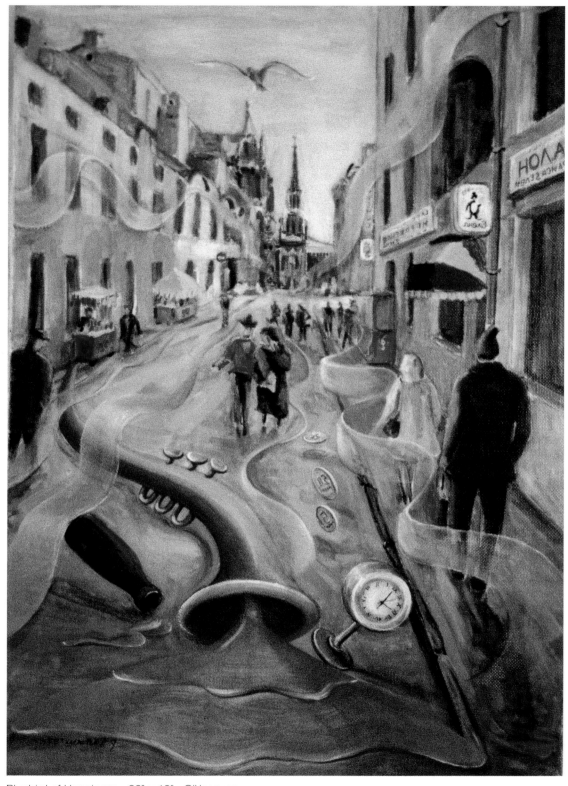

Bluebird of Happiness 26" x 18" Oil/canvas

In my motivation for painting, I am continually enveloped by the natural world and our responsibility to its ecology. My love for nature is rooted in a childhood spent in a simple village in the countryside where I learned to respect nature and strive to live in harmony with it. Though I've spent my adult life in Moscow, my heart belongs to far away fields of green and cool summer streams. All of my youthful feelings and impressions of life are what urge me on to paint. I find that symbolism is the closest thing to the freedom of a child's unspoiled outlook of life and so it is also my chosen form of expression.

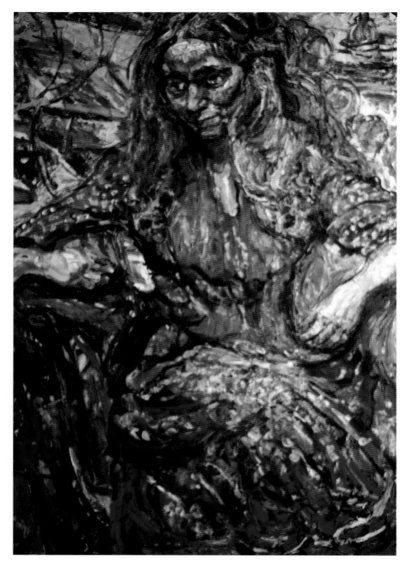

La Dolce Rossa 67½" x 47½" Oil/canvas

PHILIP LAWRENCE SHERROD

Conveying the color and motion, bustle and clatter and, almost, the sounds and scents of the metropolitan street in a sweeping on-the-spot, one-sitting capture of environment is dazzlingly second nature to Philip Lawrence Sherrod. The frantic rhythms with which he gathers his all-encompassing scope of immediacy fly into his scenes with life-affirming vibrancy and a sage comprehension of dynamic fluidity.

A key founder, in 1977, of the Street Painters Alliance's "feelism" movement, Sherrod's celebrations of the intensities of life and movement have justifiably gathered both widespread fame and historical significance. As one of the original "Eight" who stirred the New York art world in the latter decades of the 20th Century, as chronicled most notably in Lawrence Sandro's 1977 essay, "The Street Painters' feelism", he brought a loving ferocity to the seizure of visual image which brings the viewer startlingly and gratifyingly full force into the passion of his involvement with a scene.

Sherrod obtained a B.S. degree in zoology and a B.A. in painting from Oklahoma State University before venturing east to study at the Art Students League with Sidney E. Dickinson, Ivan Olinsky and other notable instructors. Recipient of many honors, including three Childe Hassam Purchase Awards from the American Academy of Arts & Letters and a Prix de Roma Fellowship, Sherrod has exhibited at literally hundreds of locations. As a poet-philosopher, as well as artist, organizer and commentator on the arts, he has been widely represented in electronic and print media and has taught at the Art Students League, National Academy of Design and other esteemed academies.

My work is alla prima! Done with easel- out in the street! I have painted 47 years and loved every minute of it! I am guilty!

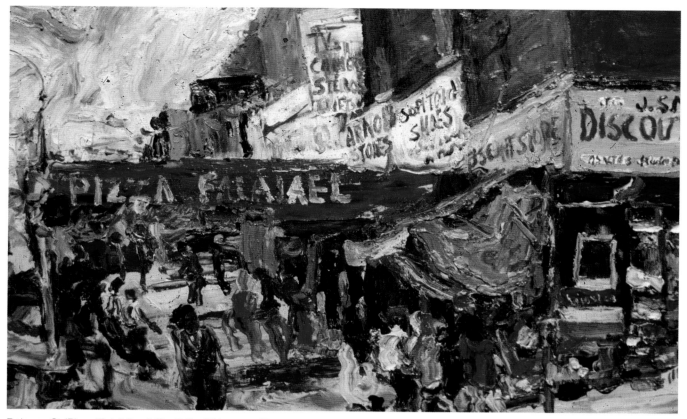

Delancy St./Pizza/Falafel! 26" x 34" Oil/canvas (Excerpted Detail)

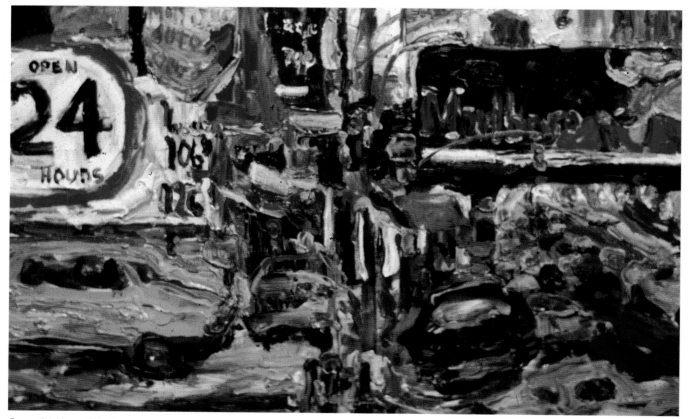

Open 24 Hours/Marlboro/9th Ave 26½" x 42½" Oil/canvas (Excerpted Detail)

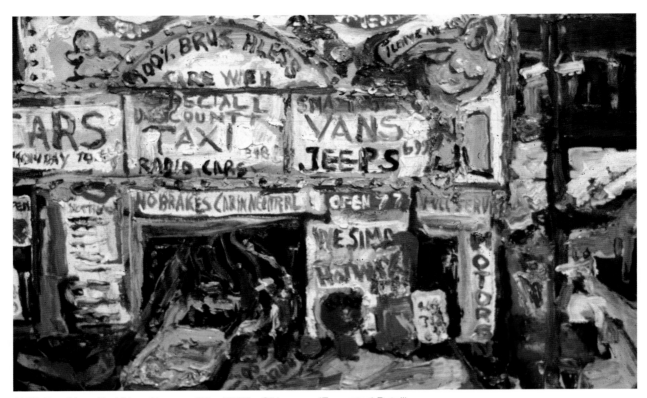

100% Brushless/Taxi/Vans/Jeeps 25" x 35½" Oil/canvas (Excerpted Detail)

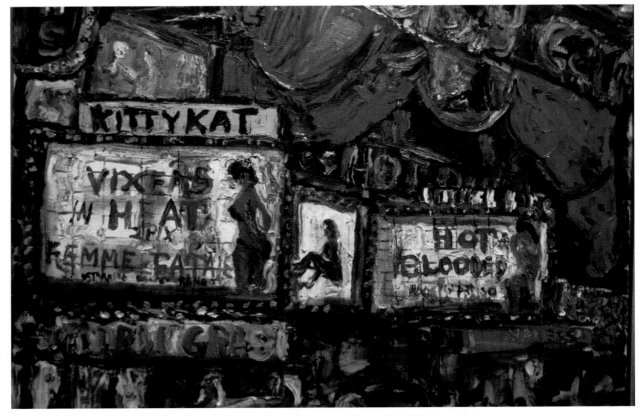

Kitty Kat/Vixens in Heat/Hot Blood Detail 34" x 32½" Oil/canvas (Excerpted Detail)

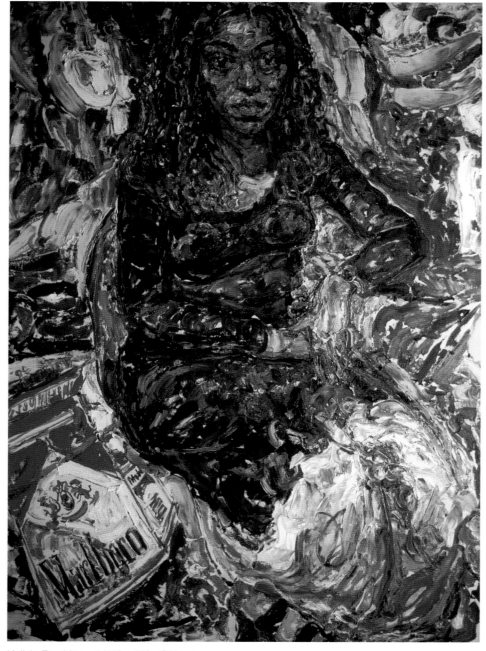

Kelly's Freckles 44½" x 40" Oil/canvas

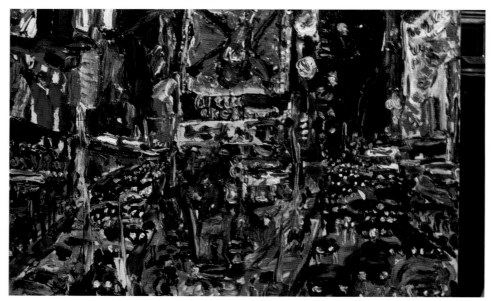

Times Square/Cars/Nite! 28" x 34" Oil/canvas (Excerpted Detail)

Untitled 24" x 36" Oil

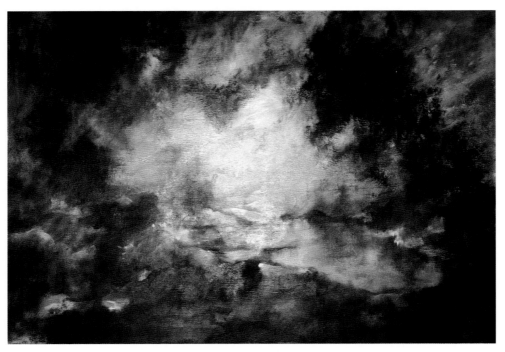

Untitled 36" x 48" Oil

BART A. INWOOD

The landscapes of Bart A. Inwood almost seem to exhibit a subtle anti-gravitational effect, lifting the viewer into wistful realms of placid light and mellifluous breezes. Mystical and inspiring effects grounded in his delicate treatment of light and form sets the viewer into a gentle tide of calm forces and reflective moods.

Born in New Jersey and currently a resident of Cincinnati, Ohio, Inwood has a B.A. in Graphic Design and a Masters in Art Education from the University of Cincinnati. After working for a decade as a graphic designer, he has taught art at high school and college levels for the past twenty-three years as he pursues his own visions in pigment. His work has been exhibited extensively in numerous venues of the American Midwest.

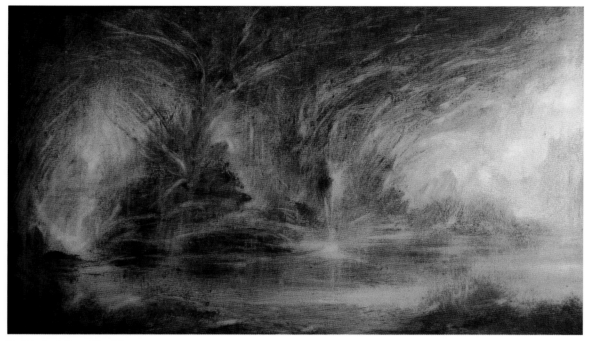

Untitled 24" x 40" Oil

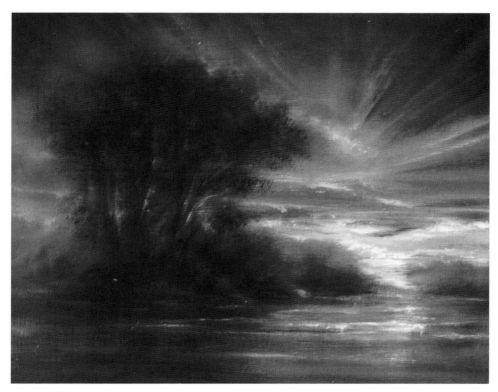

Untitled 18" x 24" Oil

I never title my work, allowing the viewer to bring their own experiences into play and sometimes see alternative images. I have been painting seriously for forty years and have called my paintings 'Dreamscapes' long before it became a popular phrase in movies, books and art. I want to take the viewer to a sublime place of peace and an atmosphere of quiet. The word 'Dreamscape' does not mean these paintings are from my dreams but are places I wish to dream of.

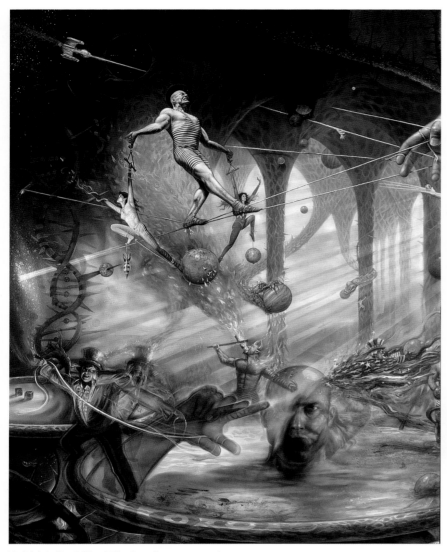

Hell (detail) 36" x 25" Acrylic on masonite

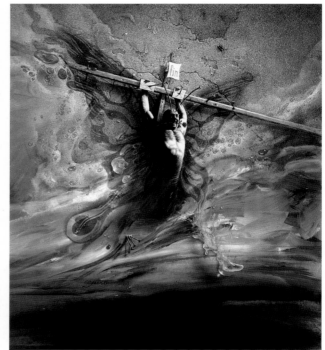

Buttercrucifly (detail) 24" x 20" Acrylic on masonite

MARK GARRO

A supple and puissant capacity for visualization provides the imagery of Mark Garro with a formidable grasp upon our sense of wonder. His preeminent abilities to carry representational figures into spellbinding realms of symbol and supposition underscore the loftiest objectives of surrealistic venture.

Born and raised just outsisde of NYC, Mark Garro earned his BFA at Syracuse University. His work has been exhibited in solo and group shows throughout the U.S. and appears on book covers, CD's, magazines and advertisements. Timeless themes such as Heaven, Hell, the Cosmos, genetics, spiritualism, and the passage of time, motivate his work.

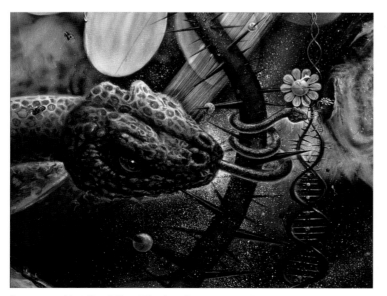

Purgatory (detail) 12" x 17" Acrylic on masonite

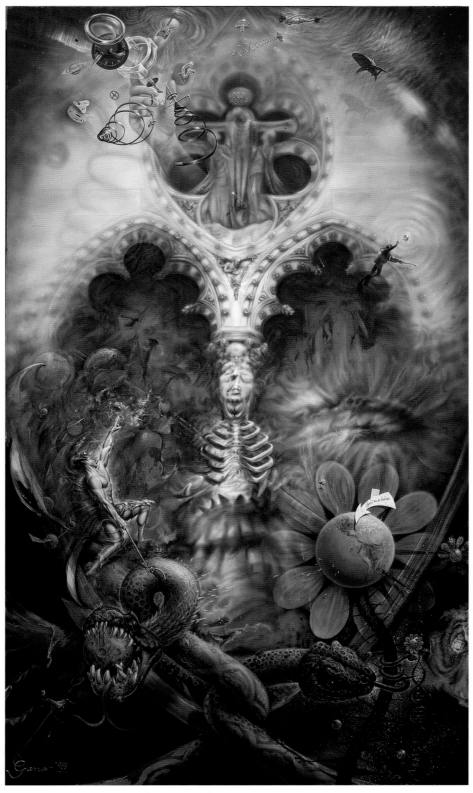

Purgatory 72" x 42" Acrylic on masonite

Seeing and feeling only the obvious is the burden of the insensitive. To interpret and observe the many layers of life, however dark or light they may be is the privilege of the perceptive. To offer the viewer more than one plane of thought and imagery through painting is what interests and occupies much of my time.

Composition and color are crucial of course, but what about concept? Concept is what stimulates the imagination and rivets the attention of even the most casual viewer.

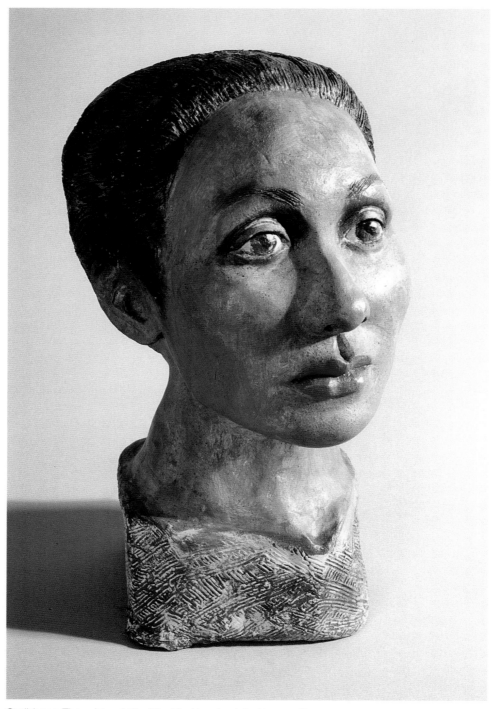

Caribbean Thoughts 15" x 6" x 5" Hand painted terracotta

JULIA SANTOS SOLOMON

As individually integral works of art or as the fulcrum of an embellishing installation, the sculpture of Julia Santos Solomon carries implication along with beauty which is meant to emphasize the artist's observations concerning cultural identity.

American ideals of homogenization aside, Santos-Solomon places an affectionate exploratory value in the distinct qualities of cultural, racial and individual elements and attributes which distinguish meaningful diversities in contemporary classifications of humanity. Expressly, the artist informs us that her most recent work "explores the concept of identity in three generations of Dominican women, particularly as it applies to gender and nationality.

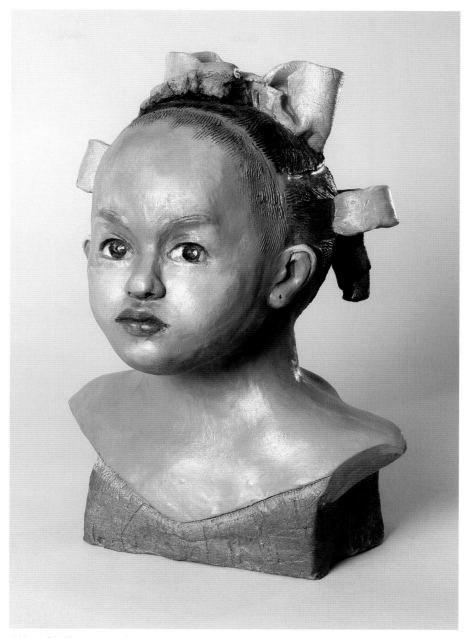

4 Year Old Dominican Girl 16" x 10" x 8" Hand painted porcelain

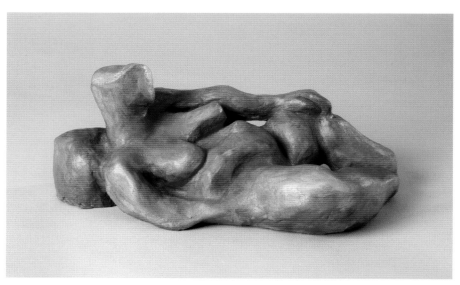

Sunburnt 16" x 6" x 4" Hand painted terracotta

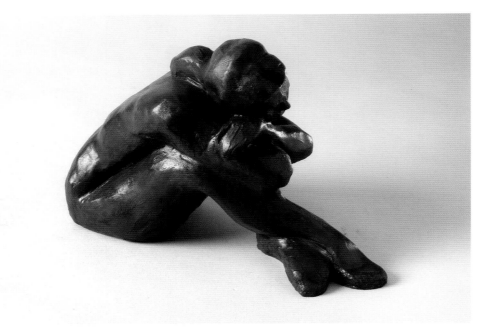

Thinking of Michigan 8" x 4" x 2" Hand painted terracotta

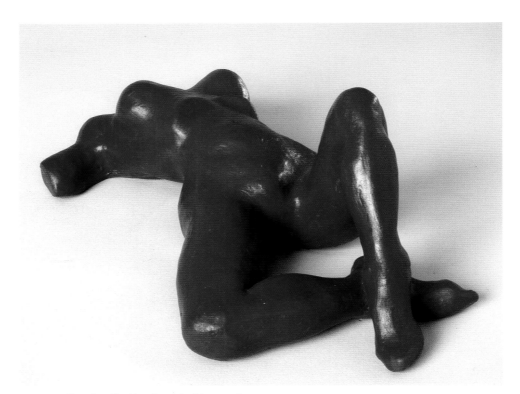

Torso 12" x 4" x 3" Hand painted terracotta

"I can only speak my own truth based on the life I have lived," Santos-Solomon continues, explaining that "these pieces have been painted according to the palette of my family's origin, specifically, the colors of the Caribbean landscape. There are no literal skintones- instead, the colors are of the waterways, vegetation, seeds and flowers; the tones of our roots. Identity is not defined merely by what we inherited from our ancestors but what we inherit from the earth. The landscape and the person are one element, residing in each other."

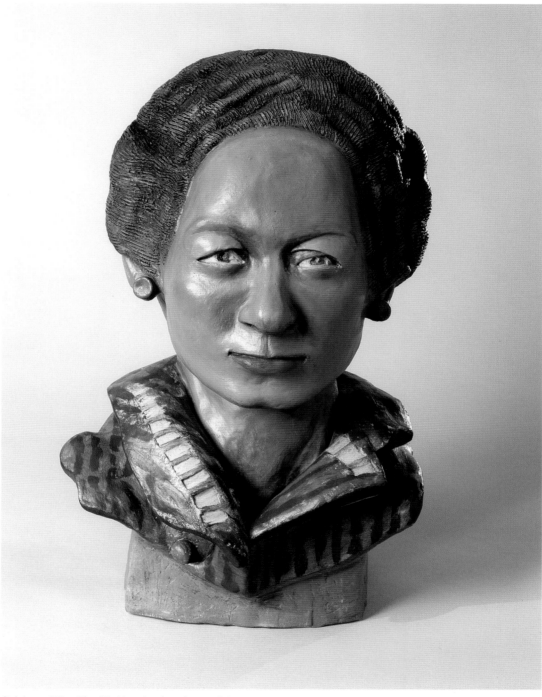

Gabina 18" x 8" x 6" Hand painted porcelain

Currently a resident of upstate New York, Santos-Solomon studied at New York City's famed High School of Art and Design; The Rhode Island School of Design, Brown University and the European Honors program in Rome, Italy before her studies continued at Brown University and the Rhode Island School of Design. Selected sites of solo exhibition include the Dash & Dash Gallery of New York City; Fletcher Gallery of Woodstock, New York; the Societa Di Saint Andrea in Assisi, Italy; La Galeria of Santo Domingo in the Dominican Republic and many others.

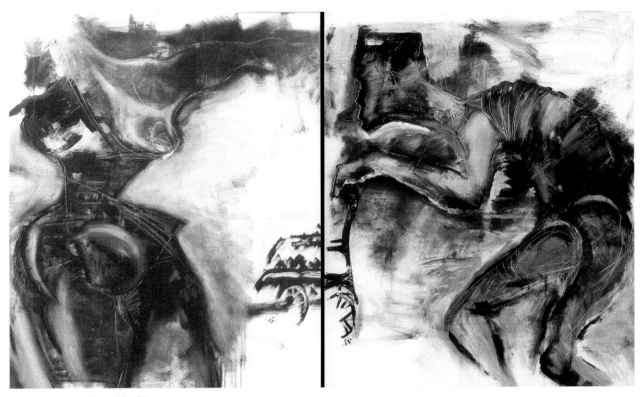

Little Pinkas 96" x 78" Oil

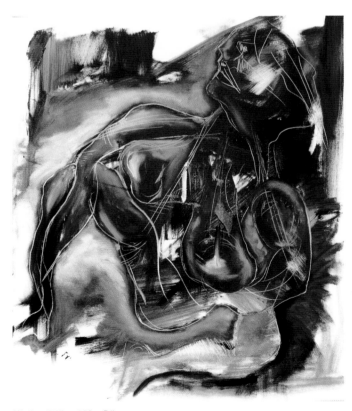

Birth 39" x 48" Oil

YAEL ZAHAVY-MITTELMAN

Blended rock like, streaming structures seemingly composed of abstract world twisting and enfolding in many complex forms and colors. A world formed by glowing power relieves a tearing rage and turns it to a sense of hope.

Yael Zahavy-Mittelman paints from her gut. The strength of colors, shapes, and line is the core of her artwork, which results in a symphonic field of expressive harmonies formed by burst of colors. The personal and psychological strength evidenced by her bold abstractions, carries through to her life outside the studio. Privet psychological and emotional self-struggles released into the canvas by thick impasto toward a secret wish for hope.

An Israeli-born, resident of the Seattle area, Yael Zahavy-Mittelman studied art in several institute in Israel as well in the United stated. Among the American institute Zahavy-Mittelman has attended were the Seattle Academy of Fine Arts, Montgomery College, and George Washington University. Her work has been shown in Seattle, the United States, and Israel.

My paintings express the power of touch, connection as well as aloneness and sorrow. Coming from a country such as Israel, these paintings bring my journey of search for identity through very strong emotional reactions to my art process. That process combines elements of death and life forming, war verses the need for peace and serenity, as well as a search for religious identity.

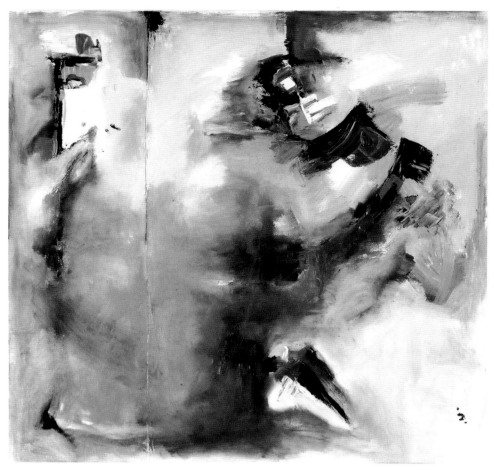

Cloudy Figures 46" x 46" Oil

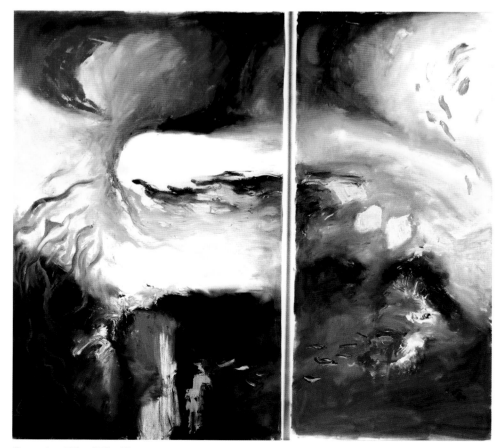

Genesis 76" x 67" Oil

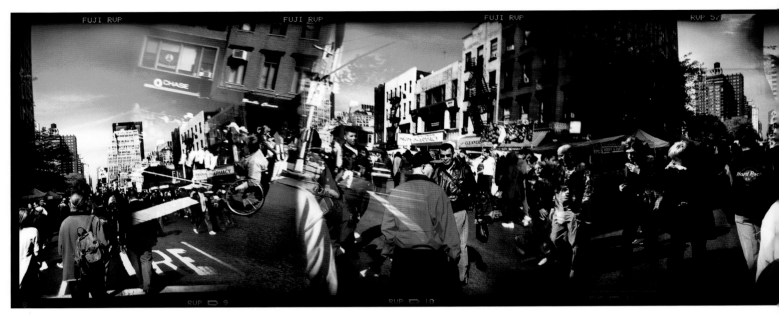

8th Avenue Street Fair 28.63" x 5½" Digital C-Print

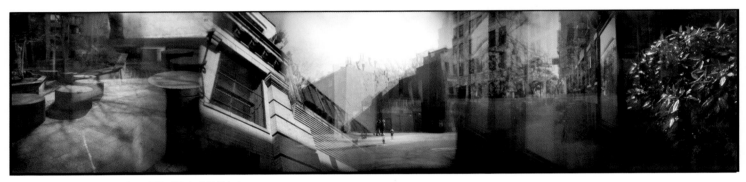

Chelsea w/Bush 24¾" x 5¾" Digital C-Print

Graffiti 28.63" x 5.38" Digital C-Print

SUSAN BOWEN

An instinctive and informed eye for fluid composition in the work of Susan Bowen transforms an inventive technique into dramatic time-lapse panoramas of form and event. Her multiple exposure manipulations cluster a flow of images into a narrative of tilt and sway; continuity and transference; reinforcing the impetus of representation with significances of cause and effect; relationship and position; progress and stagnancy and other shadowed complexities of existence.

Currently a resident of Brooklyn, New York, Bowen was raised in Baltimore, Maryland, and earned a B.A. degree in Studio Art and Photography from Allegheny College and a B.F.A. in Graphic Design from the Corcoran School of Art, adding post-graduate studies in Industrial Design at Pratt Institute. Her work has appeared in exhibition at the Soho Photo and E3 Galleries in New York City and the TPS:11 National Competition in Austin, Texas as well as in group exhibitions in Meadville, Pennsylvania; Norfolk, Virginia and Washington, D.C.

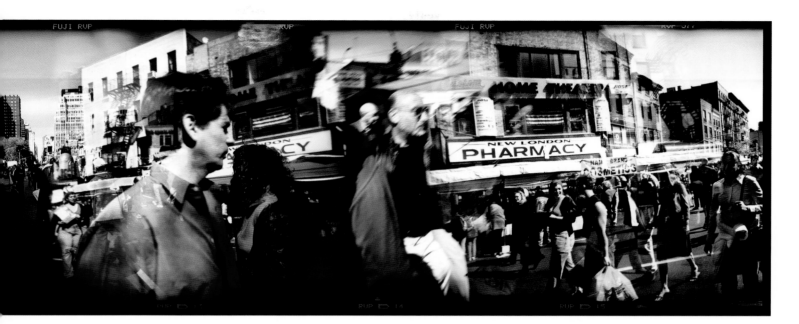

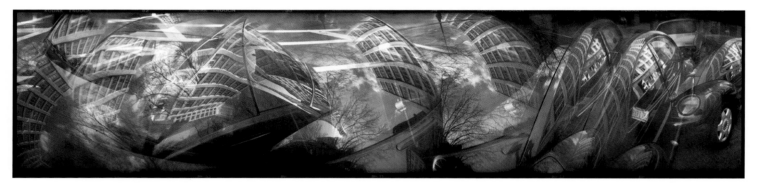

Reflections to Go 24.88" x 6" Digital C-Print

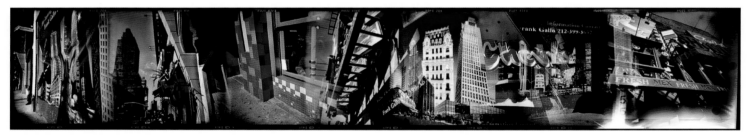

42nd Street 28¾" x 5" Digital C-Print

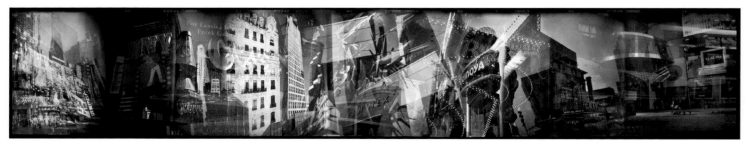

Times Square 28.63" x 5¼" Digital C-Print

Since the overlapping of the imagery is done in the process of shooting, the first viewing of a negative is for me, as much as for anyone, a moment of revelation and surprise. The role of chance in my pictures, and the low-tech-ness of my equipment, I find exciting and liberating and are defining aspects of my work.

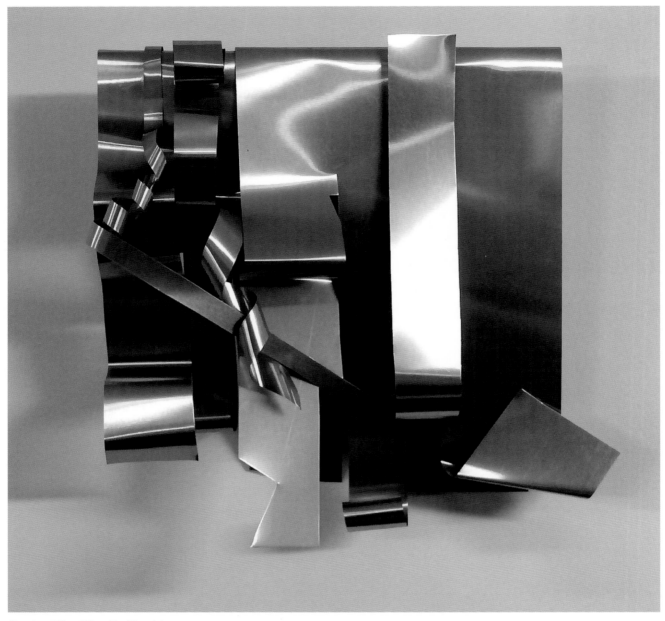

Crush 13" x 13" x 4" Aluminium

BASHA RUTH NELSON

Shimmering aluminium curves and glowing caves of light; sudden waterfalls and curls of shining spray-like metal showers; arching ends bringing the eye back to the abstract of the story; smooth drops hanging in intimacy with mottled sheets creating a tension and a questioning; colors glittering here and there to emphasis the movement and unfamiliar caress of the metal; hard vertical metal posting messages of softness and serenity; the simplicity of twisting copper strips hanging together side by side, not touching; so many works, floating to mandate another language inside shells of Plexiglas

Basha Ruth Nelson always had a secret need to create. She attended graduate school at New York University which gave her a firm foundation in the basics of her art and where she also gained insights which would stay with her all her life. Nevertheless her focus was still on representational art forms and her early work was in landscape with ever present trees.

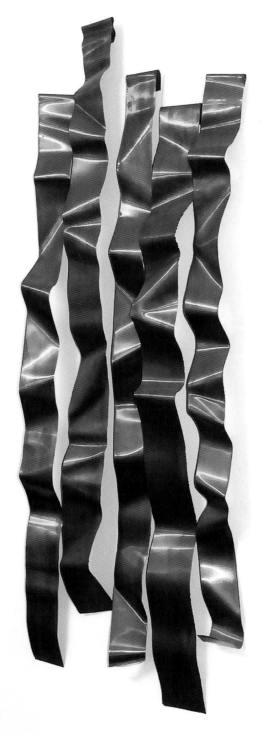

Jazz 38" x 13" x 3" Copper

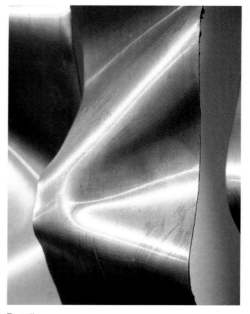

Detail

A passion for the vertical shapes Nelson's primary artistic direction. The roots of this commitment lie deep since much of her education and experience had the background of New York's skyscrapers. Now she explores this premise at an even more profound level. For her the vertical is at once spiritual and elegant and one of the simplest and strongest forms in nature.

Nelson is also very much an intuitive artist. Ideas are constantly striking her. She will concentrate on one, choosing the materials she will need with few if any preparatory drawings or photos. She arranges these initial materials until gradually they take the form related to the image in her mind. It is as if the image was already present but must be dragged into reality by measures and actions coming deep from within her unconscious. Each curve and cut is done with enormous care, and with a sense of experiment bound to her internal vision; there are rarely any errors. After several hours or months the sculpture or construction has taken form, ready for presentation.

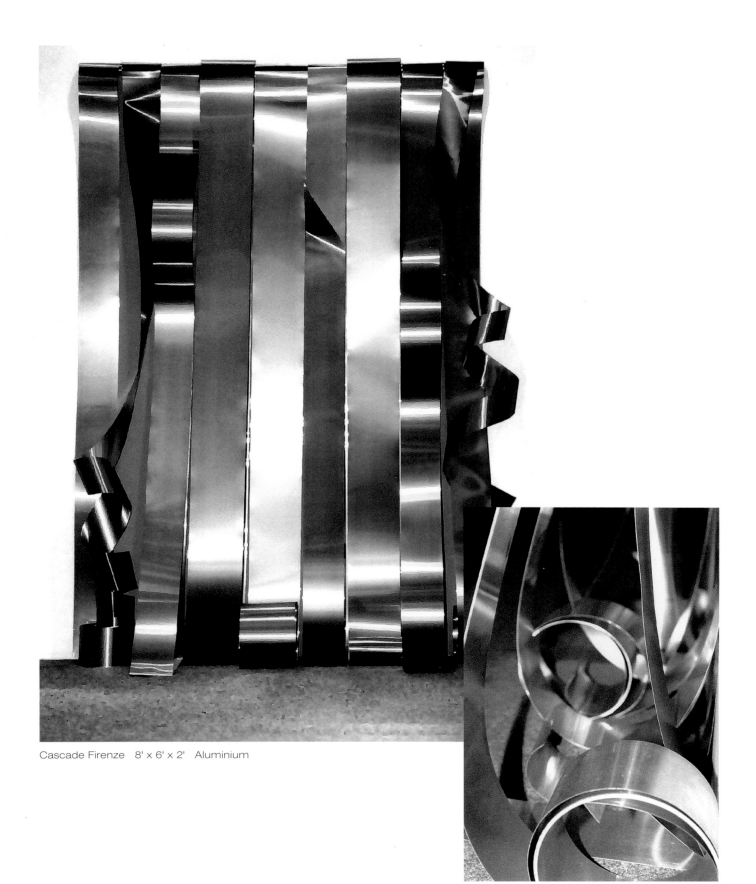

Cascade Firenze 8' x 6' x 2' Aluminium

Detail

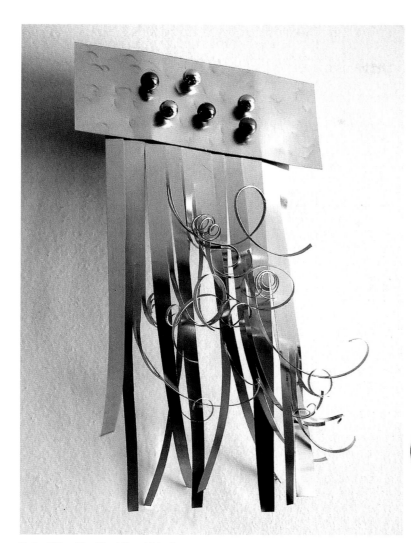

Bot 10" x 5" x 3" Mixed Media

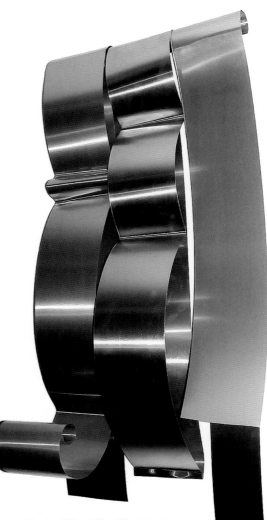

Drum Beat 30" x 19" x 7" Aluminium

Whether sculpture, construction or installation she shows the hallmark of creating unity between form and the volume in which the piece lives. Her most recent constructions in aluminium flow with grace, dignity and strength engaging the viewer through surface and scale.

Basha Ruth Nelson holds many awards for her work, most recently a Lorenzo De Medici award in sculpture from the Biennale in Florence, Italy. She is included in numerous publications and her work is owned in public and private collections. She has exhibited widely in the United States and Europe.

Detail

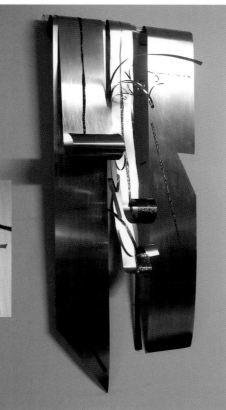

Dazzle 25" x 11" x 6" Mixed Media

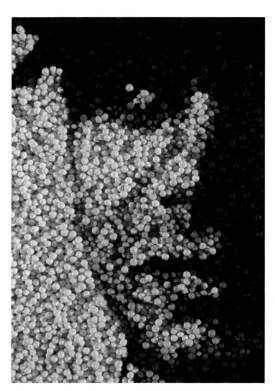

Mitosis I (Detail)

Mitosis I 4' x 3' x 3½" Mixed Media (Paint/cotton)

Mitosis II 4' x 3' x 3½" Mixed Media (Paint/cotton)

RYAN BOWN

In his *Mitosis* series, Ryan Bown brings pointillistic optics to wider dimension through the creation of images almost photographic in effect, which he does by separately painting the white ends of cotton swabs and meticulously assembling their graduations of tonality for viewing at a distance. This inventive 'Seurat meets Johnson & Johnson' approach, in his able hands, articulates astonishing and compelling effects of representational art.

A resident of Utah, Bown springs from a family with generations of background in chemistry and commonly refers to his studio as the "laboratory." Known for his monumental Braille installations, he focuses upon conceptual art "portraying scientific concepts through time intensive processes" which include painting, sketching and digitally enhanced photography. His internationally exhibited work is represented by Amsterdam Whitney Gallery in Chelsea, New York and the Cowan Gallery of Orem, Utah.

Mitosis is a self-portrait made up of 52,000 individually hand-painted cotton swabs (Q-tips). In a scientific context, mitosis represents growth and the spawning of life by a cell dividing into two cells. I have illustrated this concept of 'becoming' by populating a box with Q-tips. One dot or Q-tip became two and so on, until an image filled the empty space.

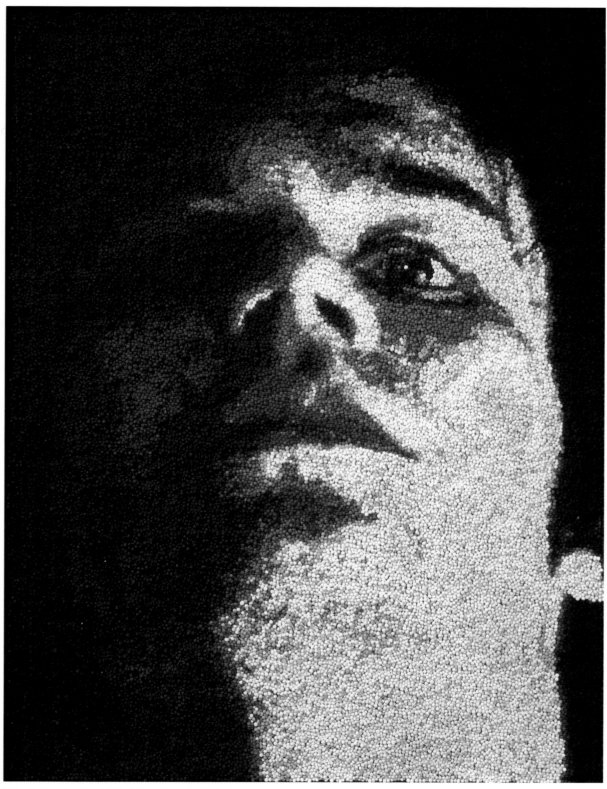

Mitosis III 4' x 3' x 3½" Mixed Media (Paint/cotton)

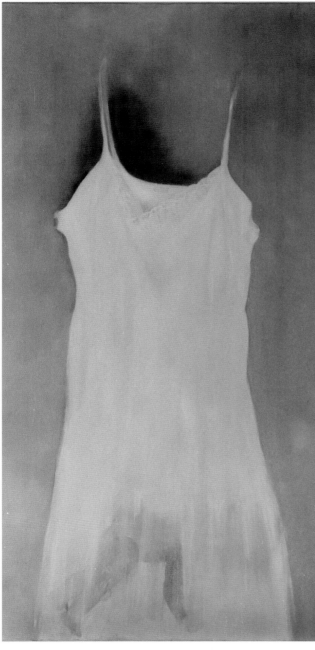

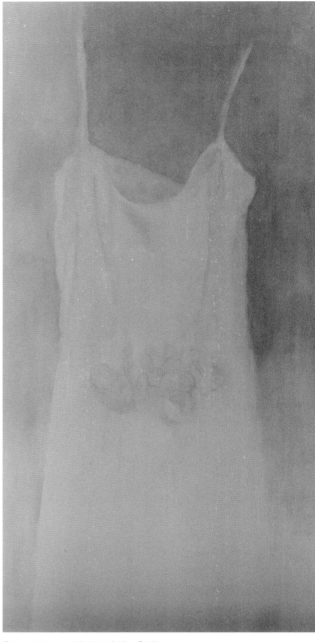

Boundaries 47½" x 24" Oil/linen

Boundaries 47½" x 24" Oil/linen

IEN DOBBELAAR

Novelist Daniel Vilmure, author of *Life in the Land of the Living* and *Toby's Lie*, describes Ien Dobbelaar's paintings in a poetic essay as conveying the experience of hypnagogic images, transforming the viewer into a conscious sleeper. Beyond their ghostly or dreamlike qualities, however, her work conveys, with hauntingly whimsical conviction, a pertinent and gender-sensitive exploration of contemporary identity.

A Dutch national, Dobbelaar obtained her degree in Sculpture and Painting from the Royal Academy of Arts at The Hague, Netherlands. Among numerous sites of exhibition are E.J. Bellocq in Ruston, Louisiana; Kunsthuis 13 Gallery, Velp, Holland; Museum Hillesluis, Rotterdam, Holland; Sentidos Gratis 5.0, Porto, Portugal and other venues.

It's not a coincidence that you paint what you paint. In our dreams our unconscious thoughts want to reach our consciousness. However, when we wake up there's a distance between the dream we remember and the meaning of the dream ... The hidden thoughts and feelings ... are often things that happened to you a long time ago. So, you have to 'decode' the dream to get to the theme.

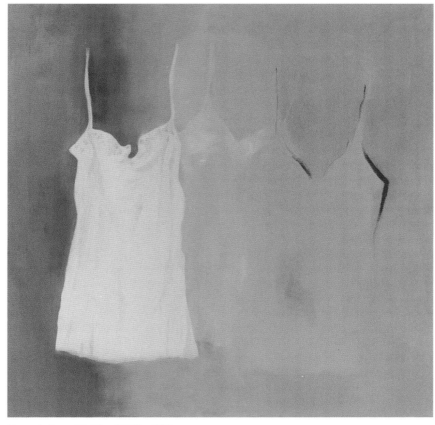

Boundaries 39½" x 39½" Oil/linen

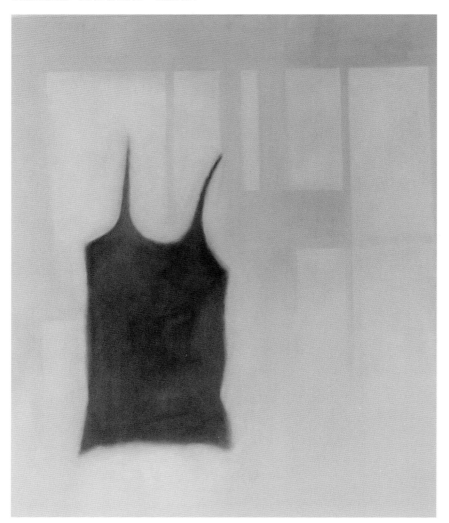

Boundaries 47½" x 39½" Oil/linen

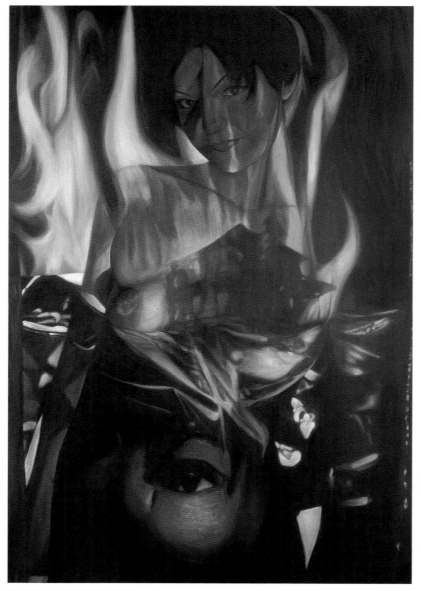

Fire Eye 48" X 70" Oil/canvas

JASON FAIRCHILD

By bringing aesthetic and isolated focus to such kinetic subject matter as portals, fractures and psychic superimposition, Jason Fairchild ventures respectful oblations toward untested limits of human perception. His often cunning dissections of visual category veer toward an element neutral objectivity while merging with an allegiant anthropomorphic sympathy.

Based in Chicago, Illinois, Fairchild was born in Ohio and studied art, science and medical illustration at Ohio State University. Sites of exhibition include Furnace Gallery and Belloc Lowndes in Chicago, Exposures Gallery of Columbus, Ohio and Art Link Gallery of Fort Wayne, Indiana.

My paintings are free-form theater. They are about elegance and obsession within rising seas of intensity, flowing fields and the silver screen. The work narrates expressions of our contemporary unsettled culture that spark various interpretations and numerous associations, allowing memories and questions to flow. These pieces suggest metonymic self-portrait, masonic and sexual motif; homage to artists and the artist's model. Through projections and screens of overlapping metaphors and color schemes, the figure becomes the star. My paintings are about life, with its good and evil; its tragedies and triumphs.

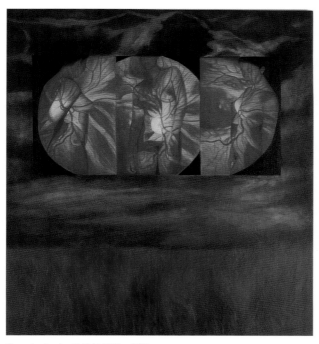

Omniscient 34" X 37" Oil/canvas

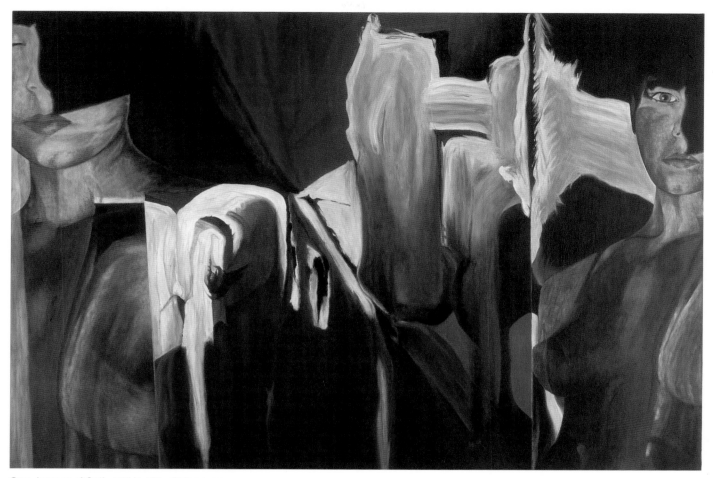

One Aspect of Self 70" X 48" Oil/canvas

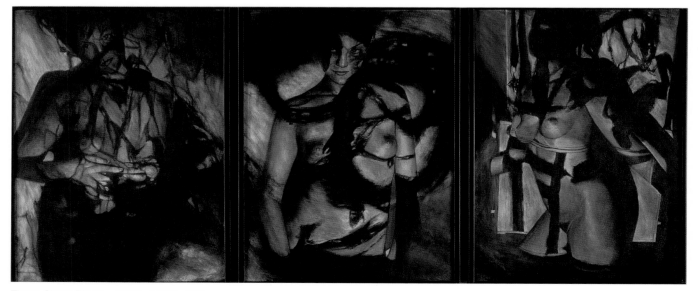

Three Sister Rings 40½" x16½" Oil/canvas

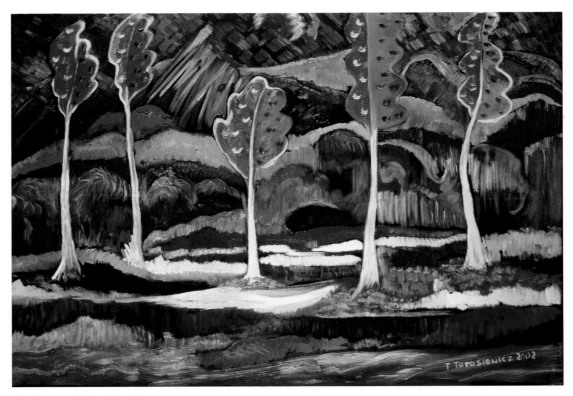

Oak Trees 58" x 82" Oil/canvas

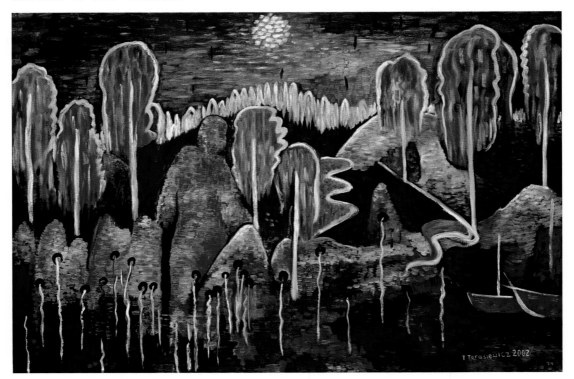

Live the Dream 58" x 82" Oil/canvas

TAMARA TARASIEWICZ

A coursing emanation of form configures into elements of landscape with a pulsing interior jubilance of pigment logic in the paintings of Tamara Tarasiewicz. A heady, leaning balance of color and contour formulates vistas which press the shapes of dream into the designs of nature.

A native of Poland, Tarasiewicz's self-generated interest in art developed as she formally studied practical nursing at Medical Teacher's School in Warsaw and the Nursing F acility in Wroclaw. Before immigrating to Chicago in recent years, she elaborated a stylistically poetic approach to oil painting and exhibited her work in numerous European galleries and museums, eventually founding her own museum and gallery in Bialowieza. Since settling in Illinois, Tarasiewicz's paintings have graced the walls of many exhibition sites in the American Midwest.

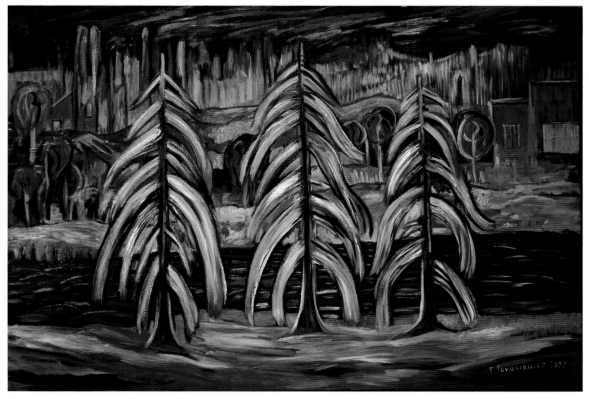

Trees In Landscape 58" x 82" Oil/canvas

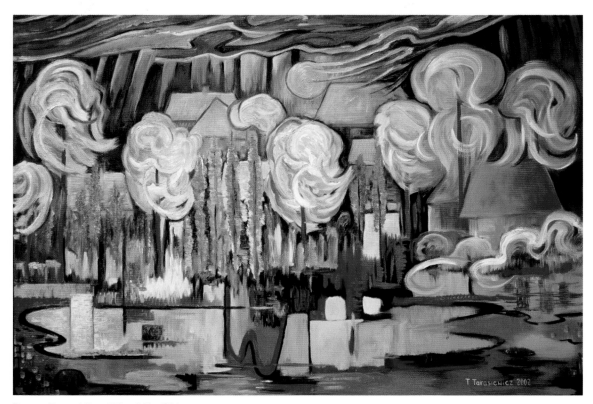

Drawn From Life 58" x 82" Oil/canvas

My fundamental idea is to gather the beauty from nature and enrich that beauty with my own emotions, expressions and explorations of painting gesture- all of which resides in areas of painterly thought which cannot be translated into words.

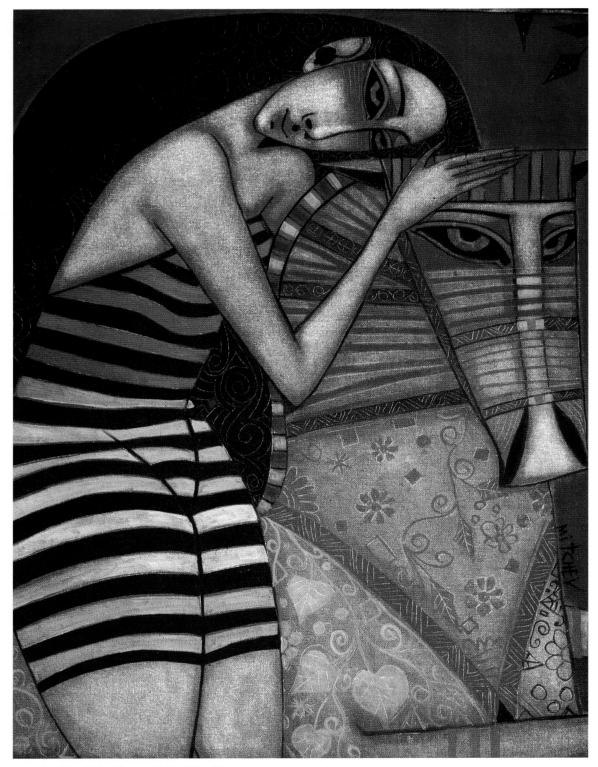

Reverie with a Fairy Horse 24" x 20" Oil on canvas on board

PETER MITCHEV

Astonishingly sophisticated for autodidactic art, the paintings of Peter Mitchev blend and transcend categories with an inspired flair for melancholic whimsy. Absorbing characters peer soulfully from his canvases in exquisitely keyed décors of color scheme and composition, trailing glimpses of icongraphic motive and traces of Byzantine inheritance seized in stages of metaphysical modernism.

Mitchev began painting in his native Bulgaria during the 1970's and became a well-known and successful artist exhibiting in numerous nations of Europe before moving to Florida late in the year 2000. Among many sites of exhibition, his solo shows have been hosted by the Galerie Artkhibios, Charleroi, Belgium; Galerie Celine, Paris, France; Gallery Knud Grothe, Copenhagen, Denmark; Capilla del Mar Gallery, Cartagena, Columbia; Palace of Justice, European Union, Luxembourg; Trihotel Gallery, Rostok, Germany and many, many other locations.

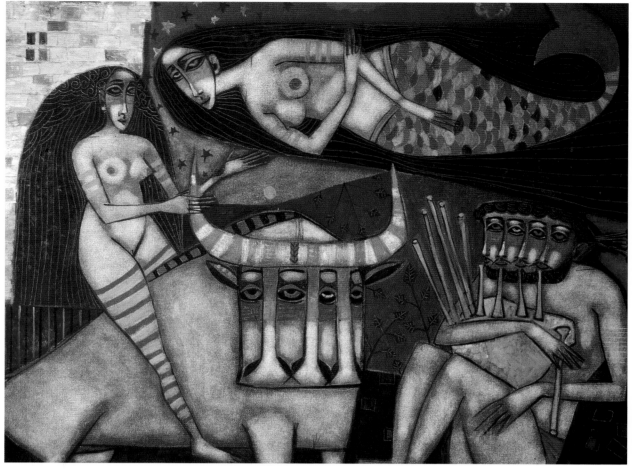

Tales for Children and Adults 24" x 20" Oil on canvas on board

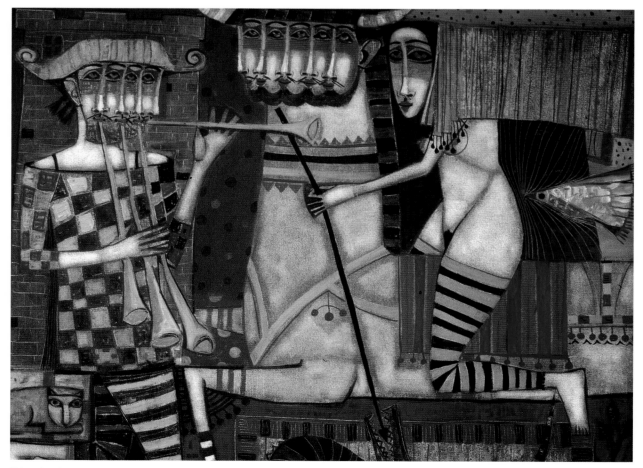

Tales for Children and Adults I 24" x 20" Oil on canvas on board

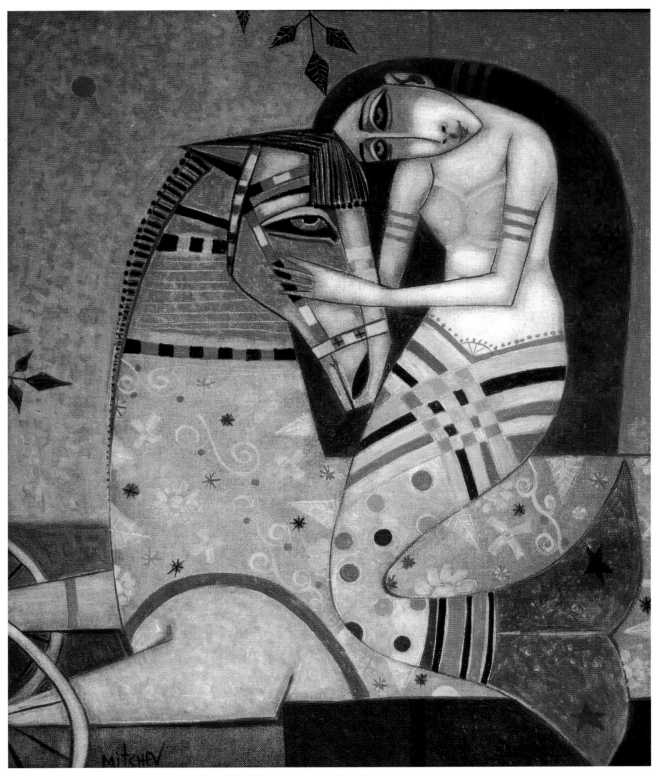

Red Haired Mermaid with a Horse　24" x 20"　Oil on canvas on board

During the past century, there was too much aggression and hostility in art and life. Because of this, I have promised myself, I will paint for love and unity. For unity between all peoples, races, religions, man and nature, and for the tolerance between rich and poor... My painting is a message to all people who need love and beauty. What everyone will see in them has already happened, is happening at the moment or will happen in the future. These images are inspired by the memory of mankind and the purest vibrations that people feel... These paintings are like children to me and that is why I am thankful if they bring joy and satisfaction. For me, painting is a form of thinking. It is a way of living. It is a mission impossible to give up. Painting is a salvation for my wicked soul...

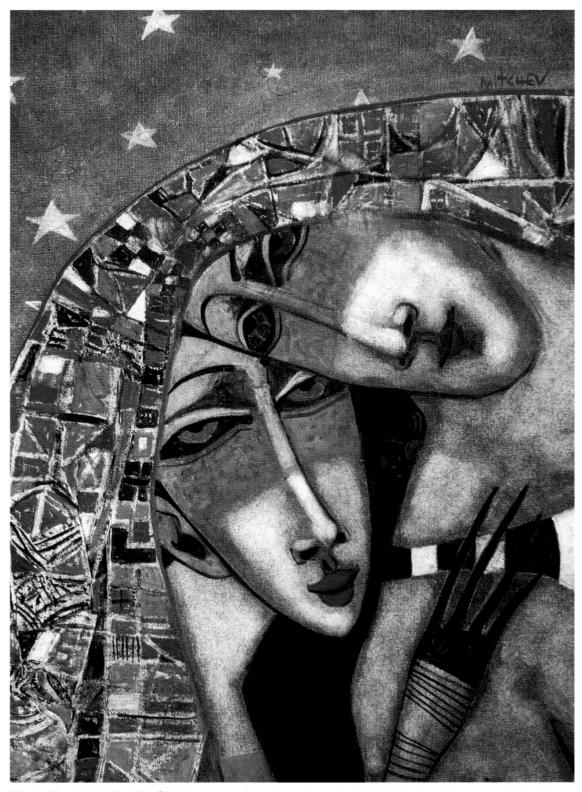

Magic of Love III 24" x 16" Oil on canvas on board

Waves Exaltation 24" x 72" Acrylic/canvas

MAREK KOSSIBA

The undulations and delicate, shifting tinctures of the sea reverberate as undercurrent in the paintings of Marek Kossiba, lending an organic appeal to the sensual eroticism of the voluptuous lines he uses to depict his impressions of subject matter from flowers to windmills.

After graduating Wroclaw University in his native Poland with a degree in physics, Kossiba studied at the State Marine School in Gdynia a further four years before taking to sea with the Polish navy and aboard commercial shipping lines. Gazing toward the horizon from the captain's bridge, Kossiba perceived a duality of worlds, above and below the water's surface, which exemplifies the duplex of consciousness and the subconscious. It was a realization which opened a space between these worlds for the explorations of his artistic instincts; an expanse in which surfaces were penetrated by light and solid objects.

Kossiba's ocean travels brought him to galleries around the globe which inspired him with ideas and traditions drawn from European, American and African cultures and his seascapes, portraits and abstracts increasingly reflect his gathered comprehensions. After studying at the New York Institute of Photography from 1995 to 1998, Kossiba has returned to the waves - this time oscillations of the electromagnetic spectrum in the cellular communications industry- as he continues his pursuit of visual expression.

Sites of exhibition include the Museum Dawnego Kupiectwa in Swidnica, Poland; Maison Internationale des Gents de Mer, Rouen, France; Mona Lisa Art Salon, Calgary, Canada; Cortland Leyton Gallery, Chicago, Illinois; Merimasten Kulturipaiwat Suomesa, Kemi, Finland and numerous other venues.

Belinda 72" x 12"
Acrylic/canvas

Brenda 72" x 12"
Acrylic/canvas

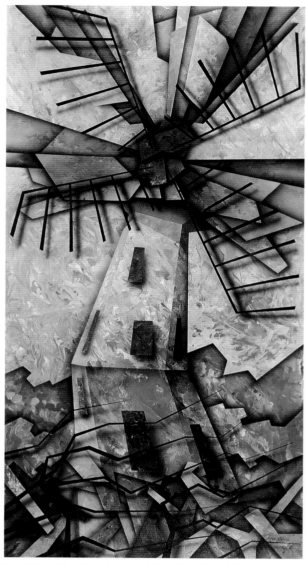

Windmills Morning Dance 68" x 36" Acrylic/canvas

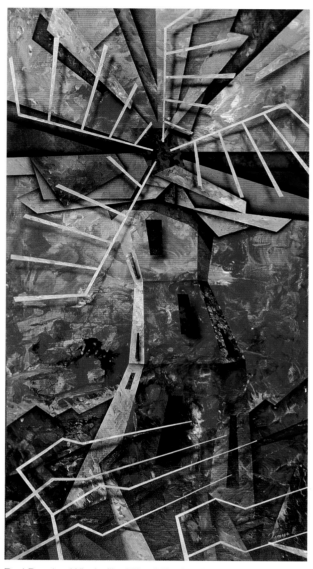

Red Passion Windmill 68" x 36" Acrylic canvas

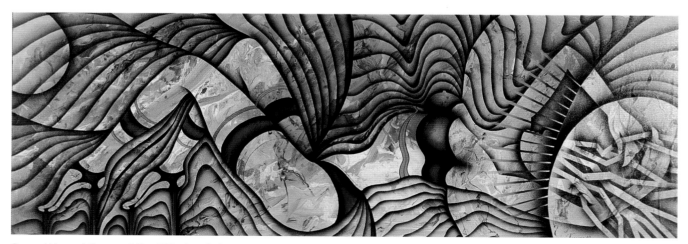

Green Waves Mirage 24" x 72" Acrylic/canvas

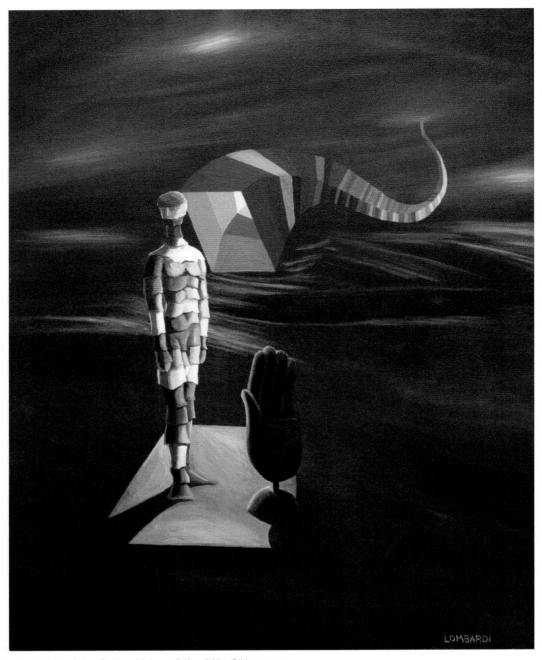

The Arrival of the Colored Man 24" x 30" Oil/canvas

STEPHEN J. LOMBARDI

Graceful and glabrous images luringly ease their provocations to thought through emblematic presences and equivocal situations upon the stirring canvases of Stephen Lombardi. His exercise of guided imagination in these surrealistic studies is delicately charged with social and human significance.

Adept in a variety of painterly modes, from realism to impressionism, Lombardi achieved his proficiency, with a minimum of formal instruction, through a capacity for close observation and appreciation beginning in early years of youth. The Massachusetts native developed his natural skills while living in the American Southwest for over two decades via a system of self-motivated studies, repetition and practice. Having recently returned to New England, Lombardi has exhibited his work from Boston to Virginia Beach and from Austin, Texas to Portland, Oregon.

Painting is the exercise, creativity is my path to healing myself and others. It is safe to say, experiencing my life through creativity has been both a blessing and a curse, although I would not have it any other way.

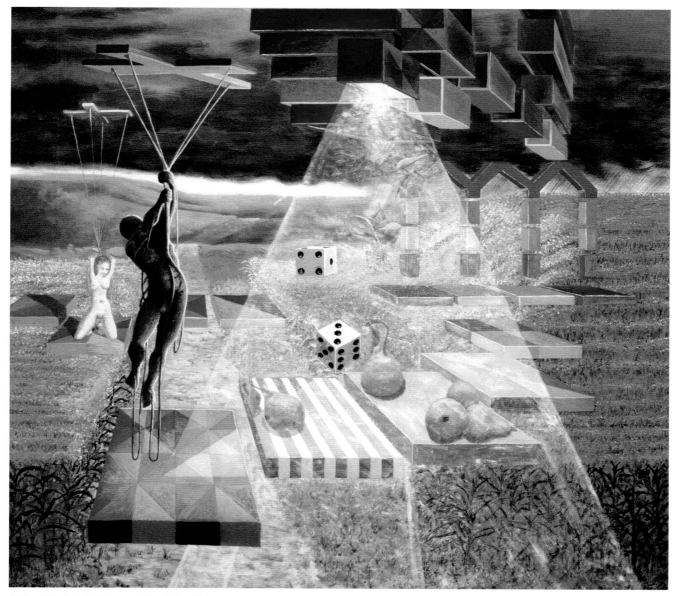

All the World's A Stage 30" x 40" Oil/canvas

Putting Together the Pieces of A Child 20" x 20" Oil/canvas

Garden of Eden 30" x 30" Oil/canvas

1987 Sacros 90 x 110 cm Oil on canvas

OLGA STAMATIOU

Olga Stamatiou uses color with an authority that captures each individual soul in her paintings. Her deft and poignant rendering of character, in feathered and featherless subjects, strikes warmly into the heart of the observer.

Born in New York City, Stamatiou's early years were strongly influenced by her mother's love of music and dance and Olga learned piano before turning seriously to visual art. After high school, she lived for a decade in Athens, Greece and studied painting with Ilias Dekoulakos.

Olga's arrival in Athens coincided with an era of political turmoil in Greece during the latter 1960's and early '70's which indirectly contributed to the temper of her creative development.

"I grew up on Long Island and, after my mother passed away, I went to Greece, where my ancestors were," Stamatiou recalls, noting that the new environment, with its Mediterranean colors and fresh cultural flavors, struck her heart. "It was a tumultuous period because of the junta- the political scene

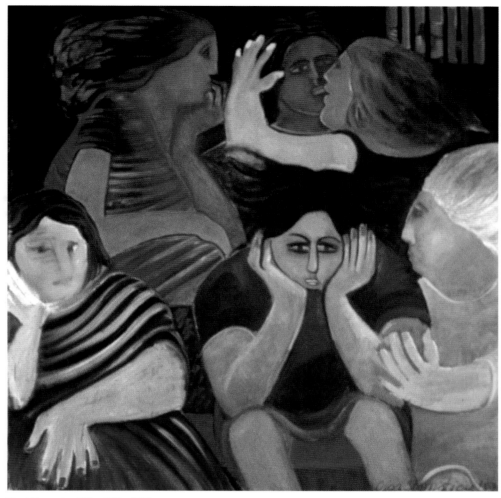

Red Carpet 48" x 52" Oil/linen

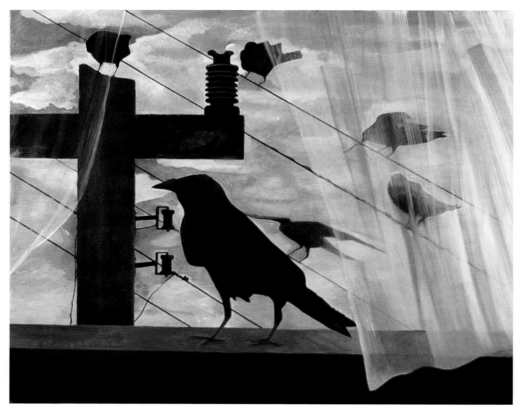

Wake Up Caw 48" x 60" Oil/linen

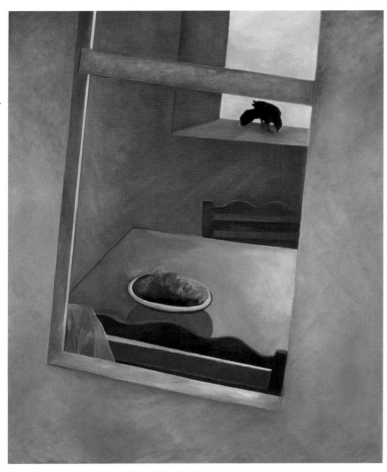

Breakfast at Tiffany's 68" x 48" Oil/linen

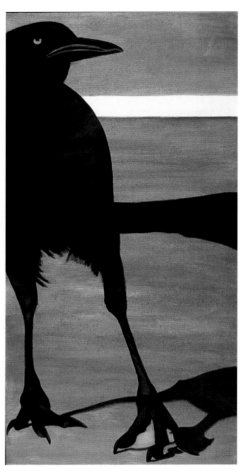

The Governor 24" x 48" Oil/linen

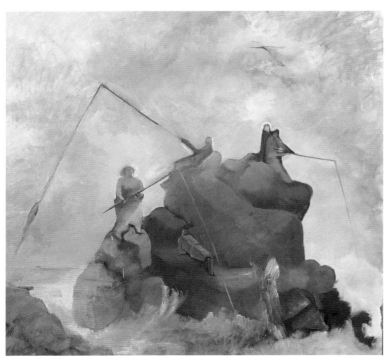

The Rock of Bounty 40" x 40" Oil/canvas

*was incredible- like you were in the '60's here, we were having
our own revolution there... I hadn't started painting before
that. I never did as a child but, when I went to Greece, it stirred
something. Who knows why? All of a sudden I just wanted to go
to my room and start painting. That happened when I was 21
years old."*

Introduced to a circle of writers and intellectuals by her aunt who
owned a publishing company, Stamatiou relished the artistic
integrity that was created in responce to the junta repression.
Against a backdrop of political tension, repression and struggle,
Olga's awareness for life deepened.

"The humanity, the people together, out there in the open; a
revolution was stirring," she recalls, "The two juntas, the masses,
the students and the rallies; people put in prisons, tortured; there
was a tremendous amount of passion in the air, and it makes you
more sensitive to life."

In early works, Stamatiou indulged her impulse for pictorial effect
with fascinating diversion from conventional schemes, applying
color with intuitive verve. Even as she leaned toward narrative
themes, Stamatiou maintained aninternal consistency to teh
mood of a given composition. When she returned to the United

Deep Thought #2 42" x 63" Oil

OLGA STAMATIOU

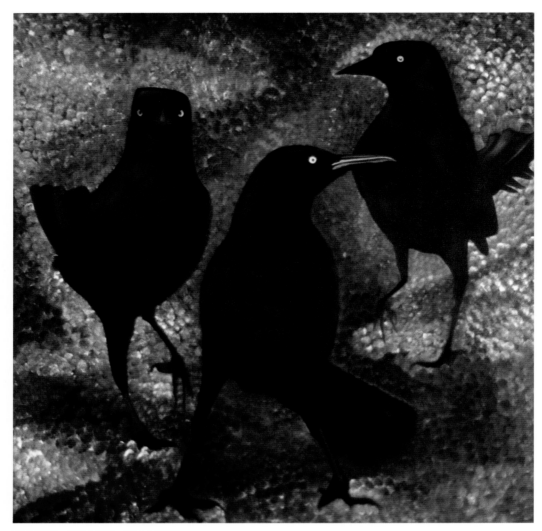

Tri Merlie 62" x 60" Oil on linen

States, she earned her B.F.A. and M.F.A. at Boston University School of Fine Arts. This added formal artisitc training to her intuitive instincts.

"I think the essence of drawing is being able to understand the inner quality of the subject matter, the skeleton; the whole foundation. That's what I strive for, that and to keep the spirit alive at the same time," notes Stamatiou, who continues to regard color as her "strongest vehicle of expression."

The blackbirds, which are prominent in recent paintings, were frequently in the background of earlier work. They were "like a sound outside the window - distant but always there."

"I have an affinity, which evolves naturally, to everyday objeects around me: animals, cats, birds, people, curtains, walls- like the walls in Greece with all the scrapings and colors that come through, just certain things. I don't really think about my subjects. They just sort of come to me... I just work from what I feel around me."

Currently residing in South Carolina, Stamatiou has exhibited her award-winning work at Gallery Art 7 of Contemporary Art in Nice, France; Laughlin/Winkler Gallery, Boston; Cornell Museum of Art, Delray Beach, Florida; Selini Fine Art Gallery, Athens, Greece and in many other venues. Stamatoiu's work has been selected for the renowned Florence Biennale in Italy in December 2003.

OLGA STAMATIOU

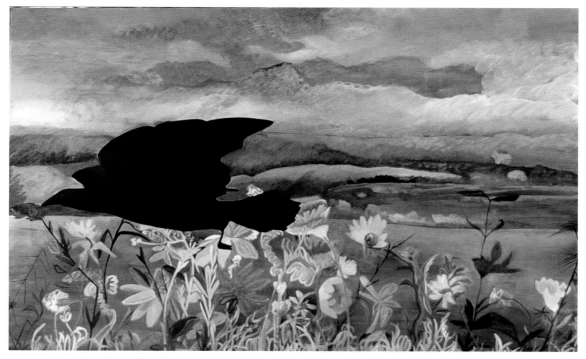

As They Fly 62" x 60" Oil on linen

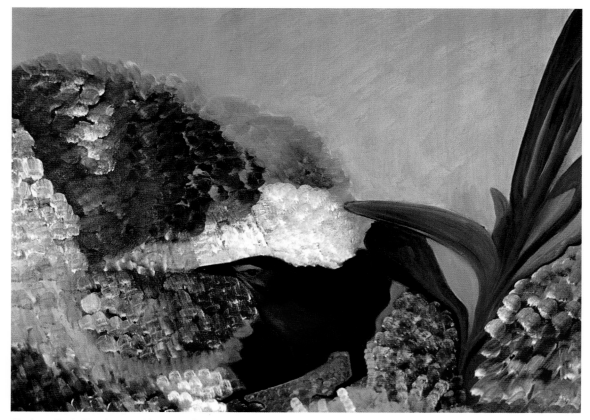

Chelsea Park Gardens 18" x 24" Oil on canvas

OLGA STAMATIOU

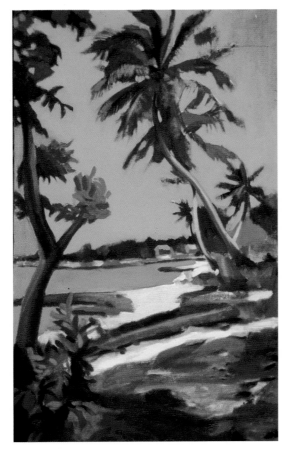

Playa Bayahibe Archival print available in custom sizes

YVELISSE

Since the heritage of tropical art in the Caribbean Sea has a distinct historical vanishing point due, of course, to European missions of "discovery" and an attendant zeal to obliterate traces of indigenous art and culture, the reinvention of art in the islands has gathered itself from far-ranging influences while struggling to retain a local identity.

The present artist, through a masterful use of native tint and tone, takes the tropical air of the Dominican Republic to canvas with a remarkable fluidity of contemporary presence. Educated in the United States and Italy, her conversance with formal technique melds into style with her obviously intimate acquaintance with the dispositions of her terrain. Her ability to convey shades of the breath-quickening variations of tropical beauty from the high tip of Cordillera Central to the lapping foam of the sea edges into new boundaries of pride and tradition.

Homage to Yorgi Morel Archival print available in custom sizes

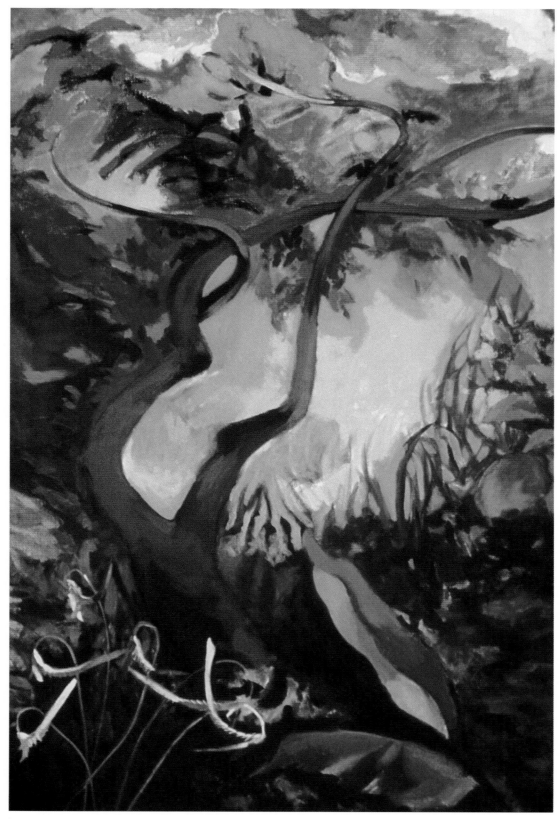

Internal Island Archival print available in custom sizes

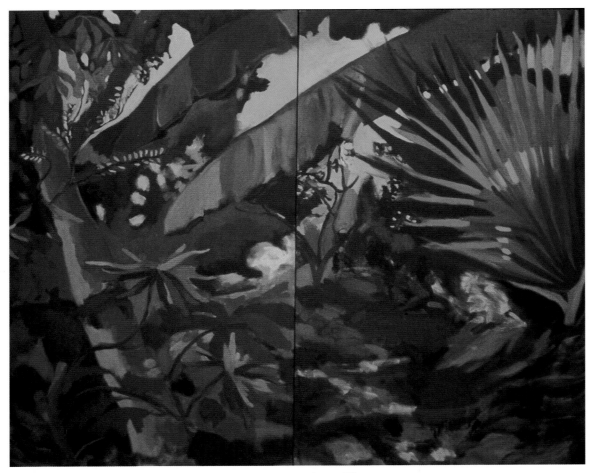

Wind and Tenderness Archival prints available in custom sizes Oil

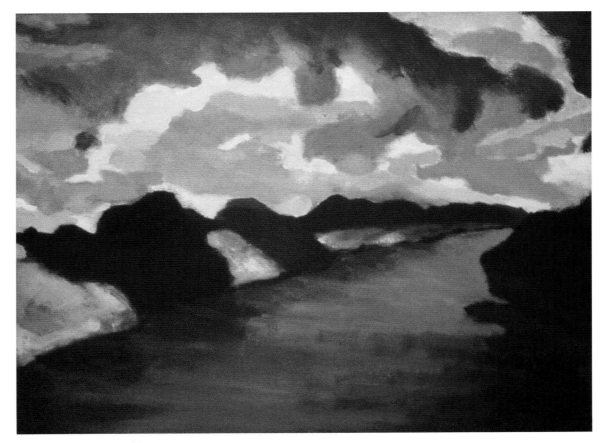

Rio Dulce 20" x 30" Oil

Enredadera 27" x 3" Silkscreen

My Heart Looks Up to the Sky 30" x 40" Oil

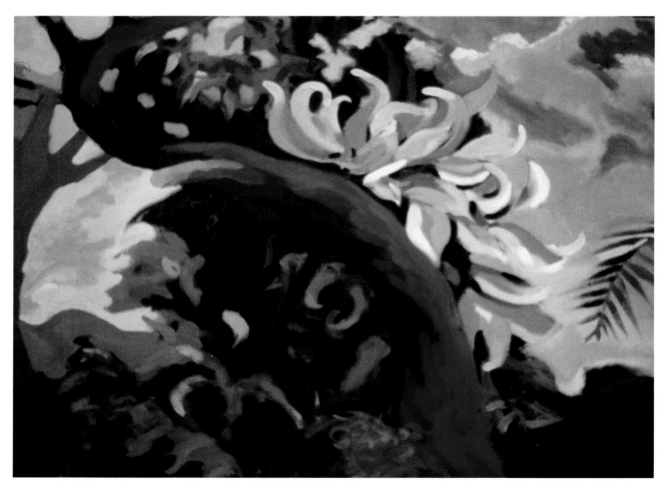

Crocuses Waking Up 30" x 40" Oil Archival prints available in custom sizes

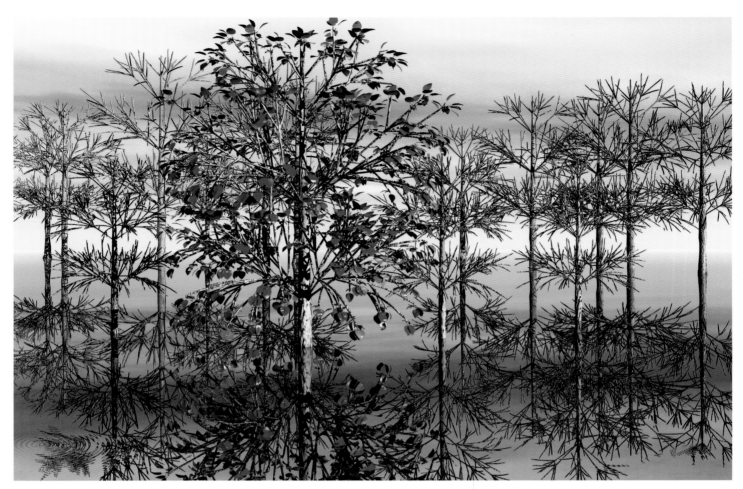

Ansel's Trees 48" x 52" Digital Art

YOLANDA KLAPPERT

Stroking forms with an electronic brush, coaxing depth and dimension with fingers set upon keyboard and curved mouse buttons, Yolanda Klappert builds scenes from emptiness, vistas and worlds in tints and textures that will solidify upon paper with a startling clarity of depth and perspective. Her musical touch, accustomed to coaxing melodious sound from other keyboards composes imaginative visual symphonies with personal flair and verve.

Currently a resident of Topanga, California, Klappert studied at Ravel Academie, St. Jean-de-Luz, France and Fontainebleau Ecole des Beaux Arts, Paris, France. She earned a B.M. at the University of Cincinnati; an M.M. and M.M.A. from Yale University and a D.M.A. from the University of Southern California. A classical concert pianist for twenty-five years, Klappert has won numerous musical awards and scholarships and recorded frequently. In 1998, she created the original CD-ROM, *From Stoneage to Rock and Roll: An Interactive History of Classical Music*, and has been involved in many other CD-ROMs and animations. Among sites of exhibition are Chashama Gallery of New York City; Long Beach Arts Center, California; Topanga Canyon Gallery, California; Fulton Street Gallery, Troy, New York and elsewhere.

I begin each picture with a blank canvas (or screen). The pictures are not scanned images that are 'doctored.' I create unique, one-of-a-kind works of art, derived from wireframe shapes and added textures, while making intuitive decisions about movement, color and depth. The resulting photographic-like paintings, created and rendered on a computer, are printed on a special photographic paper, with archival inks. Each picture's wireframe or shell substructure is composed of hundreds of individual polygons. The rendering process of the final image, (changing wireframes to objects that have shape, color, depth and volume), takes many, many hours, sometimes days to complete. The finished pictures are several hundred millions pixels in size. Often, the images are so large that they cannot be seen in their entirety (in actual pixels on a computer screen) until they are printed. The element of surprise is truly a delight as, often, I discover many unusual and exciting effects that I did not expect, plan or see originally on the computer screen.

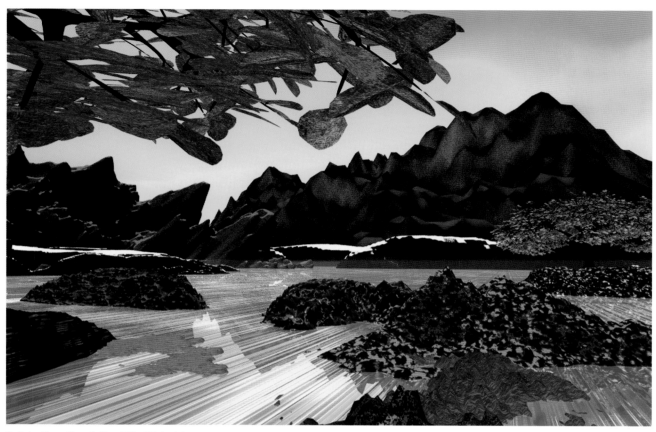

Sally's Favorite 34" x 27" Digital Art

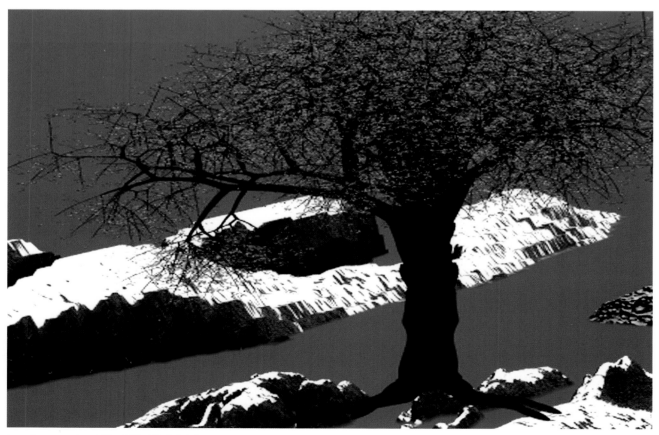

Les Agrements 16" x 20" Digital Art

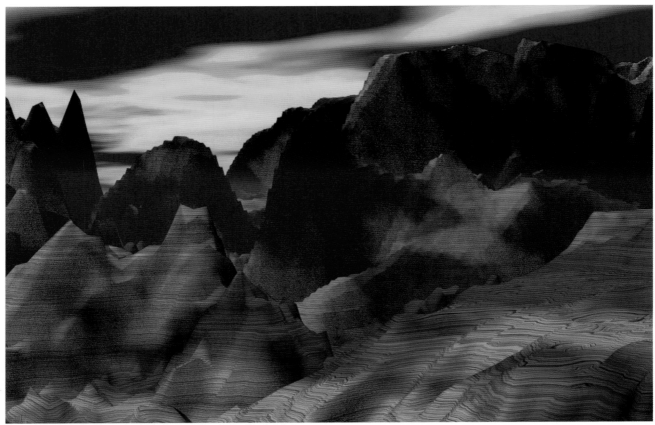

Grand Canyon in Perpetual Motion 20" x 24" Digital Art

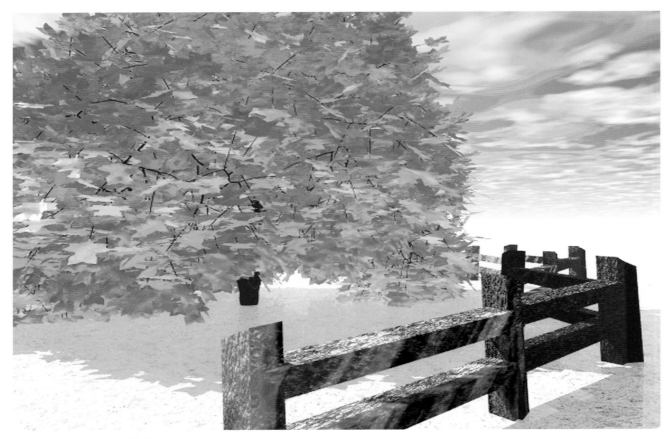

Kinda Blue 31" x 24" Digital Art

Little birdie, ounce or two,
Let me fly up there with you
And visit where the dew drops come
So that I may gather some.
 —Jerry Sedley Kaufmann, age 5

As God is my witness, I said I wouldn't write. Publishing two new volumes all but consumed the year; and my plate was full. Luckily, the residual events I now pass on would have withered on the stalk had not the Bush sweetener bought me some time.

In review, what fills my log seems pedestrian, at best. In addition to surviving the hard school of the farm, I found time to entertain my granddaughters, renovate the wood shop, raise tea roses, produce a jazz concert, and reestablish lines of communication with an old flame. On the dark side, my dentist died in my arms. His last words to me were *spit out*.

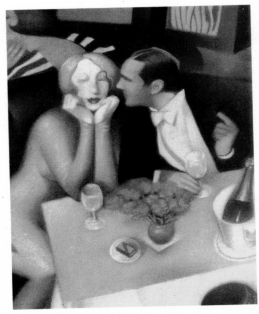

It was a year in which revelations were intriguing. I was pleased to learn that Ann Coulter is a female impersonator, that Kofi Annan is a cross dresser, and that Nicole Kidman, in preparation for the role of Virginia Wolf, borrowed Celine Dion's nose. Psychic cures were mixed. My dread of heights remains unchanged, but I can now pick up the soap I drop in the shower without fear of getting wet.

In the sex department, I would have preferred *infrequently* as two words. The year would have been a total bust if not for a stray red neckette I picked up at the Bear Cafe—a simon-pure nugget with in your face boobs and legs that didn't quit. As a general rule, I'm not into the local aborigines who roll cigarettes, wear white after Labor Day, and drop love kids like their vagina was a clown's car. But absence makes the fond grow harder, and it was either this endangered bimbo or buying a Craftmatic bed so I could blow myself.

There's more.

Getting lucky with this chippy was a no brainer for which the price of a fifth of Cold Duck and a pound of Bugler tobacco would hardly tip the scale for buyer's regret. Stripped to the nines and wearing nothing but a chest rag that had been dipped in asafetida, she morphed from provincial innocence to the sum of all furies. Reaching higher worlds, she pressed on with tearing, feral passion, fueling the flames of Vesta, shrieking *Fuck me! Talk to me dirty! Tell me you're Jewish!*

Despite the disappointment I suffered in being denied a personalized social security number, it was a very good year.

Life is just a bowl of Jerrys.

Enjoy!

Woodstock, 2003

Waldscenen 37" x 24" Digital Art

Southwest Cloudscape 48" x 50" Digital Art

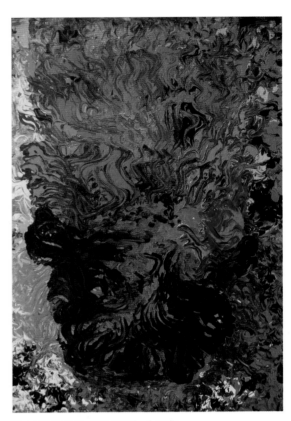

The Black Pot 24" x 30" Acrylic

Gases 16" x 20" Acrylic

Complexity II 24" x 48" Acrylic

ELLA SIPHO

As much enamored with the explosive qualities of pure color expression as the Cobra painters of the late 1940's, Ella Sipho employs a guided spontaneity in positioning the energies of her forms. Her robust embellishments of instinctive gesture are cohesively embraced by an invigorated and deliberate, if unruly, chromatic logic

A native of Kansas City, Missouri, Sipho has exhibited her work at World Fine Art Gallery, Limner Gallery, Amsterdam Whitney Gallery, Agora Gallery in New York City's Soho district and Chelsea district; California's Berkeley Art Center; Museum Gallery of Laurence KS, Kansas; Slide Slam Seattle Art Museum of Washington State; Galeri Gora of Montreal, Canada and numerous other locations.

Painting gives me the opportunity to express, within the art realm, my love of color and explorative nature by intermixing colors to the fullest extent, with no boundaries.

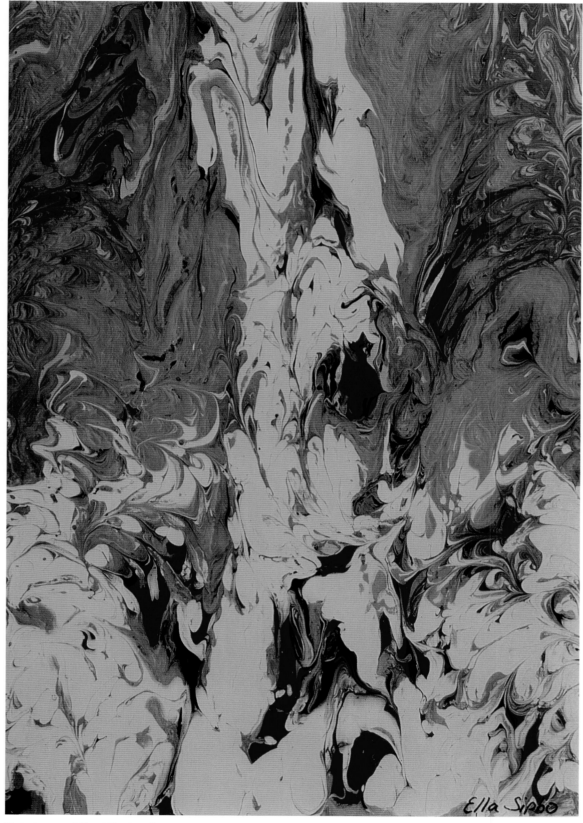

Turbulence 11" x 14" Acrylic

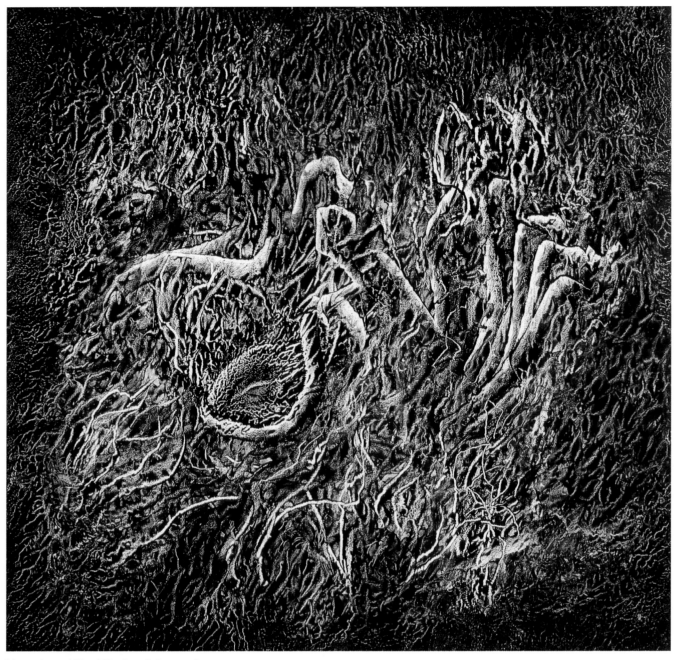

Noramius 48" x 48" Acrylic/masonite

DEREK K. NIELSEN

According to Derek Neilsen's paintings based on The Daementia Movement, incorporates a rendering technique that symbolizes the passing of the human soul through the evolutionary step of Earthy mortality. Each painting is a channeling of information designed to instruct the viewer on a subconscious level their current status in Daementia. Part of the goal of this life is to recognize the malevolent daemon influence, purge their control and rise above it. The paintings help in that respectby showing the viewer's unconscious mind how far deep in Daementia they are. The viewer's creative subconscious' mind absorbs the information and introduces new patterns of vibration to aid in rising above Daementia. To prepare each painting Nielsen goes through a series of meditations and breathing techniques to get in touch with his universal one self. The flow of the process for him is to let go of all attachments and allow the reality of the painting to merge with illusion of this world. Nielsen feels that he has an intimate relationship with everyone that will see his paintings.

Draylorius' Technique 24" x 48" Acrylic/masonite

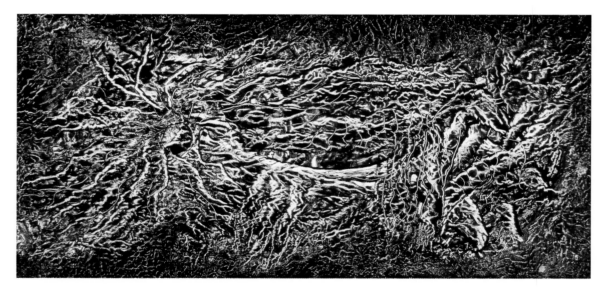

A Moment of Inspiration 24" x 48" Acrylic/masonite

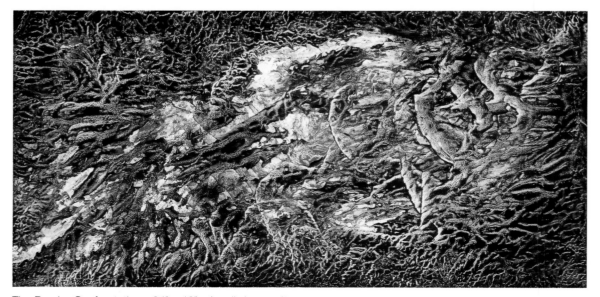

The Draylor Confrontation 24" x 48" Acrylic/masonite

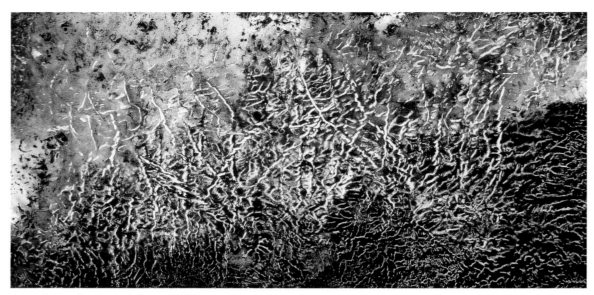

What Grows On Fertile Minds 24" x 48" Acrylic/masonite

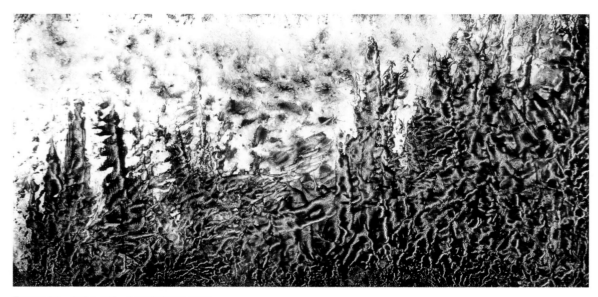

Forest 72 24" x 48" Acrylic/masonite

When we are conceived into this world we enter as creatures of pure white light. We bring with us many traits and characteristics that help form whome we become. Our light always shines from deep within, which is why I start every painting on a pure white, primed board. On the board I etch grooves and textures of natural harmonic relationships that form the basis of the painting. That texture represents the traits we bring with us into this life. Then I apply the pigment, which is usually acrylic. The color represents the control of the daemons and the layers of darkness we attract to ourselves through our loveless actions. You will notice that each of my paintings have a glow about them. That is the light that shines from within. It took me several years of trial and error to achieve that result. As far as I am aware, no other artist in modern history has ever employed my rendering trchnique. In truth, the painting already exists, and I am merely the vehicle to manifest it into illusion for you to see. Destiny is history. If you are looking at my painting it is now very safe to say that is was destiny. You will never more be the same, for through my painting we have become closer to being one than ever before.

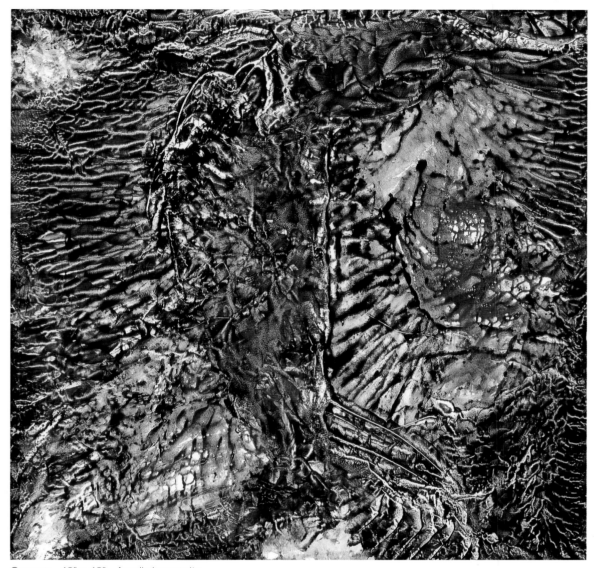

Cocoon 48" x 48" Acrylic/masonite

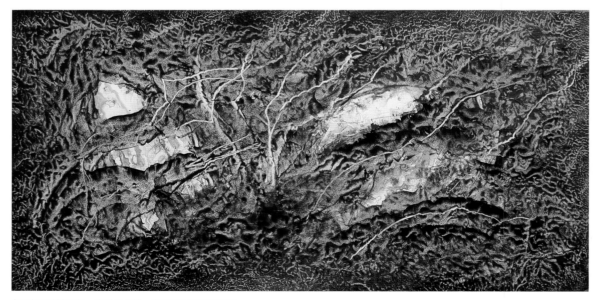

Ancient Words 24" x 48" Acrylic/masonite

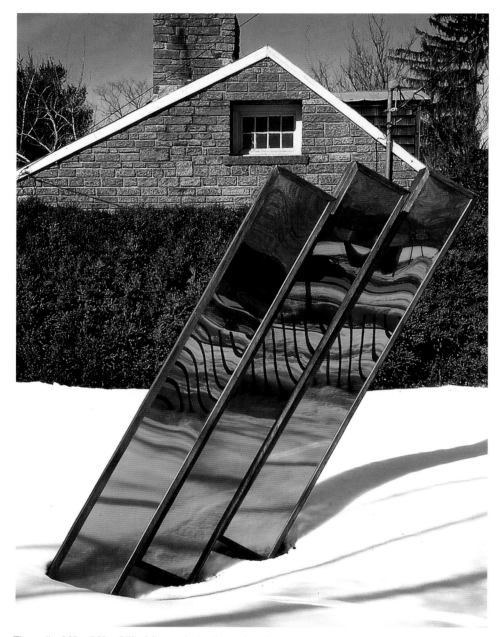

Three II 90" x 56" x 25" Mirrored plastic and mahogany

ANTHONY KRAUSS

Diamond shapes and rectangles sailing against a pale background, some amber, some blue, textured with abstract photo forms; pyramids tall and glowing orange, silver with the magic of mirrors, deep welled, reflecting passing images like creatures moving far beneath the surface; sharp rectangular relief of granite-like materials supporting a triangle of radiant copper; small metallic squares bound together, floating, suggesting thoughts and wishes of distant oceans. These and many others make up the works of Anthony Krauss.

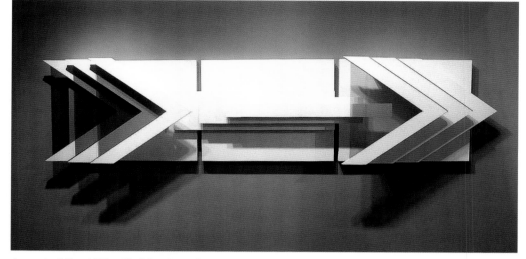

Arrow I 24" x 103" x 8" Mixed media

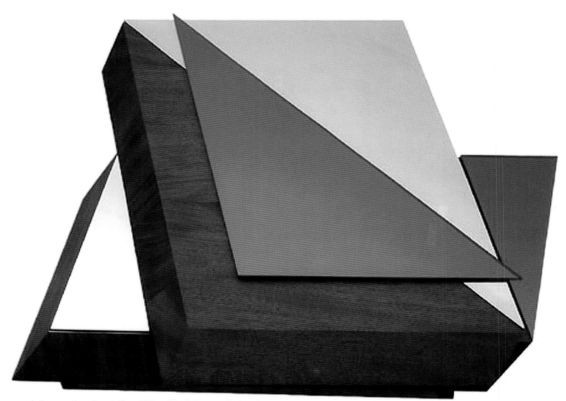

Intersecting II 14" x 17" x 8" Mirrored plastic and mahogany

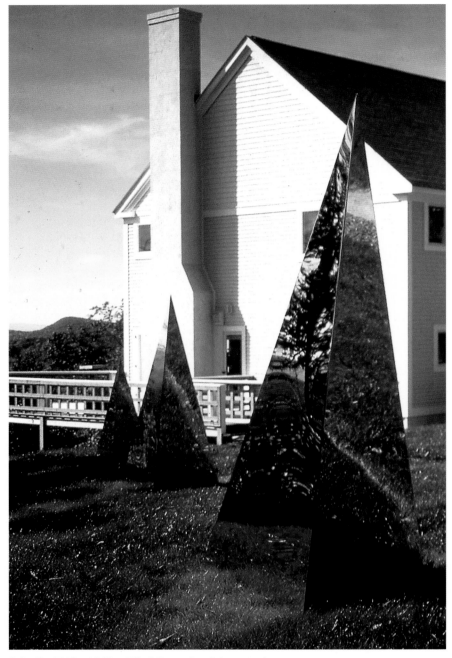

Sails III 120" x 192" x 48" Mirrored stainless steel

Krauss's recent works are constructed in stainless steel polished to a highly
reflective level. The material creates a mirrored effect and when arranged in
triangular forms offers a dazzling maze of reflections and counter visions
ranging from apparent invisibility to glittering sunlight images.

Anthony Krauss has been interested in reflective surfacing for many years.
Previously he explored the effects of mirrors, photographs with materials such as
Mylar, many of which he still incorporates in the ideas and the steps of his
process.

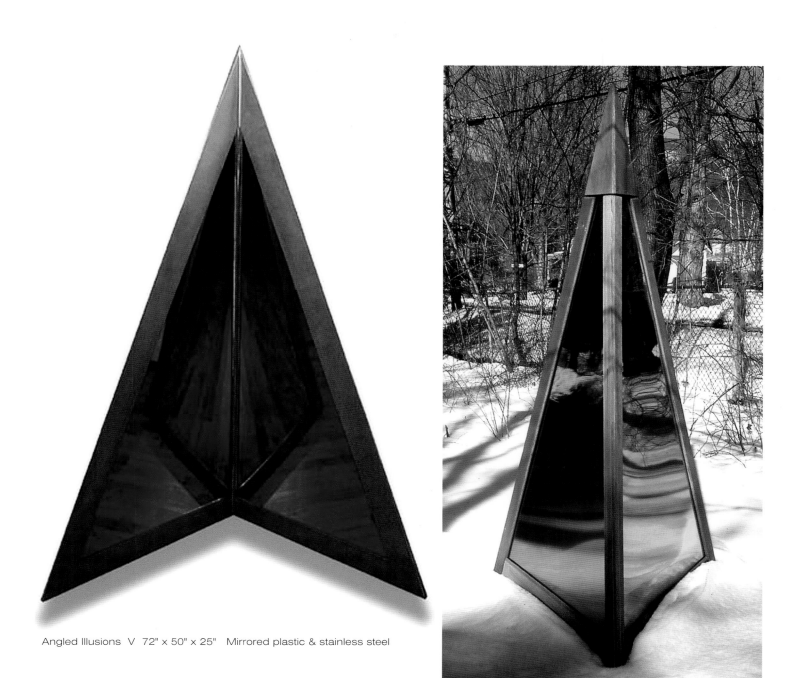

Angled Illusions V 72" x 50" x 25" Mirrored plastic & stainless steel

Tinted Reflections III 93" x 43" x 43" Mirrored plastic & redwood

Reflections, documenting the nature of existence.
As in an Asian aesthetic, a passage into the eternal
through the silence of timeless shapes

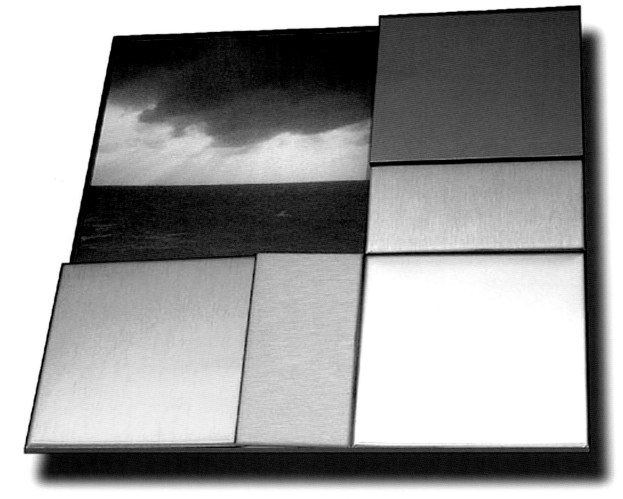

Storm Over Krabi II 19" x 19" x 3" Mirrored plastic and photography

Following his Masters of Arts degree in fine arts, he began work as a portrait and landscape painter. Later he moved his studio to Manhattan to join Pollock, Nevelson, Rivers and other 'newcomers' of the times. As a contemporary of this new 'school' he was influenced to make changes and gradually began to shift toward abstract painting, focusing primarily on progressive geometric shapes and optical illusion. Variations on the diagonal became a significant direction while later he added an interest in photography linking sculptural photographic images with certain relief materials such as wire mesh or Mylar, introducing a new series known as Photo-Sculpture.

In the early 70's he made another change and moved his studio from Manhattan to Woodstock, New York. The quality of his work, particularly in relation to his diagonal variations, rare colors and textures and the clean simple lines of his pyramidal forms reached such a high degree that through the contemporary years he has built an impressive reputation as an international artist..

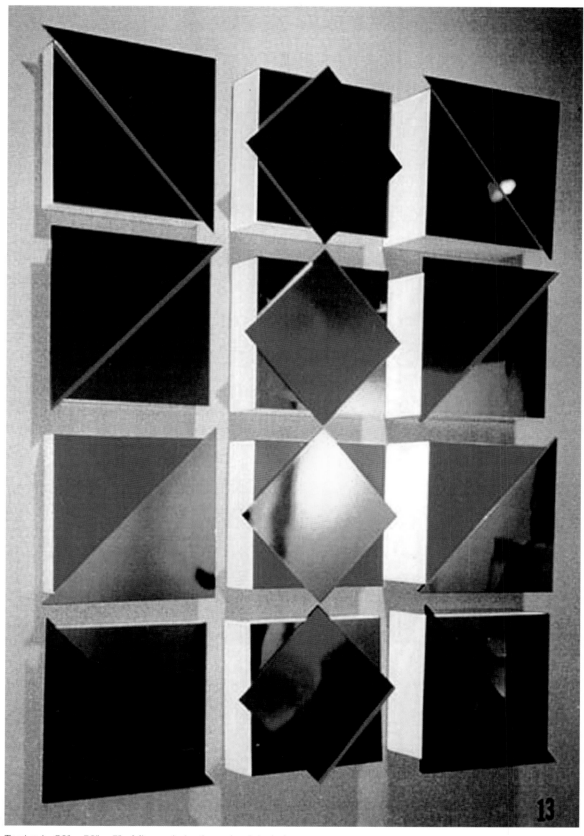

Twelve I 50" x 50" x 5" Mirrored plastic and painted pine

L.A.　36" x 51"　Vinyl on canvas

A Dog Too Can Dream　28" x 49"
Vinyl on sintra board

Promenade　36" x 40"　Vinyl on canvas

XELA

A purity of unmitigated color, contesting with separate, dedicated tonalities, each declaring at once an individuality of mood and purpose and conspiring positions in concert toward a rationale of function, is conspicuous in the artistry of Xela. Purposeful and tidy, the sleek, distinct edges and surface sheen of his vinyl colors grant a bold character of sly, shorthand expression which endeavors an abundance of effect with a minimum of gesture.

Xela is the "nom-de-brush" of a well known designer of museums and theme exhibits with over fifty of the former to his credit and a long list of the latter both in the United States and abroad. He studied art in Florence, Italy, London and New York and has apprenticed to the contemporary French-Israeli impressionist, Yitzhak Parnell.

When not engaged in an active schedule of domestic and international travel, Xela divides his sites of exhibition between Galerie Gora, Montreal, Canada and Don O'Melveny Gallery of West Hollywood, California.

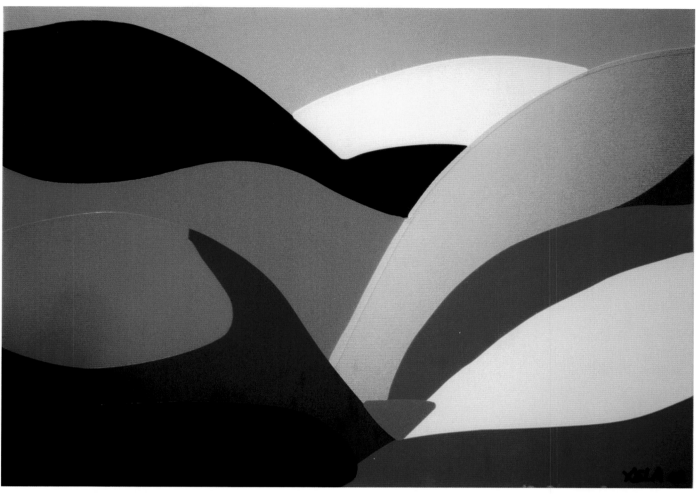

Delaware Water Gap 30" x 40" Vinyl on canvas

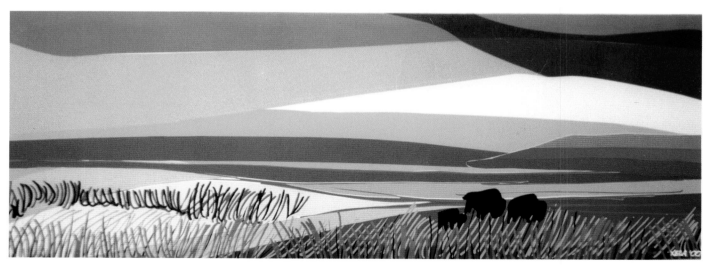

Prairie Noon 28" x 72" Vinyl on sintra board

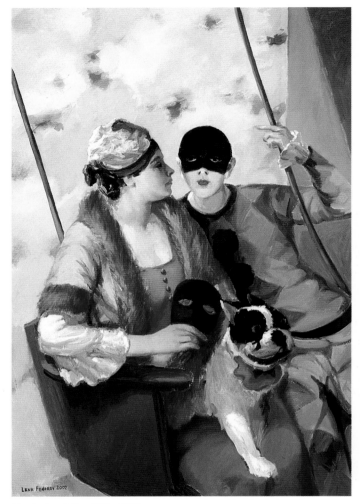

Cachely 24" x 36" Oil/linen

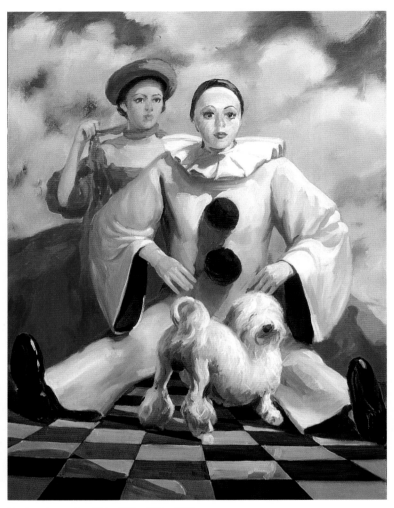

Harlequin and a Girl 29" x 36" Oil/linen

LENA FEDOROV

The infusion of amusement, irony, romance and mystery into the disciplines of classical realism curves the trajectory of subject matter in the paintings of Lena Fedorov with the slight arc of a wry smile. Her whimsical and poetic approaches to coloration and composition are frequently balanced and fortified by elegantly implied elements of human drama.

Born in Moscow, Russia, Fedorov studied under Dmitry Mochalsky in the six-year Fine Art program at V. Syrikov State Art Institute. After immigrating to California in 1991, she worked with Kent Twitchell's Art Studio on the eight-story, 11,000 square foot mural, "Harbor Freeway Overture," which features members of the Los Angeles Chamber Orchestra. Among U.S. sites of exhibition are the Art Gallery in Pasadena, Viva Gallery of Northridge and Aubergine Fine Art Gallery of La Canada, California and Greenhouse Gallery of Fine Art in San Antonio, Texas.

The key of my happiness in life is when a final artwork turns every minor thing around into a symbol of beauty... My paintings are about conversation. In a sense, I use a formal vocabulary to get into another world, another reality that allows my own vocabulary of images to spring forth. A final artwork is a life visual record of all my sensibilities at a time of creating..

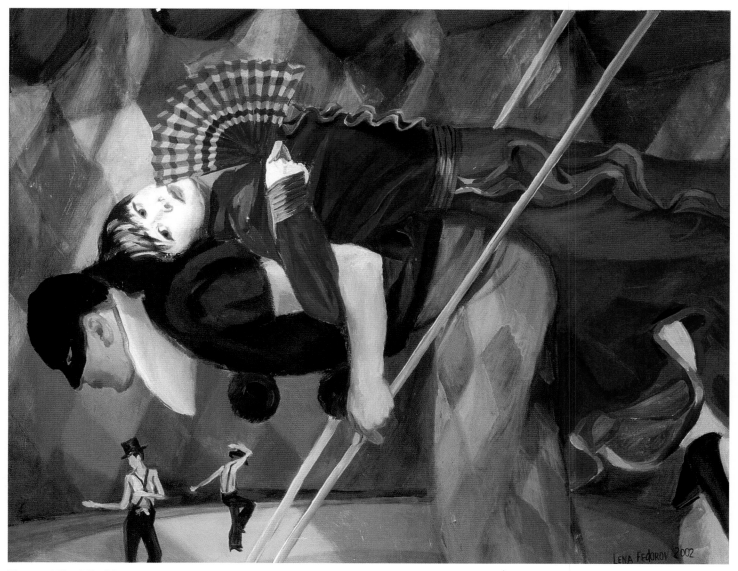

Circus 30" x 29" Oil/linen

Two Clowns 30" x40" Oil/linen

Harlequin 36" x 48" Oil on linen linen

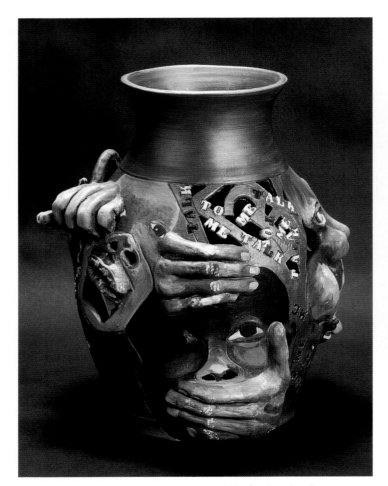

Something Like a Break Down 15" x 10½" Sculpted wall pottery

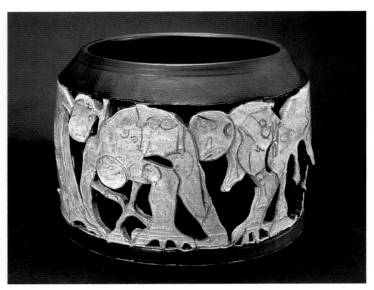

Untitled 9" x 11½" Sculpted pottery

TRACY AMEEN

Pottery depends on the simplicity of its form and the beauty of its line and has a long decorative tradition ranging from the classical to the purely ornamental. Rather than applying one convention or the other, Tracy Ameen's work combines both, redefining the traditional shapes by molding original and unusual sculptural images as seeming attachments to the basic forms.

Her ceramic structures as with most grow from the wheel or manipulation of the medium to develop the rounded forms. But then her work takes a different direction and using those initial simple structures as supports, as her "canvas," she makes a complete change by adding beautifully defined but disturbing relief images which act as surface sculptures. These relate and become a part of the underlying structures and cling to them because they are there! The pots and bowls which present at first as simply the sculptural supports for much macabre or disturbing imagery are then seen to control those images by the simplicity of their own tradition.

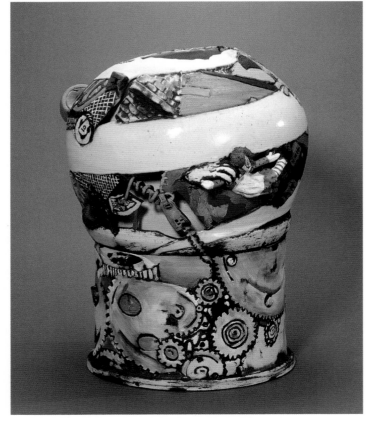

Man Unleashed 18" x 12" Sculpted double wall pottery

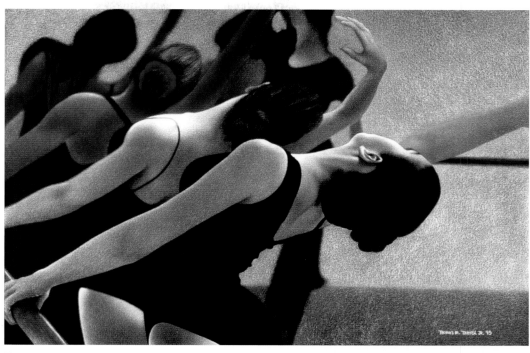

The Rehearsal 20" x 30" Colored Pencil

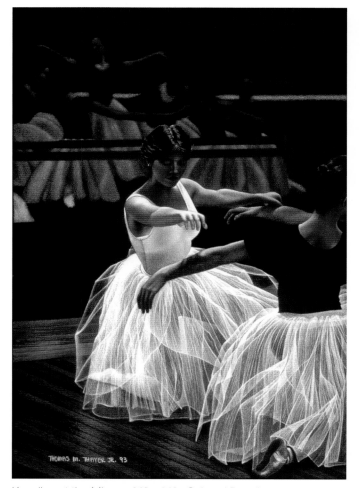

Kneeling at the Mirror 20" x 30" Colored Pencil

Out On A Limb 16" x 20" Colored Pencil

THOMAS M. THAYER, JR.

An extraordinary sentience to interplays of light and poise, evident in the "pseudo-realism" of Thomas M. Thayer, Jr., invests a radiant dimension of grace to his thoughtful and fascinating scenes. His exquisite sense of composition and perspective augments an abiding presence of humor and compassion in his subjects of focus.

Born and raised in Michigan, Thayer obtained his B.F.A. from the University of Michigan School of Fine Arts before moving to the state of Washington in 1982. An international award winning artist, his work has appeared in innumerable exhibitions and has been featured in *Creative Colored Pencil*, *Best of Colored Pencil 2* and *4*, *Exploring Colored Pencil* and *Creative Colored Pencil Portraits*.

I was told once in art school that it was taboo to draw on a black ground and I have been doing it ever since... although I use reference photos in my work, all of my drawings start out in written form, either a small sketch or a written phrase which is then painstakingly converted into a finished drawing.

Last Days of Autumn 24" x 18" Oil

ROBERT J. CARAFELLI

Compelling, atmospheric landscapes and striking, character-saturated portraits are among the most favored scenes of gifted Midwestern painter, Robert Carafelli. The extraordinary charm of his technique and subject matter sets his work quite apart and above the efforts of less ingenious celebrants of objective reality.

Born in Wooster, Ohio, Carafelli studied with Dong Kingman at the University of Hawaii while serving with the U.S. Navy and later at The Applied Arts Academy in Akron, Ohio. Despite a full-time corporate career of 36 years, he maintained an active interest in his art, selling numerous paintings and thousands of prints a year. Now retired, Carafelli has shifted his full focus to painting.

I dream about art. If I am working on something, I dwell on it and, at night, get my answers. I love to start out in the morning immediately put it down on paper.

View From The Bridge 13¾" x 21" Watercolor

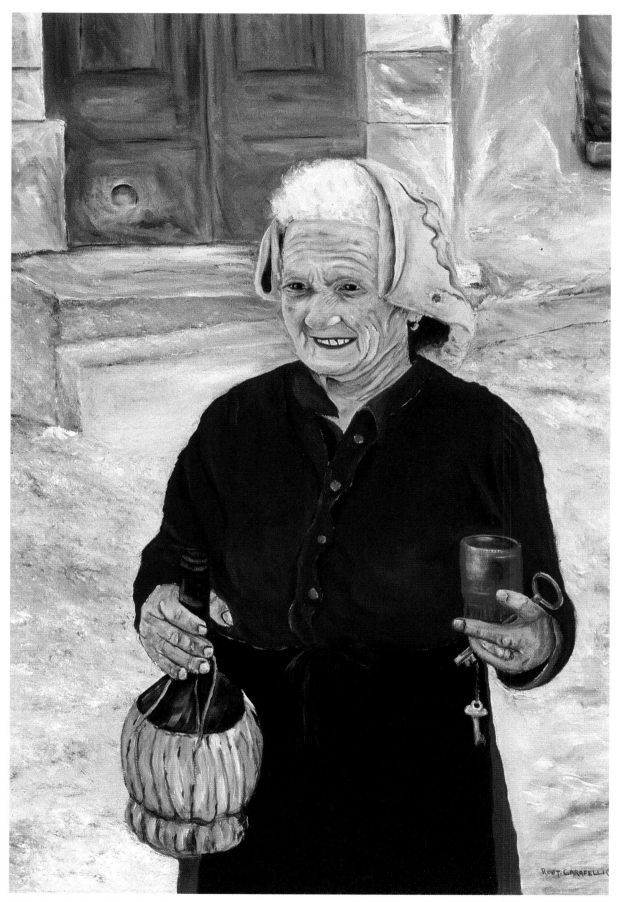

Italian Hospitality 26" x 18" Oil

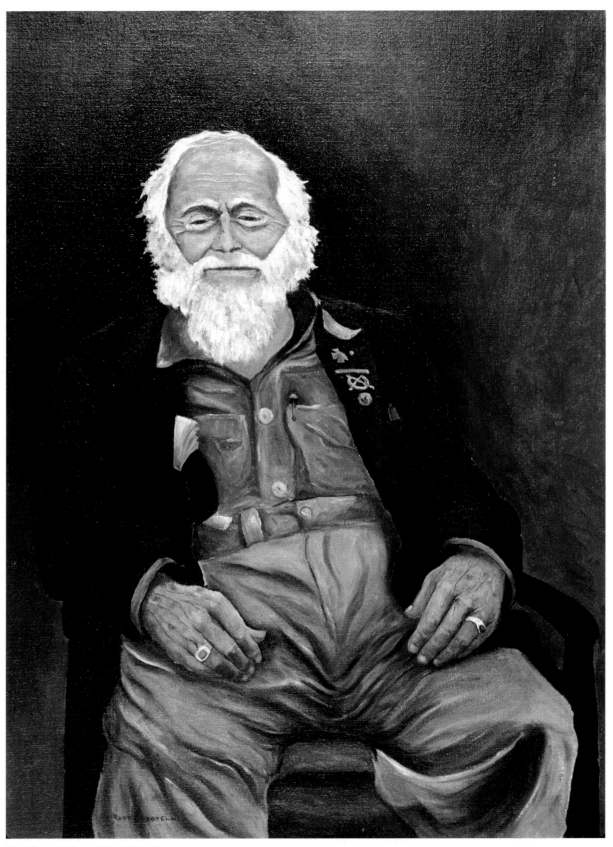

The Story Teller 20" x 28" Oil

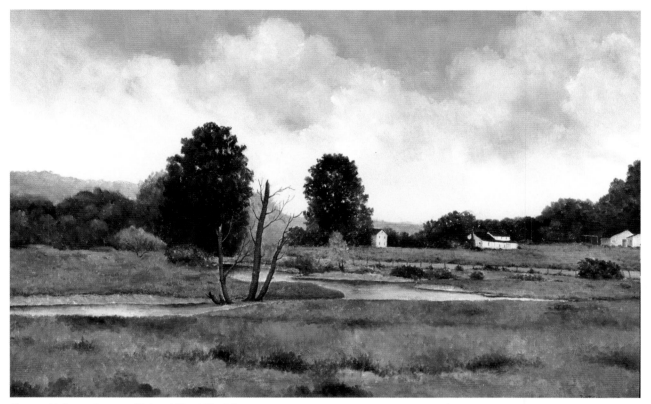

Charm, Holmes County, Ohio 18" x 28" Oil

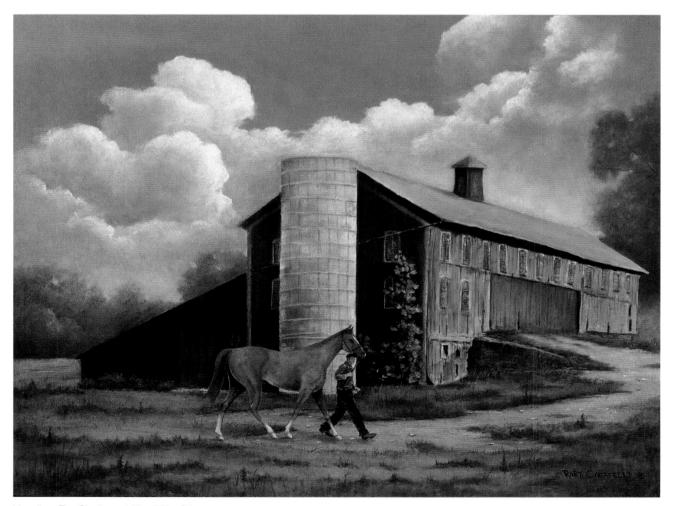

Heading For Shelter 16" x 20" Oil

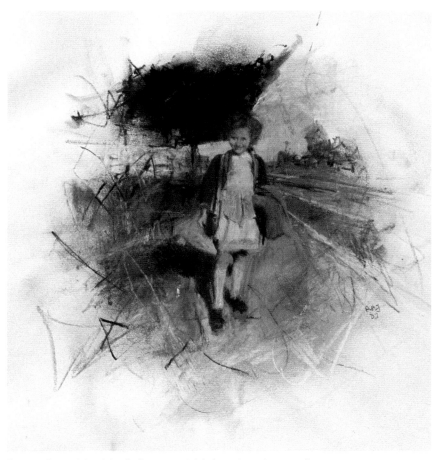

Strong Star 14 x 11 Collage, pastel, ink, watercolor pencil, paper

ROSALIE A. FRANKEL

Oddly haunting images. Figures like photos of the past afloat in chillingly unreal backgrounds. Strange backgrounds because as partners of the images they seem familiar yet are not, existing only in the abstract, making pleas for something recently forgotten. Collages mindful of pictures discovered in an attic album of people we have never known who try to tell us through their wide and glowing eyes of needs and wishes unfulfilled, pleading to make things as they should have been. Ghosts not insubstantial, contained within the mist and mystery of an unremembered place. Children's faces crying out for help; or of an adult sleeping, or maybe dead.

Frankel was born in New York, NY, and studied first at Hunter College where she received her MFA, then did further work at the Feminist Art Institute, and the Art Students League, all in New York. She has had several residencies - Haystack Mountain School, Maine; Woman's Studio Workshop Rosendale, NY ; Byrdcliffe Artists Colony, Woodstock, NY; and Hambidge Artists Residency, Rabun Gap, GA. She has also exhibited widely, most of her shows being in New York with others in Maine and Pennsylvania. She is holder of awards from Ceres National Juried Exhibition, NY, NY and the Wilner Jennings Gallery, NY,NY

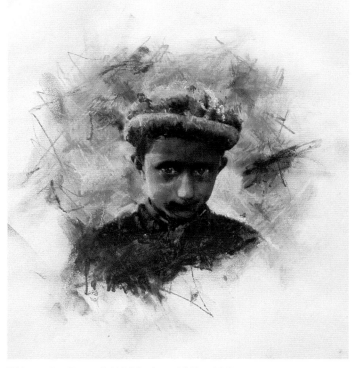

I Was 4 But Turned 400 Maybe 16½ x 13½
Collage, pastel, ink, watercolor pencil, paper

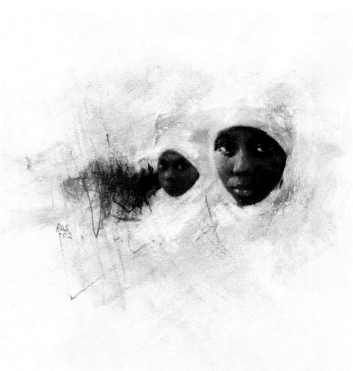

One Step, Another Step, I Come Up 14 x 11
Collage, pastel, ink, watercolor pencil, paper

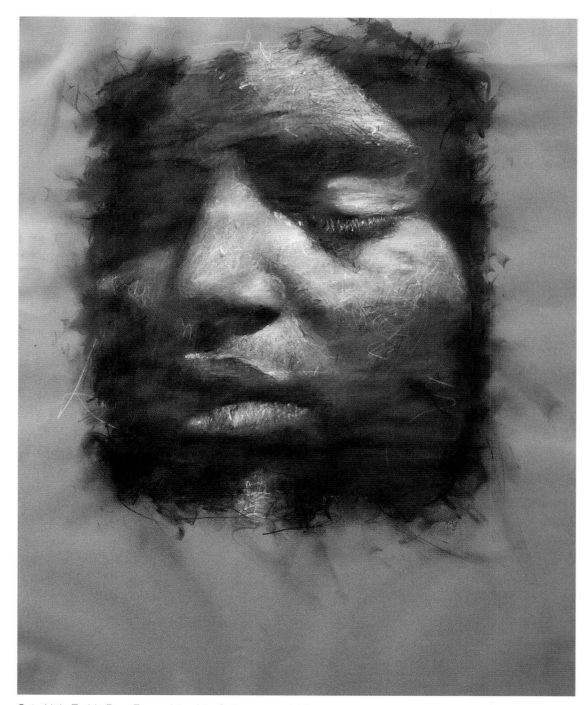

Cute Little Teddy Bear Face 24 x 19 Collage, pastel, ink, watercolor pencil, paper

My works speak on a visceral level. They are composed of images torn from reading material which seem to connect with me at some deep level. The images are subtly colorful and filled with intricate details; one must truly look to see. There is a fine line between life and death, joy and sadness, yet there is so much hope. My voice and body speak through my work. It is about humanity, love and vulnerability; I take pieces and place them together to make clarity and wholeness, to 'set the darkness echoing'. 'To those who see spirits, human skin/ For a long time afterwards appears most coarse.' 'She wished she'd been named/ Hope as a reminder.'

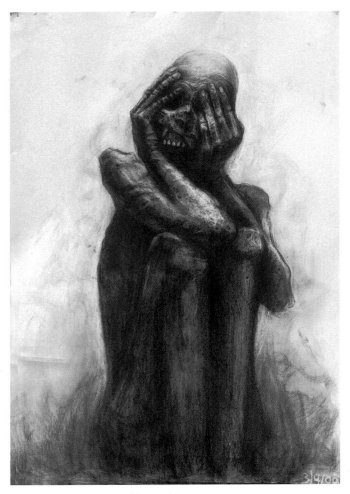

Mummy II 24" x 36" Charcoal/paper

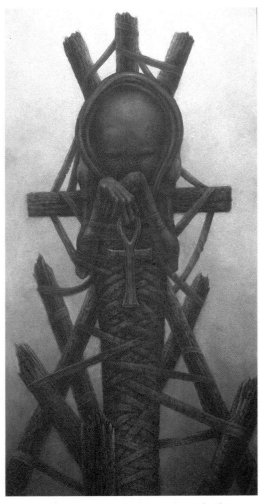

Bandages 30" x 52" Oil/masonite [#4]

D. C. KAELIN

The frequently solemn, often uncanny and always fascinating paintings of David Kaelin etch into deep corners of collective memory, dredging through primal responses inherent to the being behind the human mask. His unusual ability to touch raw points of the psyche with such rudely exquisite beauty and urgently compelling mystery can elevate the impact of his vision upon the sensitive viewer far beyond the commonly superficial efforts of current culture.

A young native of upstate New York, Kaelin has found inspiration in the Fantastic Realism and Surrealism movements as he proceeds to develop his own stylistic approach without the benefit of formal art instruction. His natural talents, as displayed in a few local exhibitions, are drawing positive response from the artistic community around Woodstock, New York.

Painting forces me to realize truths not only in the world around me but more important the truth within me. This, not the imagery that I depict, is the scariest aspect of my work. Artists are essentially truth seekers.

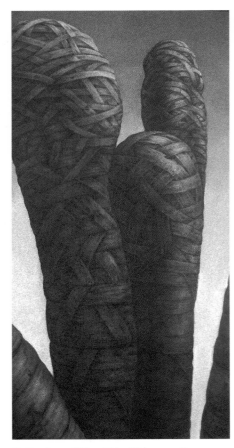

Gathering 30" x 52" Oil/masonite

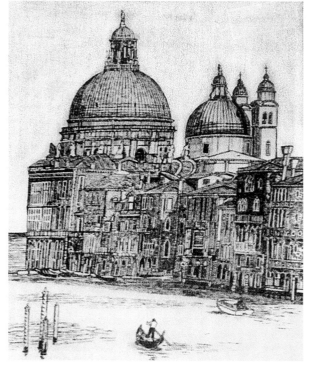

Venice II 24" x 36" Ink/paper

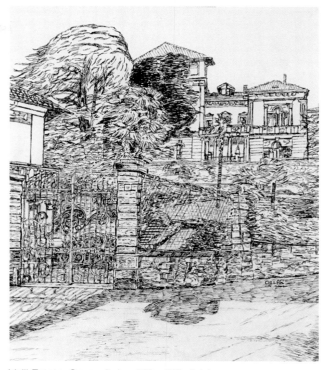

Vaili Estate, Como, Italy 16" x 20" Ink/paper

Krakow Sukiennice, Poland 16" x 20" Ink/paper

JOHN R. OILAR

Using the 'imprecise perspective' techniques developed by artists of the Italian Renaissance, John R. Oilar expertly renders ink likenesses of scenes and subjects from photographic representations. His method and skill is able to convert panoramas, through a studied regard of dimensions and relationships, into compositions which capture a charming essence of the view.

A native of Indiana, Oilar earned a B.A. at Western New Mexico University after having studied art and history in Italy and fundamentals with artist Sister M. Rufina, O.S.F., as a youth. His work has been exhibited at the Indiana State Museum in Indianapolis; Swope Art Museum in Terre Haute, Indiana; Tippecanoe Arts Foundation, Lafayette, Indiana; Limner Gallery in New York City and galleries in Nashville, Indiana and in other venues.

Of all man-made conventions, art is the most lasting. Empires collapse, movements die out, and ideas can be forgotten but art endures. Through art we can learn so much about a civilization. Art endures and adds so much to the beauty in our world. Art makes us think.

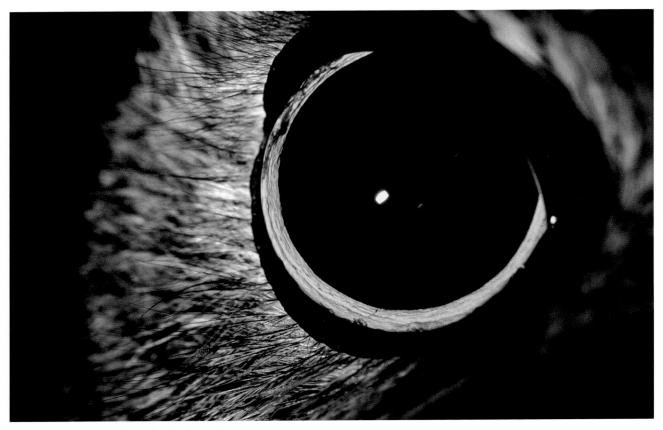

Eye of the Beholder 8" x 12" Photography

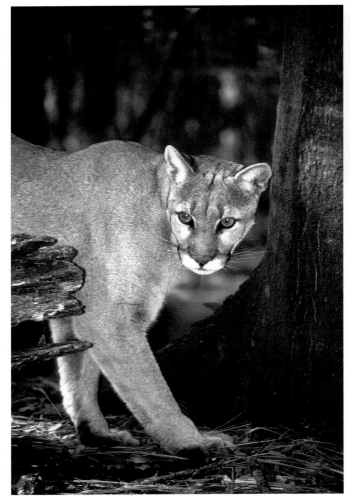

Stealthy Mountain Lion 8" x 10" Photography

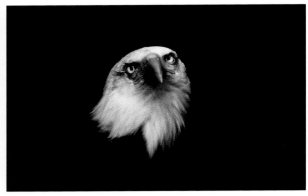

Oh Say Can You See 8" x 10" Photography

LYNN B. STARNES

Lynn B. Starnes creates photographs which are striking in their color, intensity and sense of life. The creatures she portrays seem caught at exactly that moment immediate to taking an action specific to the creature's need. Her images are caught with a poise and starkness of expression unique to the beast or bird's special secret connotation. Choosing a closeup of an owl's eye at night for example, changes it to become a pool of infinite darkness circumscribed by the edging of a golden moon.

Lynne B. Starnes has worked professionally as a photographer for the last six years. She has been selected by jury to a wide collection of exhibitions in recent years in Texas, Colorado, Florida, Tennessee, to name a few. Among others honors she was the recipient of the grand prize in the Library of Photography annual photo contest as well as being seleced for the John Hancock, New Mexico program to support the arts entitling artists to an open house and a month-long show.

Nature's Ballet 16" x 24" Photography

I consider myself a wildlife portrait artist. As it is impossible for me to place an animal in a special position I must be patient in my search. The longer the animal and the photographer are in proximity the greater the photographic opportunity. I am a biologist and a photographer, which allows me a special knowledge of animals which is rarely seen by casual viewers. I have dedicated my life to the conservation of North American fauna and I hope my love of things natural is captured in my photography.

Olden Times #1 16" x 20" Gouache

Olden Times #2 16" x 22" Gouache

TAMARA BALENKO

Whether turning her hand to warm and captivating still life or exercising her imagination into edges of the fantastic, Tamara Balenko brings a superlative sense of color and technique to an assured grasp of composition and subject matter. The rich detail of her formulations combines with an extraordinary spatial regard to communicate an alluring realization of depth.

Born in the village of Uzin in Ukraine, Balenko graduated from Odessa State Art College with a degree in painting and earned her master's in illustration and book design from National Polytechnic University. Additional studies at Los Angeles Valley College followed her immigration to the United States in 1996. Her award-winning art has exhibited in numerous countries, including Canada, Portugal, Poland, Belgium and the U.S. and in esteemed venues such as Memorial Museum of aul Verlain in Metz, France; Brunico Graphic Museum of Art in Brunico, Italy and others.

Soul's Flight In the Temple 24" x 33" Gouache

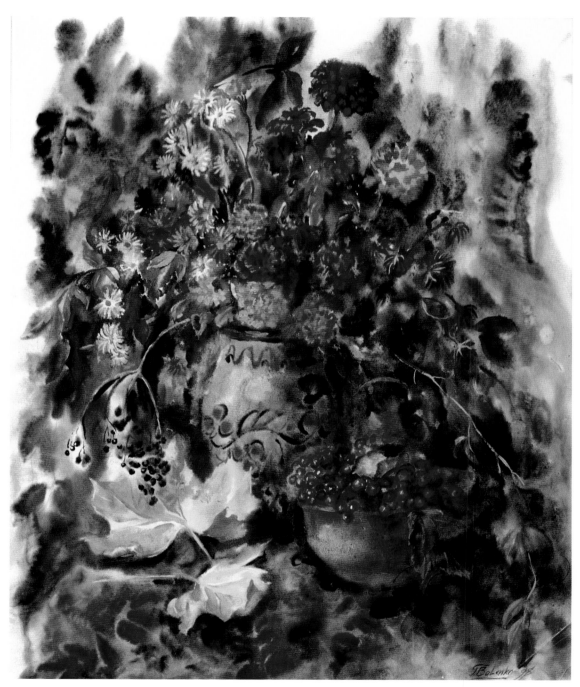

Flowers 22" x 18" Watercolor

*My artworks merge reality with fantasy; sentiment with sarcasm;
romantic and philosophical ideas with rationalism. Using symbolism, I
correspond to contemporary perceptions of the world.*

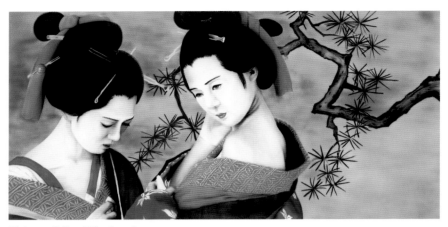

Sisters 21" x 42" Acrylic on canvas

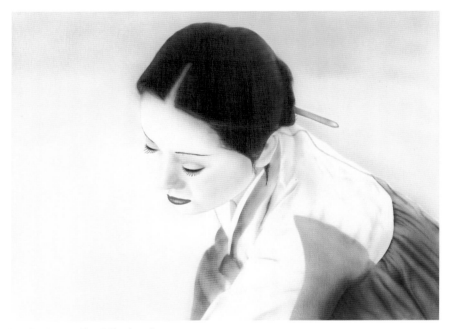

Meditation 18" x 24" Acrylic on canvas

DAVID OVERBY

By demonstrating an unusual ability to bring a breath of the archaic charm of classical Asian painting into the striking depth and clarity of contemporary technique, David Overby creates an unexpected realm of tableaux depicting the grace and sensibilities of his subjects. His images provide a more fully realized portrayal of the human element in the high cultures of the Orient, displayed with dramatic and uncommon beauty and vitality.

Currently an Arizona resident, Overby worked his way though Southern Illinois University as a draftsman and spent over 25 years as a cinematographer in the television and motion picture industries. Among many sites of exhibition in California and the American Southwest are El Taller Gallery of Austin, Texas; Vision Gallery of Chandler, Arizona; Exclusive Collections of La Jolla, California and Art Encounters of Las Vegas, Nevada.

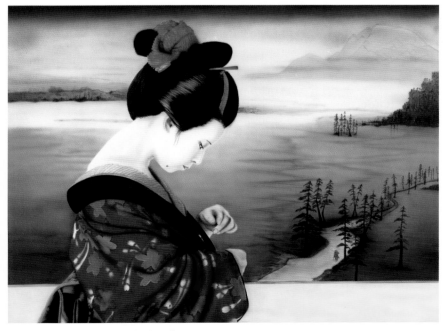

Floating World 30" x 40" Acrylic on canvas

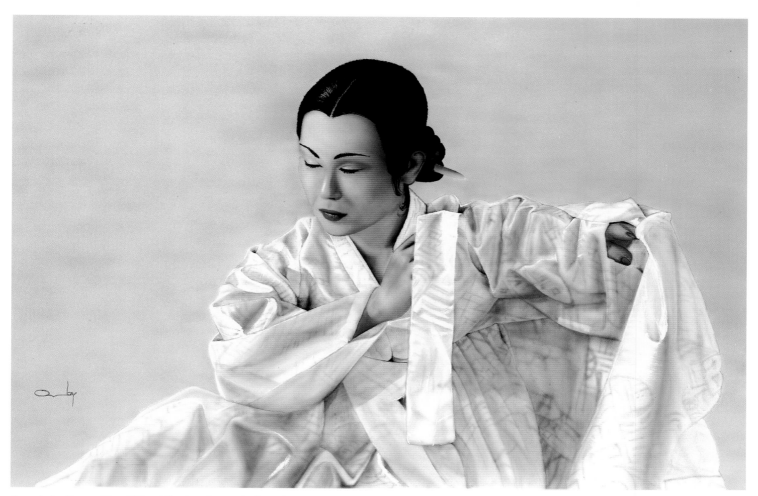

Search for Tranquility 32" x 44" Acrylic on clayboard

*I paint on canvas, museum
board, masonite and clayboard,
favoring transparent acrylic
paints, airbrush, paintbrushes
and pencils. I use layering to
enhance depth and an
assortment of instruments,
from sandpaper to dental tools,
in creating detail and highlight.*

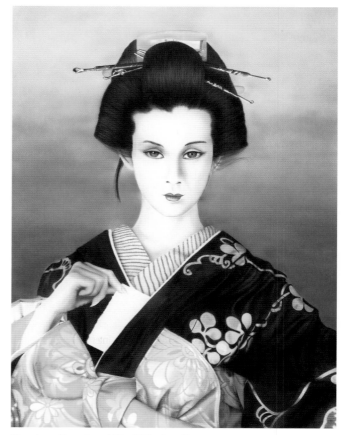

Timeless Beauty 40" x 30" Acrylic on canvas

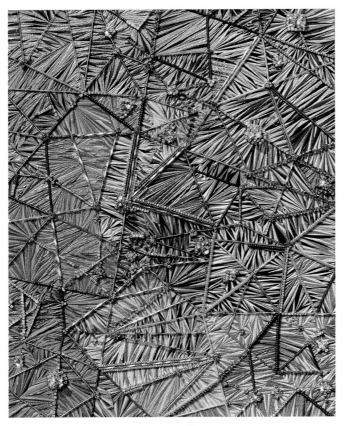

Untitled 20" x 16" Oil /mixed media on canvas

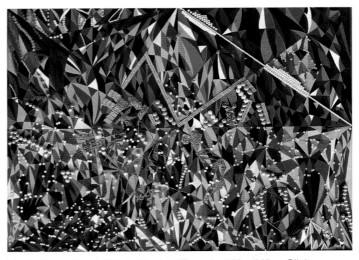

Music Score No. 1 (title is Musical Tones) 48" x 36" Oil / mixed media on canvas

MARKCY PARKYURIN

A two-dimensional page can scarcely hint at the objectives of Markcy Parkyurin's art. His images are designed to combine visual and auditory elements into a unitary *gestalt* figure.

Born in Japan, Parkyurin has taken a circuitous route to artistry. Although his Masters was achieved in Pharmacy and Medicine at the University of Nagasaki, his postgraduate investigations extended into cognitive study, molecular design and quantum mechanics. Impressed by the theories of English biochemist Francis Crick, a co-discoverer of DNA structure, Parkyurin was inspired to explore the dynamics of the human response to beauty at a molecular level. His findings led him to the development of an artform which seeks to approach consciousness through interrelated cerebral mechanisms not obvious to standard systems of awareness.

The current works, painted in Argentina, have been exhibited at La Salon in Paris, France; the Spanish Awards Exhibition at Barcelona University and the French and Japanese International Salon Exhibition at the Tokyo International Forum.

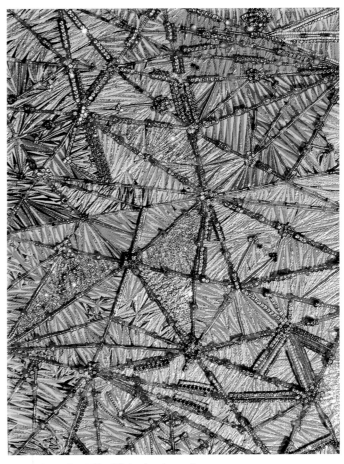

Untitled 16" x 12" Oil / mixed media on canvas

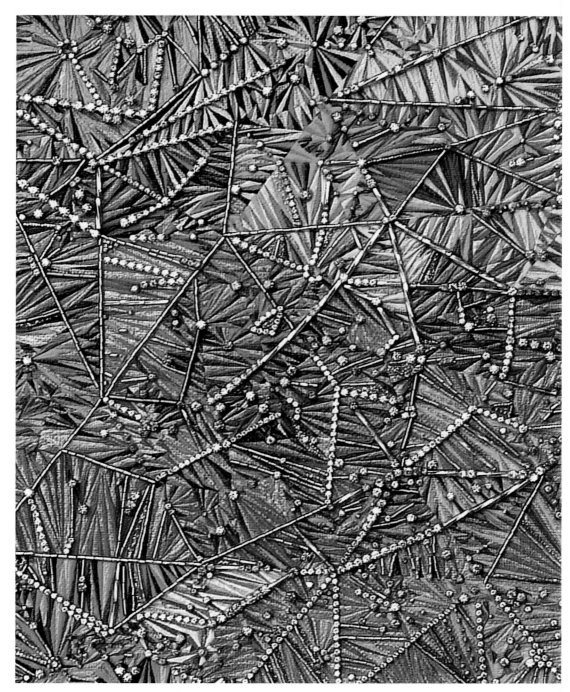

Music Score No. 2 (title is Musical Tones) 16" x 14" Oil / mixed media on canvas

My art combines sound and vision... I start by drawing a picture in three dimensions and then my wife and I compose music which perfectly corresponds and harmonizes with the picture... I consider that it is time for human beings to elucidate how the function of human feeling works. Scientifically, all matters, such as light, color, form, motion and sound are taken sensuously and freely as the brain reacts to them automatically (on a subatomic level) to change cerebral energy levels unconsciously. Does the brain and consciousness work in the same way? Now (we can) analyze the raw data of brain function indirectly and study the function visually (through methods such as) Positron Emission Tomography, FMRI, SPECT, etc. I consider that true art which raises brain activity should be shown...

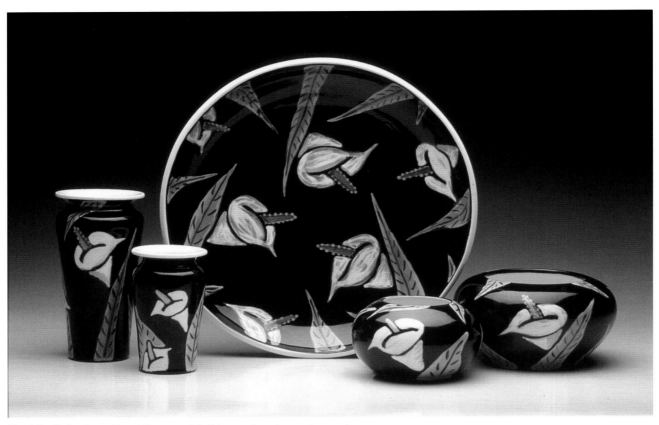

The Lilly Collection Hand Thrown - Multi-layrs of under and over glazes

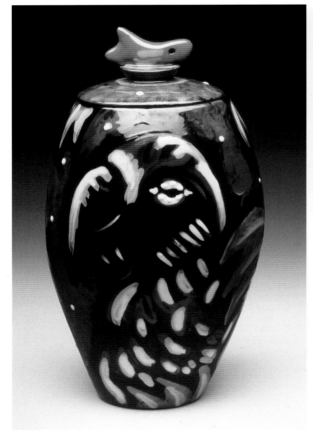

Birds of A Feather 12" high Hand Thrown -
Multi-layrs of under and over glazes

New Spirit Lilly's in the Vineyard 14" round Hand Thrown -
Multi-layrs of under and over glazes

ZAK ZAIKINE

As a child, Zaikine was fascinated by the eclecticism of art, through the influence of his father, himself a well known muralist. Now years later, he has explored many forms of sculpture, studied design and technique in the Pratt Institute and built for himself an international reputation for the aesthetic quality of his work. His eclecticism, which also includes painting and sculpture, ranges from the whimsical to the exquisitely formal. Shown are ceramic works of sheer beauty, expressions of profound unconscious sensuality, lustrously glazed in dramatic wells of cryptic space.

It is 50 years that I have worked with the earth, (Zaikine states), specifically clay. I am truly amazed by its capacity to teach me something new every moment I am with it. Like a good friend you cannot be away from for too long a time, it comforts me as I reflect on what we have both created together.

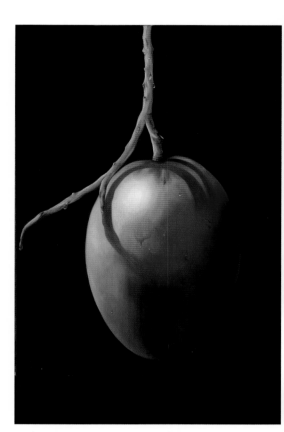

Le Grand Mango 40" x 30" Oil/linen

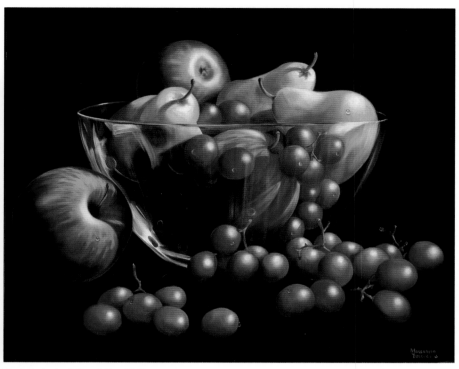

Fruit Salad 20" x 24" Oil/linen

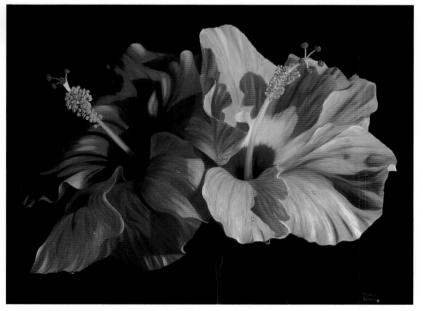

Love Never Fails 24" x 30" Oil/linen

MARGARITA DELEUZE

Opulent texture and depth distinguish the enthralling representations of Margarita DeLeuze. Her scrutinizing celebrations of realistic natural beauty fairly vault themselves into the viewer's most instinctive considerations.

A native of Caracas, Venezuela now residing in Florida, DeLeuze studied with a number of the master painters in her homeland and continued her artistic development in the United States. Among numerous sites of exhibition are the Hortt Museum of Art in Fort Lauderdale; the Florida Museum of Hispanic and Latin American Art in Miami; the San Francisco Museum of Contemporary Hispanic Art; Art Expo '96 in Barcelona, Spain and many others.

The message of my art is simple and direct, without a profound statement or complex idea. Its purpose is to embellish a surface with color, harmony and balance... Rather than attempting to force observations to fit preconceived ideas which arise from the failure to observe and actually see the magnificence that surrounds us, my challenge comes in using light to define form and space, and in capturing the essence of a subject through the use of composition, color, technique and design.

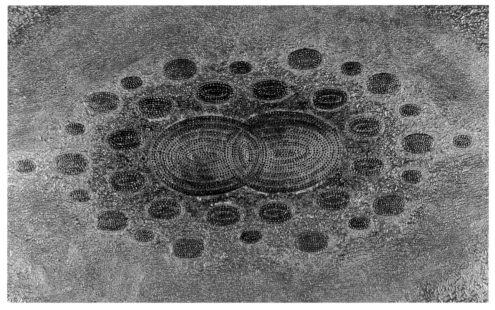

JT #2 20" x 30" Oil on canvas

JT #3 20" x 30" Oil on canvas

JT #1 48" x 60" Oil on canvas

JUDY TANIBAJEVA

With seemingly simple shapes and shades of color, J.T. creates delicate and complex interplays of harmony and balance. Subtly mystical and compelling gestures to symbolism lure subconscious analysis and projection toward the tantalizing comforts of hidden mystery.

Born in Tallinn, Estonia, J.T. completed a specialized 10 year curriculum at Estonia Art School and added a Business and Commerce degree from Tashkent State University of Economics. After traveling widely throughout Europe, she settled in New York City in 1999, energized with paintable images in her mind. Containing convex areas and composed of individual Seuratesque dots, her scenes inch beyond two dimensions to communicate images partly inspired by the sense of wonder she experienced at age 14 when she and her mother witnessed what we call an "unidentified flying object." Exhibitions took place around museums of Central Asia. J.T.'s work is in the permanent collections of the following three museums in Uzbekistan (Museum of Mukarram Turgunbaeva, Museum of Tamara Khanum, and the Museum of Fine Arts).

While residing in New York, I don't feel that time will allow me to transfer all of the ideas and images from my mind to canvas, but I am exhilarated and energized at the prospect of trying.

Rishi 24" x 16" Acrylic and turmeric on canvas

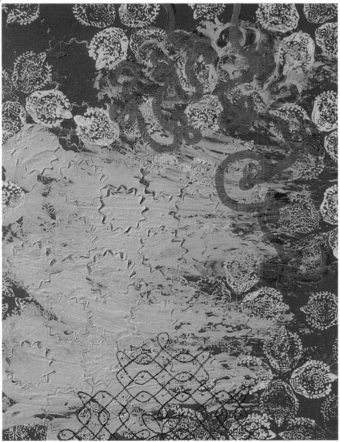

Uncovering Urban Creeks 34" x 28½" Acrylic, ash, casein on canvas

PERRY RATH

Two isosceles triangles, one a textured puzzle of convoluted curling parallel yellow strings, the other similar but the string texture is dark green are superimposed one upon the other to form a tall six point star, the whole on a field of red. Here and there, seemingly at random over-scratched in white are familiar conventional shapes. The scratched shapes appear accidental, disturbing in their contrasting ordinariness and help create the tension of the imagery. This example of Perry Rath's work as with his others, is painted in acrylic; to give "a naturalness to his works he adds authentic organic substances such as tea, spices, ashes." Rath's works are salient and disconcerting in the manner in which they combine seemingly incongruent forms and by juxtaposing them, persuade them to belong together, so developing a sense of inner challenge which grows rather than lessens as they are studied.

Perry Rath comes from Ontario, Canada, having studied widely in various other disciplines and belief systems. His work has been shown in solo and group exhibitions in Canada, Australia, India and Germany and is in private collections in many of the places he has visited.

In my work I display a deep sensitivity to materials and explore the relationships between materials and the subject of the work where technique is as important as intent. My paintings suggest echoes of recognizable forms drawing on botanical and geological motifs, maps and cultural iconography.

Thiruvannamalai 24" x 18" Acrylic, ash, casein, turneric / canvas

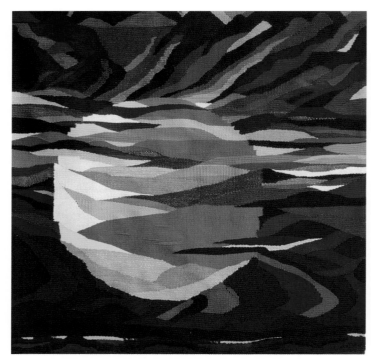

The Green Planet 54" x 54" Tapestry

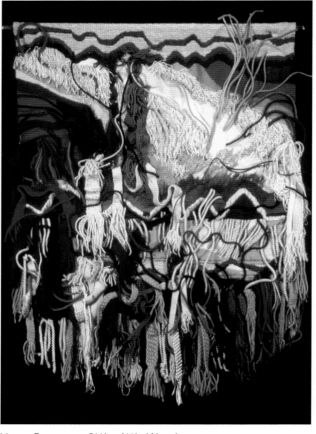

I Love Summer 2½' x 4½' Weaving

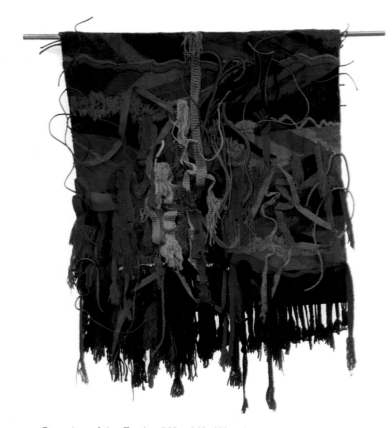

Greening of the Earth 50" x 60" Weaving

ILSE KILIAN-TAN

With her assemblages of hues and shapes in scenes composed of soft materials, Ilse Kilian-Tan taps into elemental forces of nature and seeks to impressionistically describe their correspondence. In doing so, she creates amazingly sensuous and mutable fields of quasi-representational color and form that are a delight to behold and stimulating to contemplate.

A resident of Washington State, Kilian-Tan possesses Magna Cum Laude degrees in Fine arts and Literature in Foreign Languages from Eastern Washington University and also studied art at Fort wright College, Washington State University and in Germany. Currently teaching a variety of art disciplines, Kilian-Tan has exhibited in numerous venues, including the Art Spirit Gallery of Coeur D'Alene, Idaho; Art Kapella of Leipzig, Germany and other sites.

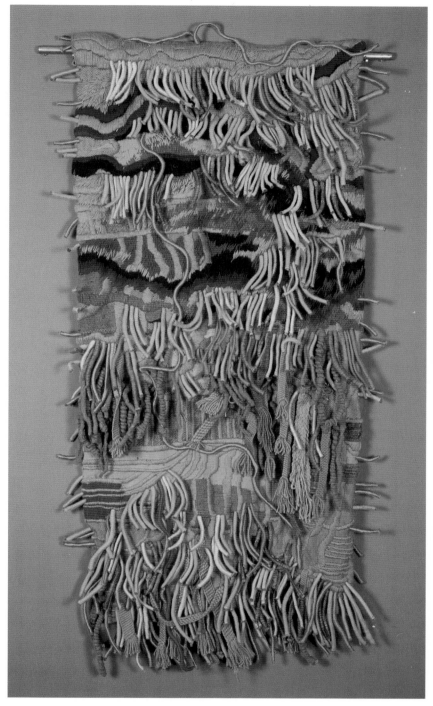

Palouse Harvest 48" x 90" Weaving

My work is concerned thematically with color and structurally with texture. Woven fiber paintings are inspired by the organic forms of nature, although they are intended to be evocative rather than representational... Likewise, although modeled on external living forms, they seek to address lyrically the full range of subjective consciousness, including memory, fantasy and thought. Through this, I hope to awaken in the viewer an immaterial spirituality which sees in the abstract natural forms of my art, the reflection of itself...

My method combines planning through sketching and gathering materials with spontaneous loom technique that relies on the subconscious to produce poetic abstractions.... Materials include various yarns, cotton, linen, wool and synthetic fibers.

Morning 30" x 30" Oil/canvas

Eternity 72" x 48" Oil/canvas

Together 30" x 30" Oil/canvas

SALLY RUDDY

Like songs played on heartstrings, the paintings of Sally Ruddy are drawn from a sensitive range which remains close to an emotional core. Her blendings of sense and sentiment are poetically designed to induce immediate and lingering response from varied realms of passion within a viewer.

Born in California and raised in Nevada, Ruddy majored in Education at the University of Nevada before studying Art and Philosophy at Modesto Junior College and earning a B.A. in Fine Art and Painting at California State University. Additional studies continued at the College of Arts and Crafts in Oakland and Visual Art Access in San Francisco. Among exhibition sites for her award-winning art have been the Haggin Museum of Stockton, California; Sacramento Fine Arts Center; the American Embassy in Almaty, Kazakhstan; Woman Made Gallery, Chicago, Illinois; Richardson Gallery, Reno, Nevada; Artserve Gallery, Ft. Lauderdale, Florida and other venues.

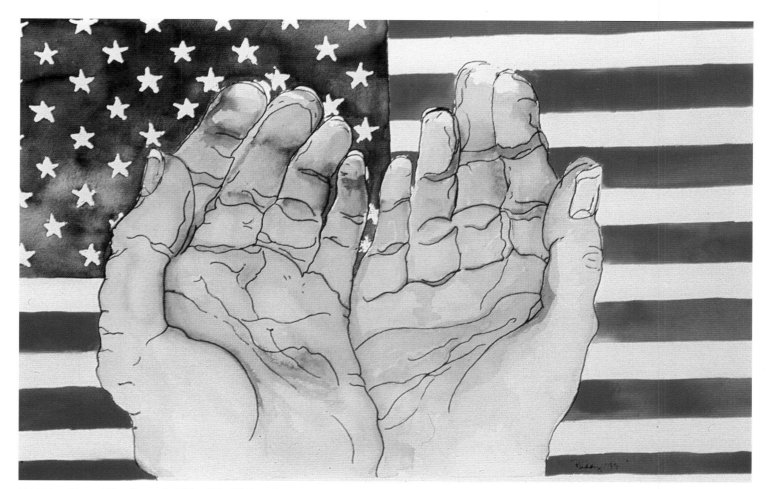

Honoring Those Who Served 26" x 35" Watercolor

Dove 14" x 11" Oil/canvas

I am a woman deeply committed to my marriage and family. Longing (not shown) shows a woman, living in a Patriarchal world, whose arms are bound by her big heart, as women often feel bound by those they love. I published an article in CATALIST magazine (November 1996) called 'The Soul of A Woman,' in which Longing was used for the color illustration. The large oil painting of Eternity was my effort to honor those victims of September 11, 2001. My paintings are like poetry; you understand the words, but sometimes they are put together in a way that surprises you.

Persephone　13" x 13"　Encaustic and found objects

CHERYL WOLF

Finding a sum greater than its parts in aggregations of image and association, Cheryl Wolf employs wax and pigment techniques whose origins are ancient but little used since the classical period. Her application of contemporary dispositions and appreciations through uniquely personal perspectives produces strikingly appealing results.

A resident of Rhode Island, Wolf studied at the University of California at Berkeley and the Rhode Island School of Design. Among her sites of exhibition are the Amsterdam Galerie and Galerie Debloise of Newport, Rhode Island.

I enjoy making roughly built, crustily painted assemblages and collages. The structural elements, deliberately rough, and the photographed or isolated elements that they frame suggest a tension between raw actuality and idealizing fantasy. (An underlying anxiety which might be worth making more visible.) ... My work is a continuing dialogue between concept and the nature of material... The images evolve through manipulation of encaustic; a very malleable (and forgiving) medium; and layering (additions symbolic or realistic) ... The question for me is what carries emotion in art. I'm interested in combining materials that in isolation might not convey emotion but, when juxtaposed and manipulated, may hopefully cause unexpected feeling.

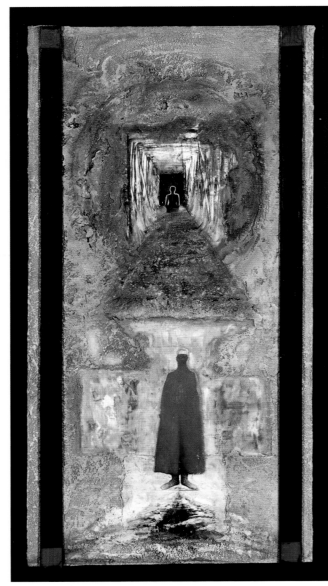

Life's Ponderences　14" x 26"　Encaustic and found objects

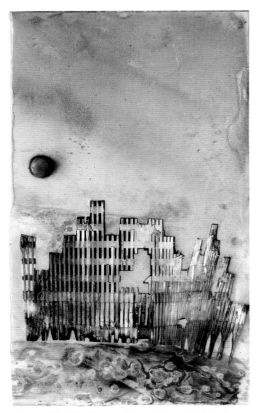

9/11　4" x 7"　Encaustic and found objects

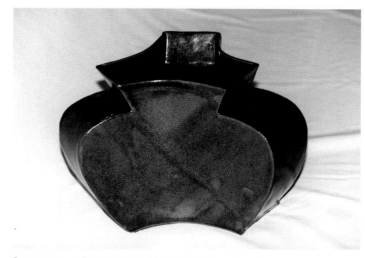

Stoneware, 6 Sided Vase 7" x 10" Temmoku glaze

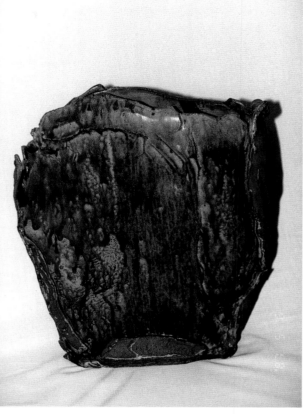

Stoneware Vessel 11" x 12" Turquoise glaze oxid rim and sides

IRENE SINGERMAN

Using combinations of oxides and glazes to enhance tone and luster, Irene Singerman fashions stirringly organic forms honoring the subtle natural hues of nature. Her unargu ably garnished shapes ornament a multitude of earthy blends of expression.

Although she had majored in art in college, Singerman's early interests were diverted into a career in industry and, then, in theater where, for many years, she was Administrative Director of the American Theatre Wing (which, together with the League of American Theatres and Producers, annually presents the prestigious Antoinette Perry, or "Tony" Awards for Broadway Theatrical Productions). When she ultimately returned to art, her study and creation of ceramic artistry led to showings in several New York City galleries.

I see working with clay as an extension of myself and my closeness to the earth. I am always in awe as to how a piece of that earth can become a piece of art in the hands of a potter, be it purely functional or something which gives pleasure to the eye.

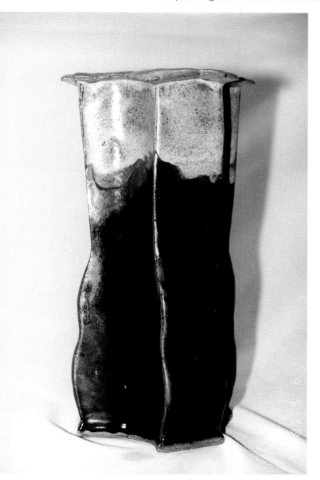

Stoneware Vase, 6 sided 11½" x 6" Temmoky with blue chun glaze

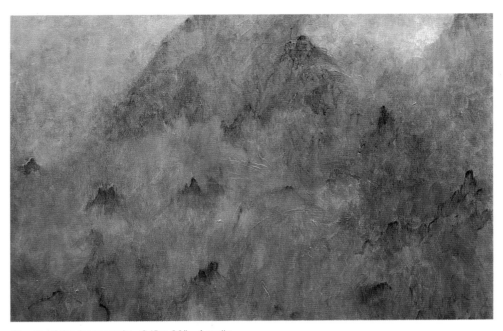

Abode of the Immortals 24" x 30" Acrylic

Burnt Topaz Morning 36" x 48" Acrylic

Place of Golden Peace 31" x 41" Acrylic

RUTH ABRAMS DRAYER

Drayer's works reveal a mist of overlapping colors, to create soft impressionistic landscapes which expand in the mind of the viewer. Changing from washes and sweeps of color one over the other, her work sometimes appears to vibrate into distant red brown mountain forms ridged with sharp and mysterious rocks, or swirls of clouds penetrated by the golden yellow of almost hidden sunlight. The essence of her thought is expressed through landscape shapes; her work is abstract and active yet implies the forms and colors hidden in our minds when we relax, lie back and dream.

Ruth Drayer's art experience began through the study of pottery and sculpture, interior design, window design, and the mystery of feng shui and numerology. She moved to India for a short time and returning to the US began to write, non-fiction. Eight years ago she began to integrate the broad eclecticism of her life into painting, producing work which shows a deep love of color and design in relation to her studies of Asia and the Orient. Born in Washington DC she attended the University of Texas in El Paso. She has had three solo shows in New Mexico, one in Santa Fe and two in Las Cruces and in 2002 won a purchase award in the Mesilla Valley Seventh Regional Exhibition. Ms. Drayer is also the author of "Wayfarer's : The Spirtual Journeys of Nicholas & Helena Roerich", published by Bluwaters Press, 2003.

Over the years as I have grown, so has my love of color. My background is widely eclectic and includes a commitment to art and design. I reached a place where I wanted to use color only in the abstract and though I had been taught the eye naturally is drawn to shapes it can recognize this was conflicted with my need to paint non-objectively. Therefore I developed methods of working which allow me the freedom I desired. Asking my "inner painter" for guidance I begin by laying down washes of color then many more colors upon colors until the moment arrives when the order and harmony of the painting would please and satisfies me I know the painting is complete.

Affairs of the Heart 38" x 31" Acrylic

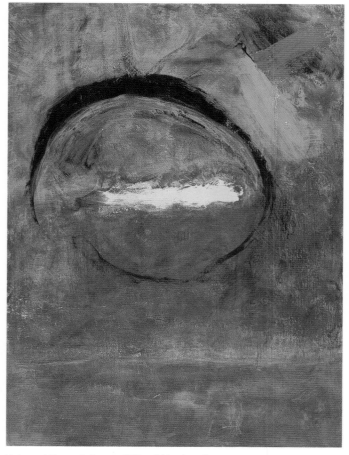

External Expectations 38" x 31" Acrylic

JEANNINE DUFFEK

Pure impulses of color sensation bring a sensual warmth to the vibrant, expressionistic configurations of Jeannine Duffek. Compostional suggestions of strength, tension and position advance sympathetically tendered undertones with captivating allure and emotionally stirring provocation.

A resident of Florida and Wisconsin, Duffek has exhibited her work in Tallahassee at the La Moyne Art Foundation; the Ridge Art Association in Winter Haven; Cornell Museum of Art in Delray Beach; Sarasota Visual Art Center and other regional sites as well as Franklin Square Gallery in North Carolina; the International Museum of Art in El Paso, Texas; the International Society of Experimental Artists and the Northern National Exhibition, Rhine Lander, Wisconsin, as well as many other venues.

For a change of direction from my traditional painting, I began studying abstract painting in 1996 and found it to be fulfilling yet demanding. Perseverance and practice has found my work being accepted and award-gathering in both regional and national competitive exhibitions.

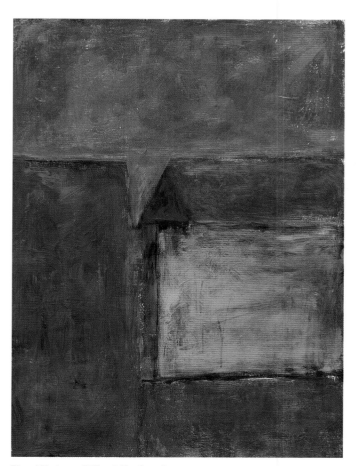

Blue Wedge 38" x 31" Acrylic

Meditation 9" x 12" Pencil

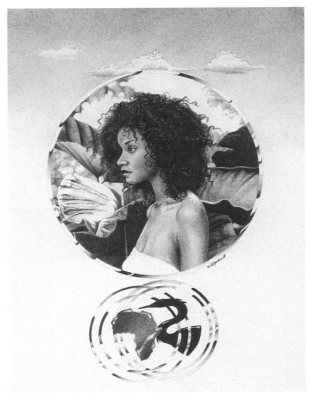

Urban Portrait 14" x 17" Pencil

Island Portrait 9" x 12" Pencil

HERB JORDAN

An enhancing blend of imaginative embellishment positions the subjects of Herb Jordan's portraiture into a correspondence of appearance and character which artfully elaborates persona and emphasizes qualities which are present in subtle or obvious measures. A compelling sense of equilibrium sets composure and surroundings into an appealing jell of aesthetic consistency.

Experienced in conceptual communication and calligraphic illustration, Jordan studied drawing, painting, typography, calligraphy and illustration at Columbia Union College of Takoma Park, Maryland and black and white design and graphic communication at Community College of Philadelphia. He has exhibited his work at the Glassboro Community Art Show and is currently freelancing illustration and portraiture.

Untitled 45" x 60" Acrylic/canvas

Untitled 45" x 60" Acrylic/canvas

VIOLA MOTYL-PALFFY

Sensing and describing the spiritual essences of events, individuals, places and objects with the intention of conveying images from the inner eye to the outer surfaces of canvas is a process which delivers the soft, dynamic paintings of Viola Motyl-Palffy. Excitation of an instinct to speculative projection within her liberal organizations of motion, tone and form offer the viewer an active role of conceptualization.

Born in Sobrance, Slovakia, Motyl-Palffy studied at the Academy of Arts in Presov, Slovakia and currently divides her time between Switzerland and the United States. A member of Zurich's Visarte Artists group, her exhibitions have been hosted by numerous fine galleries of Germany, France, Italy, Japan, Belgium and other nations.

There is a very particular association between human ideals and life reality in my work... I believe in symbols...those things that make us think of our social and historic roots as gathered through our individual life experiences... The main objective of my art is to create sensations, feelings and motivations for the viewer which will encourage thought about their meaning and reveal, with each work, a new perspective of my "abstract spiritual world.

View of 2004 50" x 60" Acrylic/canvas

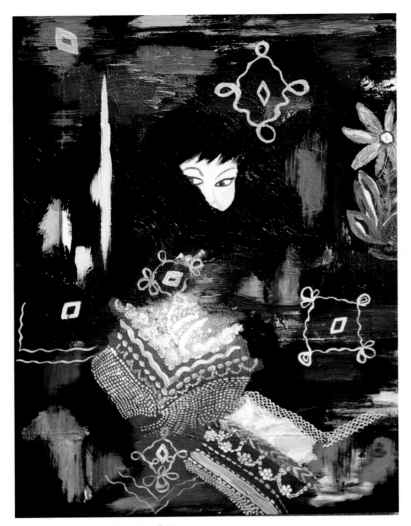

Behind the Veil 24" x 18" Oil/canvas

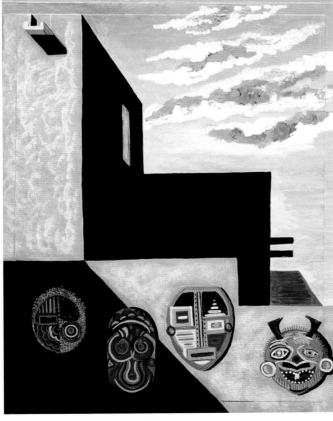

Mask and Shadows 31" x 27" Acrylic/masonite

ELIZA MARIA SCHMID

Atmospheres of mystery and speculation form within the interplay of symbols in the paintings of Eliza Maria Schmid. Fantasies meandering between figurative and abstract terrains assume bright and friendly postures of color and intriguing interassociations of being and cause.

Born and raised in Vienna, Austria, Dr. Schmid unexpectedly found her anatomy classes at the Medical School of the University of Vienna to be the "second best art school in town" and her specialty training in Anatomic Pathology particularly instructive in the basics of sculpting. Following a fellowship at California's Stanford University and a shift to psychoanalysis, she discovered affable new relationships to the whimsical scenes and creatures of her paintings. Sites of exhibition include the Ojai Center for the Arts and Whitney Young Cultural Center Mansion, San Francisco, CA; the Center for Contemporary Art and the Read Street Fine Arts Gallery of Santa Fe, New Mexico; Dartmouth Street Gallery of Albuquerque; Limner Gallery of New York City; Ashland Gallery of Phoenix, Arizona and many others.

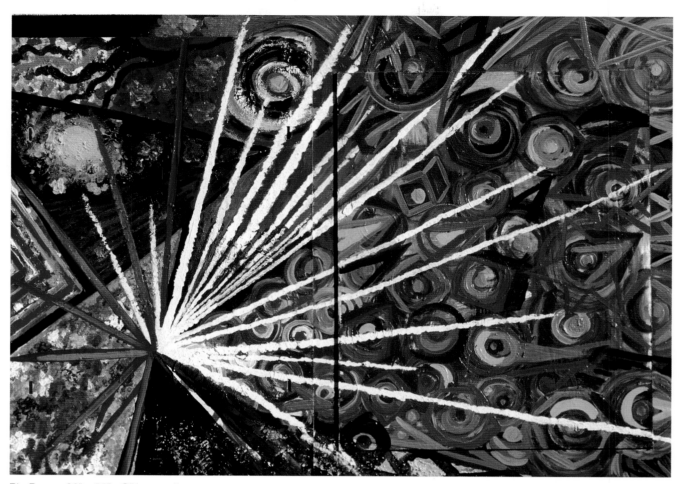

Big Bang 26" x 36" Oil/masonite

The themes of my paintings come out of my experience as a psychiatrist, such as from dream analysis, but also from my social and political convictions, as well as from memories of my baroque-catholic upbringing, the fairytales of my childhood, mythology, and the cultural experience of a European in America... I like to paint on masonite, wood, glass, plexiglass, cardboard, old photographs...As a finish I often use a transparent veneer...which gives the pictures a gloss and durability.

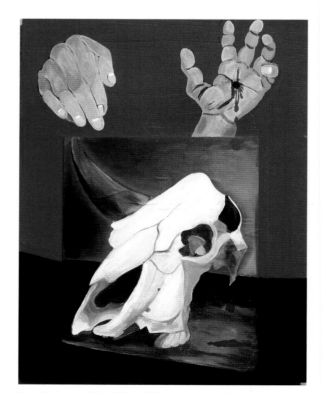

Crucifixion 31" x 27" Oil/canvas Acrylic/masonite

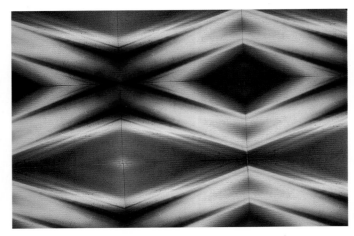

Psychdelicious 16" x 20" Polarized Light Photography

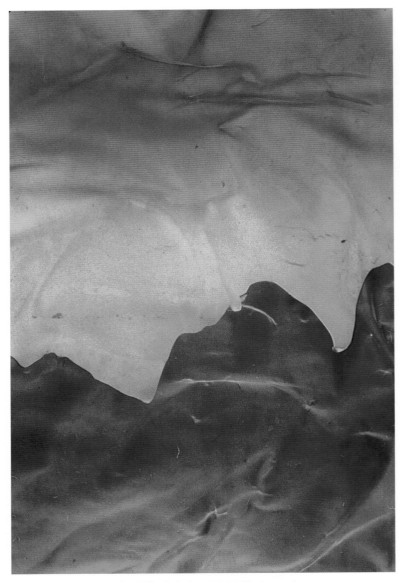

Alien Landscape 20" x 16" Polarized Light Photography

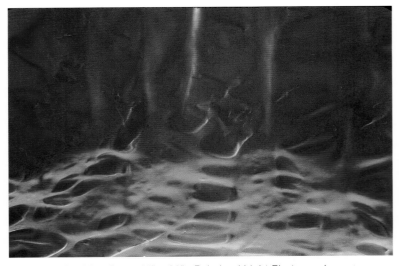

Ion Storm On Alien Sea 16" x 20" Polarized Light Photography

MARTIN GROFFMAN

As a painter or sculptor applies tools to surfaces to create the visual or dimensional results of their art, Martin Groffman utilizes his own specialized tools and ingredients to wring out colors and effects which would not otherwise emerge. Inventively accomplished in every area of the photographic arts, from "photomorphs" to "phototessellations" to macro studies, his eye in these recent creations has turned to explorations and manipulations of polarized light and clear colorless plastic objects.

A native New Yorker whose early interests in photography were developed as he earned his B.A. and M.A. in Science and Education at Brooklyn College and Columbia University. Advanced study at the Nikon School of Photography keyed upon color techniques. Vast experience as a photographer and instructor was supplemented by managing a camera business, serving as an educational audio-visual coordinator and writing a series of science text books. A frequent traveler now living in Florida, where he serves on the Advisory Board of the Florida Keys Council of the Arts, he lists among exhibition sites for his award-winning photography the Northport Gallery on New York's Long Island; East Martello Museum of Key West, Florida; Bougoinvillea House Gallery, Marathon, Florida; Parrish Art Museum of Southamption, New York and other venues.

Photographers will often use a polarizing filter on their camera lens to deepen sky color; enhance and saturate outdoor color; I place and manipulate various clear plastic oblects between a pair of large Polariod sheets to capture the innate, but normally invisible colors inherant in them. I use this technique as a photographic artform. Many of the images produced are abstract. As I gained more experience with the technique...it appeared that the images could be separated into types. At this time, I group them into several areas: recognizable objects; geometric abstracts; formless abstracts; fanciful images and others.

Euclidean Geometric #1 16" x 20" Polarized Light Photography

Euclidean Geometric #6 16" x 20" Polarized Light Photography

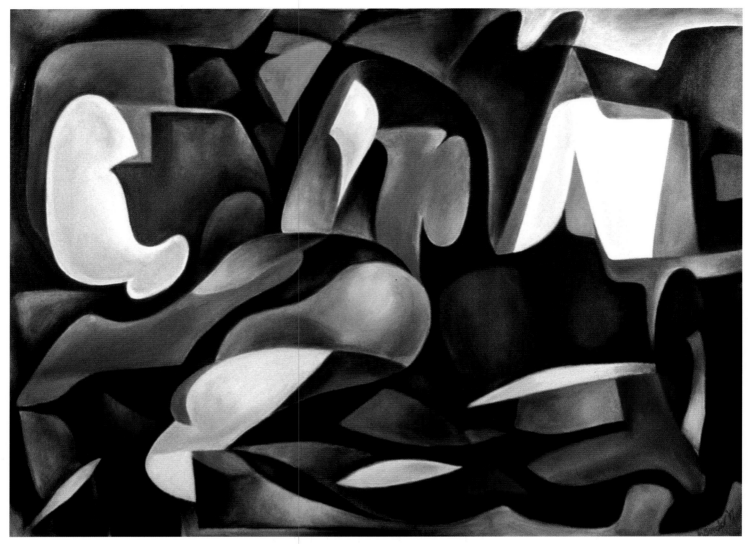

Terrain III 30" x 40" Oil/canvas

MAY BENDER

When observing the abstract expressive paintings of May Bender, art critic Dominique Nahas speaks of a "tumultuousness" and a "serenely dream-like quality." Gerrit Henry, an editor for *Art News* who reviews monthly for *Art In America*, is impressed by Bender's melding of figural and abstract impulses and "great, good painterly rhythm." Her range of expression embraces "geometric" and "non-objective" territories of image with a zestful brush.

A graduate with honors from Newark, New Jersey's Art High School, Bender continued her studies at the Art Students League of New York with such masters as Howard Trafton and Vincent Malta. Among the numerous sites of exhibition for her paintings are the Artform Gallery in New York; New Jersey Performing Arts Center in Newark, New Jersey; Georgian Court College in Lakewood, New Jersey; Middlesex Gallery in New Jersey; Red River Valley Museum of Vernon, Texas; Kirkpatrick Museum/Omniplex in Oklahoma City, Oklahoma and Seville Museum, Spain.

The ultimate abstraction takes place in mathematics, where words are replaced by symbols. Connecting the symbols is rigorously defined by writing and computerization. Abstraction in art becomes mathematics in its visual aspect within the basic elements of art... color and form, which words cannot define.

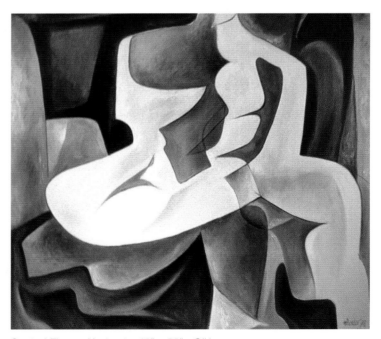

Seated Figure Abstract 48" x 38" Oil/canvas

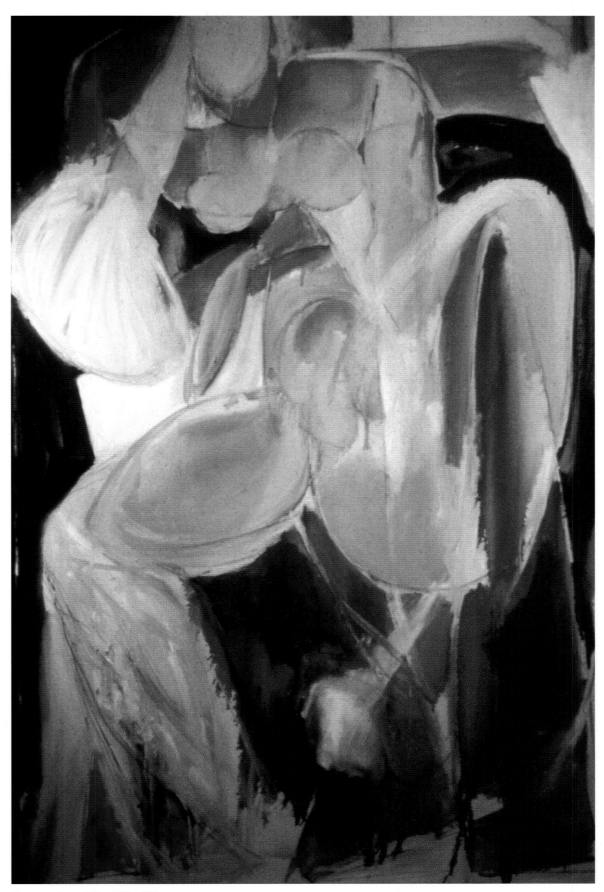

Aquamarine 50" x 30" Oil/canvas

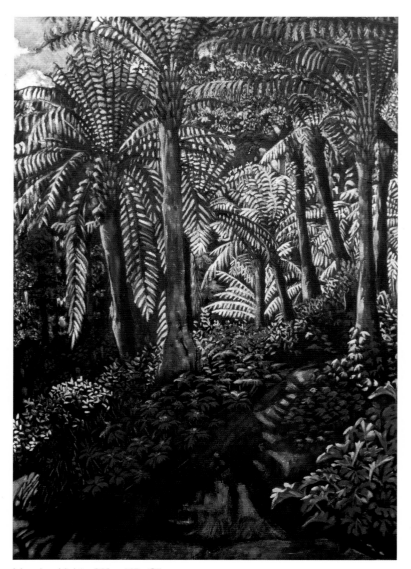

Morning Light 30" x 40" Oil

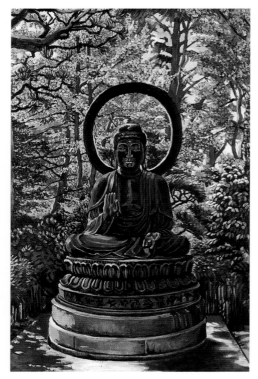

Buddha 18" x 24" Oil

BONNIE CHRISTY

Sun-drenched surfaces and contour-enhancing pockets of shade spring brilliantly to life in the contemplative landscapes of Bonnie Christy. A palatable depth of stillness and the natural serenity of captured moments project alluring spells of aesthetic refinement.

Born in Chicago, Illinois, Christy became acquainted oil paints and brushes by the age of six and won a youth scholarship to Kansas City Art Institute, where she studied under Wilbur Niewald. Currently a resident of the San Francisco area and a member of the American Artists Professional League of New York, she has exhibited her work at the Newington-Cropsey Foundation Gallery in New York; the Amarillo Art Center and the Abilene Fine arts Museum in Texas and at other sites.

Light hits objects- whether animate or inanimate- and gives them shape and definition. The comparison of one object to another helps one to see that no object is of any one color. Consistent with this relationship is the thought that an object may be labeled 'black' or 'white' in society but, if seen through the light of the color theory, this object may be of any color. In its truest sense, each object will appear more life-like and more completely evolved in space and time if seen without any preconceived notions which society or education has placed upon us. This allows one to see an object as it is and not as it is expected to be...When I observe life, I see the color theory in its truest form. The purpose of my work is to emulate the color theory, create a clearer understanding of it, and present this theory with a new approach to enhance one's vision, lift the soul and help define life's purpose and our relationship with it.

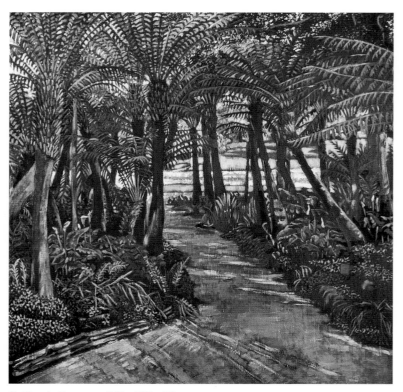

California Dream 36" x 36" Oil

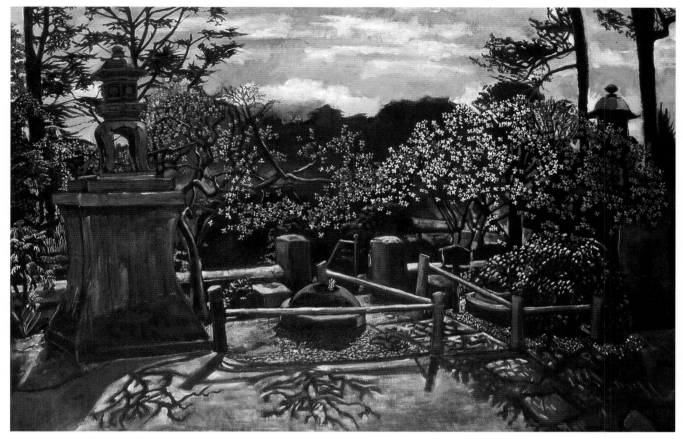

Early Spring 36" x 48" Oil

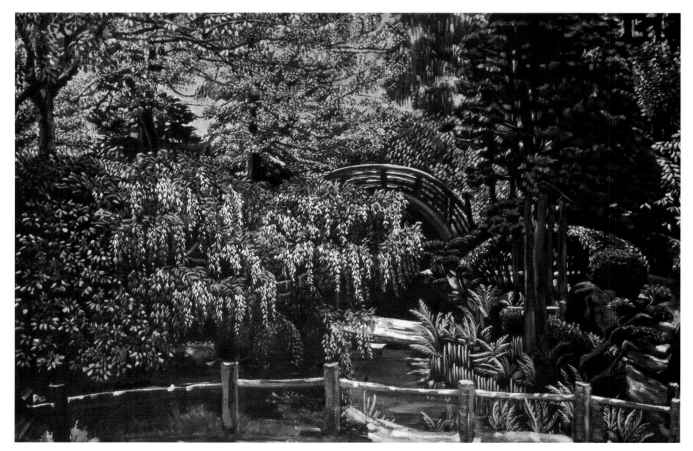

Wisteria in Spring 36" x 48" Oil

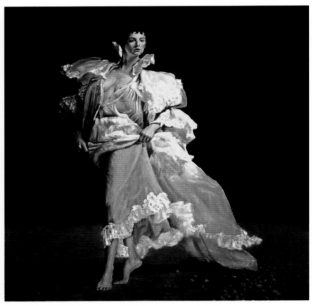

Muse 36" x 36" Oil/canvas

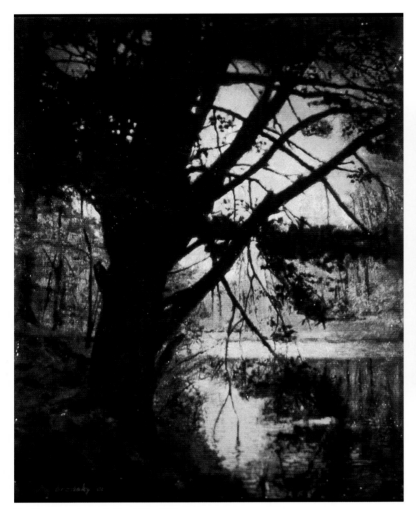

No Trespassing 24" x 18" Oil/canvas

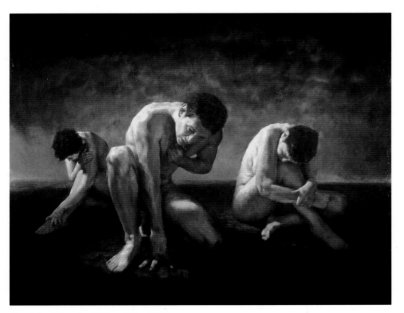

Anxiety Cloud 36" x 48" Oil/linen

ALEX BRODSKY

Rendering portraiture with a remarkable solidity of presence and gravity, Alex Brodsky captures demeanor and pith beyond the surface of flesh. In other figurative work, he displays a splendid and peculiar drollery in atmospheric wonders evoked, often from a limited and sparing palette, and a deeply human regard for the exotic circumstances of common existence.

Born in the former U.S.S.R., Brodsky studied at the Interior Design College in Kiev, Ukraine and immigrated to the United States in 1976. Currently a resident of Pennsylvania, he has exhibited his work at the Javitz Center Art Expo in New York City; Agora Gallery in Manhattan's SoHo district, the Museum of Russian Modern Art in Jersey City, New Jersey, the Amsterdam Whitney Gallery in Chelsea, New York, the Ward-Nasse Gallery in SoHo, New York, and the Ward-Nasse Chelsea, The Artist's Gallery in New York.

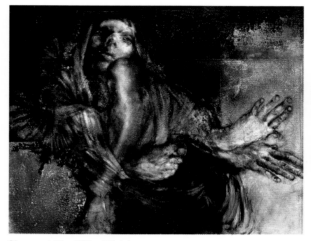

Sleep 15" x 20" Oil, ink on

OLGA MIZONOVA

Darkness. Figurative sensual forms. Deep shadows with images merging into their background shapes and energies. Figures locked tightly in poses of strain as if attempting to control emotions almost too deep to express. Others twisted, exposed, circumscribed by the volumes of controlling shade. An image of a single figure arms locked about the knees suggesting the intolerable tension of someone filled with almost limitless desire, forcing the body with infinite patience to be still. Groups of action figures, images armed with the authority of their refusal to change perfection; elsewhere, metaphors of death disguised as sleep. Bodies blending with their surrounding shapes, the certain action or the agony of feature lit only by feeble beams of light exposing the power of their inner need.

Born in Moscow, Mizonova initially thought of art as a hobby, studying mathematics then later, medicine, qualifying as a doctor in 1992. Moving to the US that year she had a perceptual change and took the opportunity to study art in Georgia Southern University then the Fashion Institute of Technology in New York where she received her BFA and AAS in Illustration, qualifying summa cum laude. In Georgia Southern University she studied techniques of drawing, sculpture, printmaking and illustration finally focusing on figurative oil painting which has now become the main direction of her work.

My art is mostly memories or desires which find their way into my paintings. They are solutions to my sense of yearning, acting as an opportunity to fictionalize my life and create unlived experiences. My art reflects my perception of myself and others translated within specific and varied contexts. I see my paintings as being sensual and elegant.

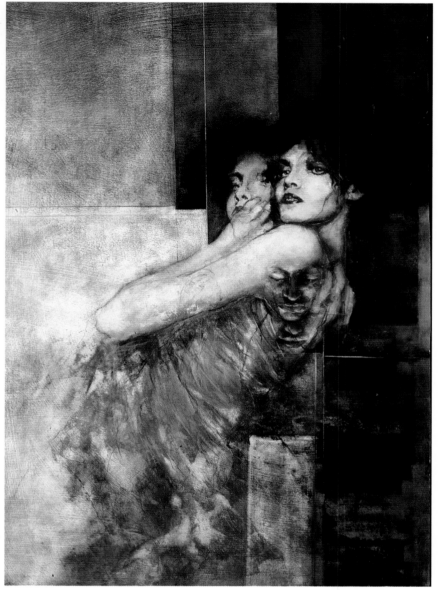

Waltz 24½" x 17½" Oil, ink on board

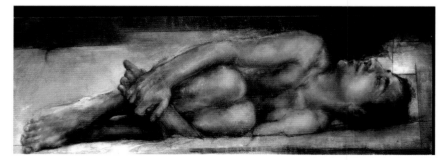

Awaiting 12" x 35" Oil, conte crayon on wood

Sisley 24" x 36" Oil

Guillaumin 24" x 36" Oil

MARY I. D. SMITH

In this remarkable series, Mary I. D. Smith pays homage to masters of the Impressionist School with the selected object of an empty chair rendered in reflection of the given artist's style, pallet and character. By so honoring Manet, Renoir, Morisot, Sisley, Pissarro, Guillaumin and others, Smith honors the object and endeavor of the school with her own supple and fascinating abilities of composition and implementation.

A native of rural Maryland, Smith graduated Frederick Community College and informed her award-winning brushwork with the methods and manners of the Old Masters through study with portrait artists Lester J. Stone and the late P. Richard Eichman. She has exhibited in many fine venues, including the Delaplaine Visual Arts Center and Washington County Museum of Fine Arts.

Listen and embrace life's beauty, happiness, sorrow and everyday events with the elementary understanding that in so many small ways, as we come to pass everyday objects, even a simple chair can hold fast the colors of a soul. Embedded in all subjects, even the most aggressive, is a peaceable quality. I paint to manifest that quality.

Pissarro 24" x 36" Oil

Sisley 24" X 36" Oil

Nature Reclaimed #4 30" x 24" Acrylic/canvas

Bois De Bambou 24" x 18" Acrylic/canvas

MICHELLE COFFEY

The lush tropical colors which may have seemed exaggerated to the European eye in Gauguin's later paintings are gloriously validated in these island studies by Michelle Coffey. Her starkly affecting conveyance of atmospheric charm and magical presence ripples with rare caprice and light-footed energy.

Born in Paris, France, Coffey's life stream was abducted by a brief vacation in Tahiti, where she remained for several years and the tropical spells of which permeate these works. Beyond painting, her interests and involvements include dance, costume design and photography.

Painting to me is a personal dream with no limit on total freedom. I am a passionate photographer and my camera is always my intimate companion. It is the witness of my memory somewhere in time. My canvases are not isolated moments but a sensitive reflection of lifetime memories. I do not like to paint the subject of the moment directly onto canvas...I wait for an extraordinary transformation of mood so strong I can almost hear and smell the adventure before it appears on the canvas.

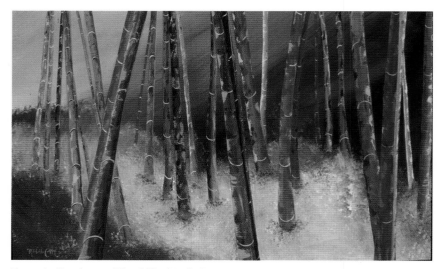

Reve de Bambou 48" x 30" Acrylic/canvas

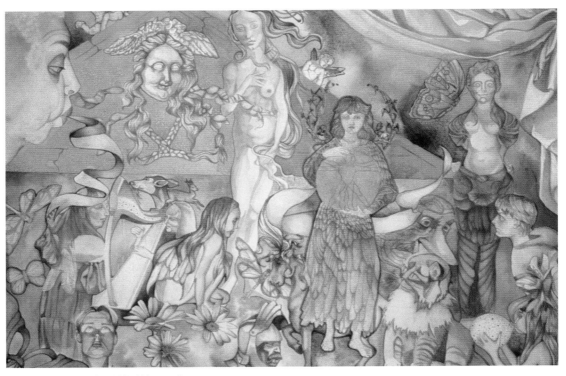

Renaissance 22" x 30" Watercolor

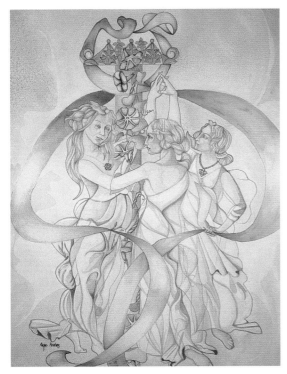

Goddesses of Light 22" x 30" Watercolor

My imagery and interest in painting has many influences; the form and sculpted faces of the Italian Renaissance artists, especially Botticelli; the line quality of Ingres; the vividness and grandeur of nature and what I believe to be the more intangible yet intrinsic spiritual aspect of all souls. I feel most drawn towards exposing the internal meditative and reflective part of ourselves, that part which is seeking the truth and beauty within us and others.

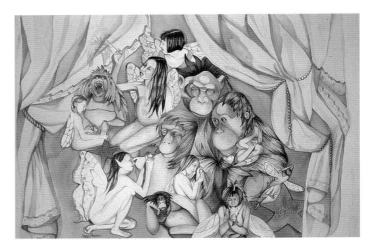

Primate Fantasy 22" x 30" Watercolor

ALAYNE ABRAHAMS

A watercolorist, Abrahams applies her medium in an unusual way. Using its inherent transparency she creates detailed descriptive worlds of glorious fantasy. Her colors are delicate yet strong and her paintings have evolved from mystical yet figurative imagery to a style where dancers or assorted bizarre people and animals interact, expressing the weight and stillness of their existence. Her dreamlike colors, gold, soft greens, pale reds, mauve, dovetail with her ideas, completing them and adding a seeming effortless translucence and balance to her compositions.

Abrahams was 'drawing almost as soon as she could hold a pencil' and her commitment to art has continued ever since. She earned a Bachelor of. Science degree from the University of Maryland and a Certificate of Fine Arts from the Maryland Institute College of Art. Her preference is for the freshness and light of watercolor. She has shown in various galleries in Washington DC, Santa Fe, New Mexico and her works are in many private collections.

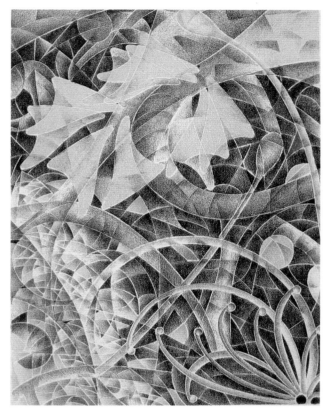

The Space Dragonfly 15" X 11" Color pencil

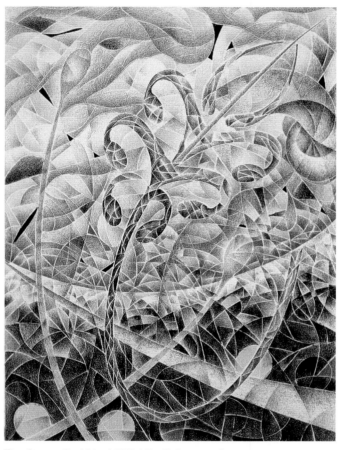

The Space Orchid 15" X 11" Color pencil

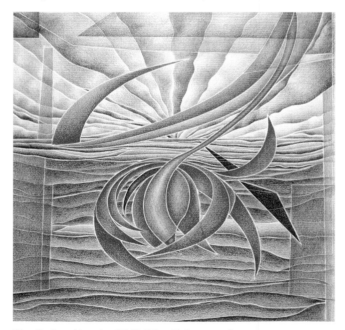

The Broken Heart 15" X 15" Color pencil

IRINA V. DIATLIKOVA

The use of facets to create illusions of space and form is an immediate and arresting feature in the art of Irina Diatlikova but, while phases of her geometric divisions both divide and unite her images, her inventions of space rarely suggest emptiness. Rather, they strongly imply a filled and active, interdimensional connectiveness through which vigorous exchanges of energy, syllogization and relation pulse.

Born and educated in Moscow, Russia, Diatlikova speaks of an "inner screen" through which her visions flow into instantaneous realizations she feels duty-bound to transfer to paper; "It comes from the sky, grass, the whiteness of snow, people's eyes, smiles, from their body and facial features and their voices. It also comes from the smells of drying grass, the ocean, fall leaves, roses, coffee, cinnamon; from the silence of a broken heart and from color itself."

Diatlikova studied technical drawing, physics, mathematics and history at Bauman High Technical Institute in Moscow as well as cartography and topography at the Moscow Institute of Geology, where she received an M.S. Degree in Hydrogeology and Engineering Geology. Further art study ensued as three year course in easel painting and graphics at the faculty of fine arts at Peoples' University of Arts, Department of Russian

Ministry of Culture as well as Business Translation and Interpreting English at Moscow International School of Translation and Interpreting. She was a senior engineer at the Institute of Physics of the Earth at the Russian Academy of Science, where she researched in geophysics with emphasis upon earthquakes. She also worked as a graphics artist for the Design Bureau Company and Committee of Human Rights Defense, both of Moscow. Diatlikova's primary exhibitions have been in Russia, Denmark, Pennsylvania and New York.

Energies of Our Universe 20" X 26" Prisma Color Pencil

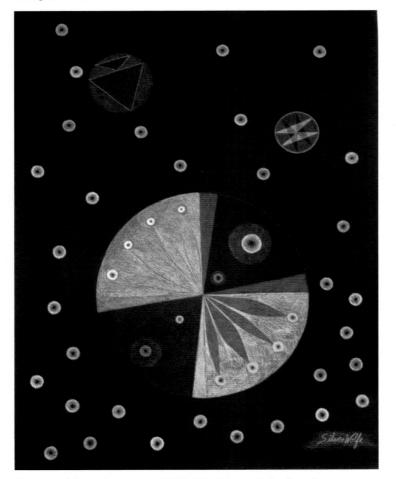

Change of Consciousness 20" X 26" Prisma Color Pencil

LAURA J. TERRY

Meditative sensibilities convey an uncluttered sensation of space and universal mystery in the paintings of Laura Penrod Terry. A mandala-inspired self-unity and austerity arranges position and relationship within "New Age" values of composed consciousness.

Born in rural southern Idaho, Terry, whose interests include poetry and photography, studied art in high school and Rick's College (now BYU Idaho) and has exhibited her work at group shows and county fairs.

To bring together the spiritual, emotional and physical meaning of life in a visual form in order to awaken the divine healing power in us all.

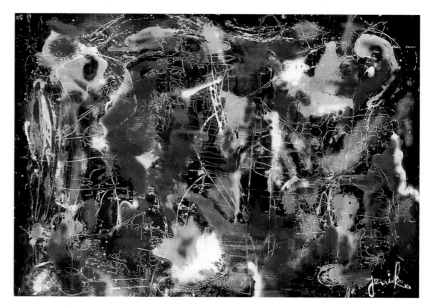

ABS No. 23 54" x 68" Acrylic

JENIK

Where restraints of form contain the ebullient enunciations of Jenik Cook, they are themselves subject to intuitively persuaded gravities of posture. A decor of emergence, more beholden to intrinsic dictums of spectral conformation than prescriptions of category, strikes an exceptional covenant with logistic poise.

Widely recognized in contemporary arts media, Jenik's talents were tutored in various stages of development by noted artists in Iran, Scotland and the United States. Currently a residnet of Califorina, her work has most recently exhibited at glaaeries in various parts of that state as well as Las Vegas, Nevada; Orlando, Florida; New York City and Germany.

"My art is the expression of life and the joy of being alive. In my art, I look for some essential radiance, just as I seek that radiance in nature...as a child, when I went to school, everyone told me that I was an artist but I really did not know what that meant. I kept that idea in my heart, trusting that some day I could and would experience its meaning. I can say now that I do... I have lived in many Europian countries and have had opportunity to see the works of most of the great masters...When I saw the work of munch, it had tremendous impact on me. It inspired me to tell the story of my life through art... I ma always surprised about where this art comes from but it manifests so easily, like a fountain, just as I get ready to apint. It is amazing to me how clearly art illuminates the journy of one's 'self'."

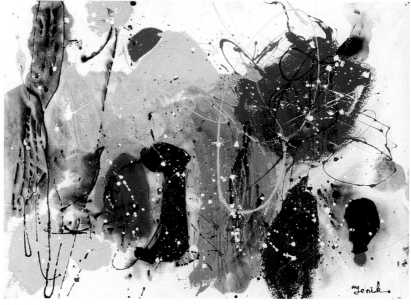

ABS No. 24 46" x 66" Acrylic

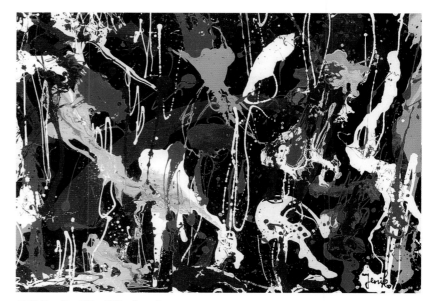

ABS No. 9 46" x 60" Acrylic

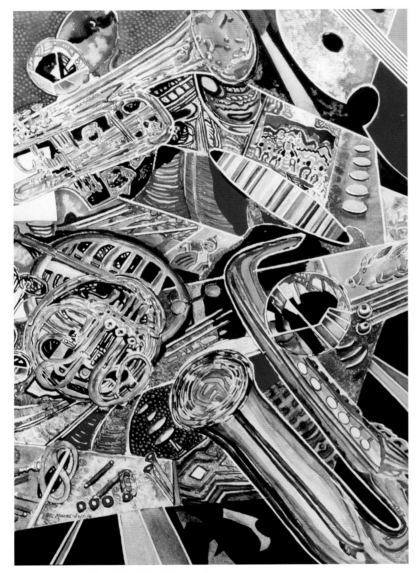

Music Series XV 00" x 00" Watercolor

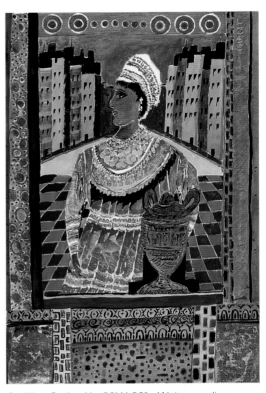

Cadillac Series X 30' X 22" Water-medium

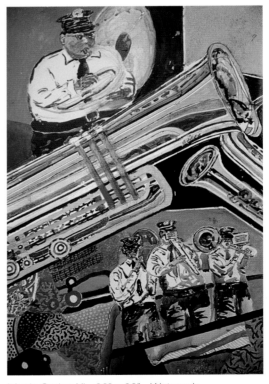

Music Series XI 00" x 00" Watercolr

HAL P. MOORE

The bright and strikingly buoyant quality of Hal P. Moore's
"non-objective semi-realism" brings an almost invariably
uplifting influence to canvas. His warm-natured perspective
treats myriad variations of subject matter with communicable
optimism, flourishing activity and fondly situated exuberance
and humor.

Born in Pennsylvania, Moore graduated from the University of
South Carolina and founded an automobile paint company
long before he began seriously applying colors to surfaces with
the object of creating fine art. Since that beginning in 1963, he
has studied with numerous nationally known instructors and
won awards in more than forty exhibitions.

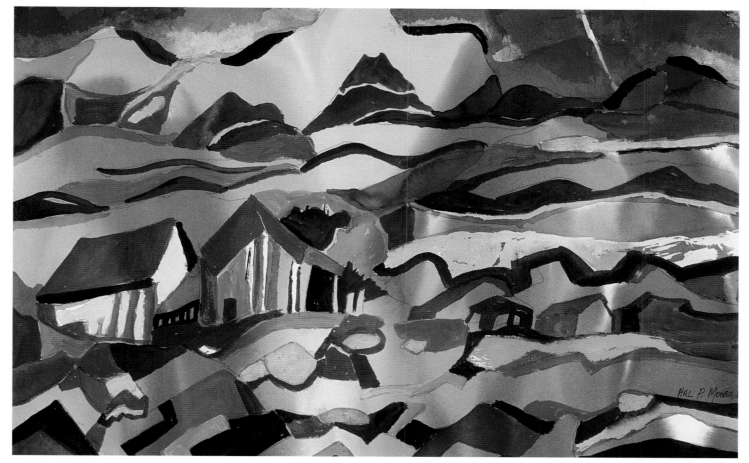

Grosdorf Series I 11" x 15" Watercolor

*I hope to express to the viewer of my paintings a joyful, happy
message of life- a message of nature and how wonderful it is to
have all the blessings of life...I try to paint from my heart and
from the competitive nature I possess... I enter a lot of national
invitational art exhibits and this helps me to keep striving to
improve my work- hopefully, for the increased enjoyment of
people... If you want to become a good artist, paint from your
heart and paint as often as you can.*

Formal Attire Suggested IV 40" x 30" Acrylic

Formal Attire Suggested I 36" x 36" Acrylic

KAREN DEICAS DEPODESTA

Edging from her frequently non-objective work toward satiric celebration in this series, Karen Deicas DePodesta retains a vaunting flow of gestural impulse in a loose and light disposition of organization. The amusing thematic formulation is underwritten by a sturdy sense of divergent stylization.

Born and raised in Mexico City, Deicas completed her education in the United States and currently resides in San Francisco. Having lived, worked and toured in over 20 countries around the world, she has exhibited her work in Mexico, Argentina, Japan, Cyprus, Germany, Sweden, Switzerland, Spain, the UK and the US. Sites include Ickenox Fine Art Gallery, London, England; Cohen Rese Gallery, San Francisco, California; Limner Gallery, New York City; Schacknow Museum of Fine Arts, Plantation, Florida; ARC Gallery, Chicago, Illinois; Grupo Batik Art, Barcelona, Spain and many other venues.

I paint believing that the act of creating, and one's reactions to, art should be edged on subconscious perception, causing one's instincts to come alive. The movement of my body and the subtle rhythm of shifting forms of color lead the way as I use different sensations of light and patchwork to allow the elements on the canvas to dialogue with one another... My work's meaning is indivisible from the viewer's reaction.

Formal Attire Suggested III 48" x 48" Acrylic

Untitled 5 48" X 48" Acrylic/canvas

Right Angle Series #1 48" x 48" Acrylic/canvas

KIRBY CLEMENTS

With precise angles and delineations, reserves of culmination and absence, Kirby Clements targets a triad of exchange between the instincts of nature, civilized restraints of human sentiment and the emotional distances of technology. His view of an inclination on the part of technological advance to diminish individual identity finds symbolized resistance in alignments of positioning color.

Clements has a Bachelor of Science degree in Liberal Studies from Portland State University. His sites of exhibition include ARC Gallery of Chicago, Illinois; Savage Gallery of Portland, Oregon and Period Gallery of Omaha, Nebraska.

My work consists of the study of shapes and color in relation to energy, nature and computing. I intend, as I have in the past, to investigate the line and curve, in relation to how they balance one another. My shapes have an emphasis on form and function, when pertaining to architecture in the 3 dimensional field and also in the software and networking arena; the idea of building something through negation... The suggestion of an increasingly synthetic world is the main premise behind the work.

Pod 48" x 48" Acrylic/canvas

Embrace Your Irritations 27" x 36" Oil/paper

Impermeable 23½" x 27" Oil/paper

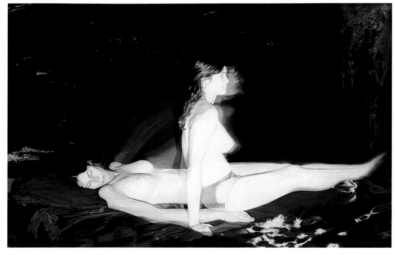

Reverie 40" x 70" Oil/canvas

Reverie (detail) 40" x 70" Oil/canvas *

ANNA KAYE

Exploring the energies of activity which involve her subjects with physical or cerebral motion brings an extra-dimensional edge to the refined surfaces of Anna Kaye's paintings. Detailed representations of form are actuated with invigorating and poised vivacities of implied animation, visibly instilling viabilities of living existence to figures possessed of life.

Born in Detroit, Kaye gathered numerous awards on her way to a B.A. in Fine Arts at Skidmore College in Saratoga Springs, New York. She also studied in the intensive Norfolk summer program via a Yale University fellowship award. Currently pursuing an M.F.A. in Fine Art at Washington University in St. Louis, Kaye has exhibited her work at the Baker Art Center in Liberal, Kansas and the Tang Museum in Saratoga Springs, New York.

My oil paintings are focused on the figure in an emotionally reactive environment. I blur the figure and then bring it into sharp focus. This dramatic contrast between abstraction and realism allows me to show a range of emotion in a succession of time... I choose subject matter that slightly transcends reality in order to merge sensual perception with mental discernment... I draw inspiration from moments when I suddenly catch sight of an object or person that forces me to stop, observe, emote and record in paint... As I paint, I give my work absolute focus so that there is a channel of energy that flows from my mind to my eyes to my hands to the painting and back again until the whole process becomes a steady rhythm.

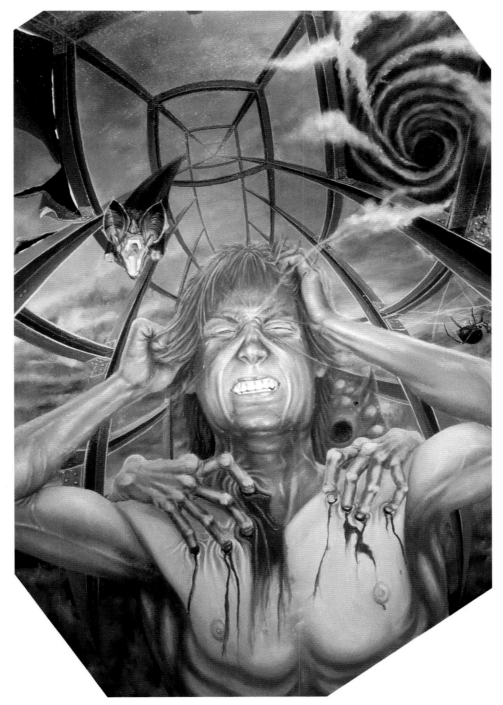

The Struggle to Overcome the Self (detail) 4' x 4' Oil/canvas

MIKE M^CGOFF

In the profound psychological disturbances depicted in this scene by Mike McGoff, we find a dizzying blend of shifting forces and a remarkable facility for conveying the impact of such torment. Perhaps his enjoyment of authors such as Dean Koontz and Clive Cussler contributes to his ability to envisage such piercingly vivid images and, perhaps, his work as Activities Therapist in the psychiatric unit of a hospital provides additional inspirational input. On the lighter side, McGoff also enjoys Tai Chi and an interest in Deepak Chopra and the Dalai Lama as well as ceramic sculpture. He is a resident of Pennsylvania and has also taught at local colleges.

Whether your life is a horrible mess or pretty good or somewhere in-between, we all have those miserable times in our lives that we have to overcome. Here is the thing we often miss and sometimes never discover. We have the power to overcome and create ourselves anew. Paul Klee put it succinctly." Becoming is superior to being."

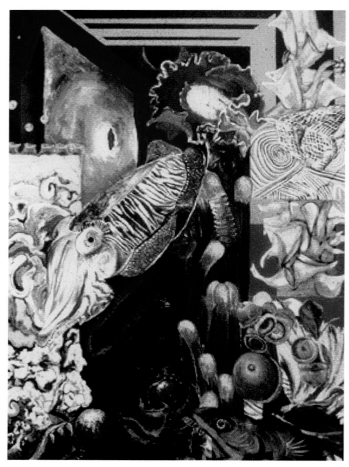

The Watcher 36" x 60" Acrylic

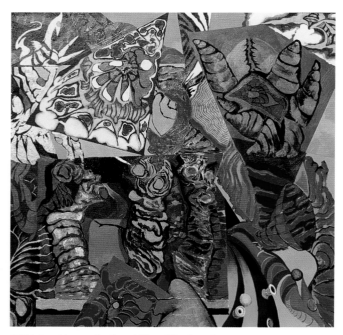

All Natural Ingredients 48" x 48" Acrylic

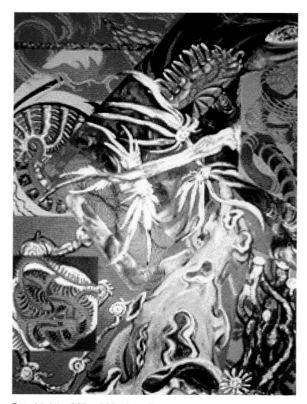

Star Light 36" x 60" Acrylic

CHRISTINE DENG-THOMPSON

Melding topic and shape with the dynamics of pseudo-abstract design, Christine Deng-Thompson probes associations of imagination and expectation. Disparate relationships of form, clustered by the demands of line and space, elicit interesting and unexpected response.

Born in Brooklyn, New York, where she invested years of weekends in classes at the Brooklyn Museum Art School, Deng-Thompson proceeded on to earn her B.F.A. from Pratt Institute and her M.F.A. from the University of Miami in Florida. A practitioner of equine dressage and various disciplines of the martial arts, she garnered certification in certification in educational leadership from Nova Southeastern University and instructed in art in the public school systems of Florida for three decades. She is currently an Adjunct Professor of Painting at Lake City Community College.

The relationship between dissimilar objects can be surprisingly interesting and dynamic. When given the ability to choose from several such relationships, a viewer may seek the most compatible, depending upon current mood and mental set. This series of paintings, therefore, are user-friendly in that there is a comfortable place for one's eye no matter how one feels.

Latte Laughs 48" x 48" Oil/canvas

No Perfect Cut 24" x 36" Oil/canvas

JODI BONASSI

Frank, gritty gulps of social verity are gathered in tilted clusters of activity and brazenly swept into a crowded glance for the fascinating paintings of Jodi Bonassi. In her folksy public interior atmospheres, interplays and characterizations come tumultuously to life with rich, clamorous sensations of community.

Ultimately a self-taught artist, Bonassi is a California resident whose work has been applauded by *Los Angeles Times* art critic Josef Woodward as "Silly Putty Realism" and has appeared in Harper's Magazine and other notable publications. Among numerous sites of exhibition are the Bowles-Sorroko Gallery of Beverly Hills; Palos Verdes Art Center; Orlando Gallery of Sherman Oaks, California; St. Louis Artists Guild, Missouri; Rockville Arts Place, Maryland and Cambridge Art Association National Prize Show in Massachusetts.

I think of myself as a visual recorder of history. The series of paintings from 1999 to the present reflects my on-going study of shared moments that occur in the public settings of barbershops, beauty salons and cafes. It is important to create a visual sense of community, shared heritage and history through interesting and diverse visual narratives. The transformation experienced by salon and cafe patrons coming from the harried and stressed activities of the day to a relaxed and accepting environment is the key narrative that I wish to express to the viewer.

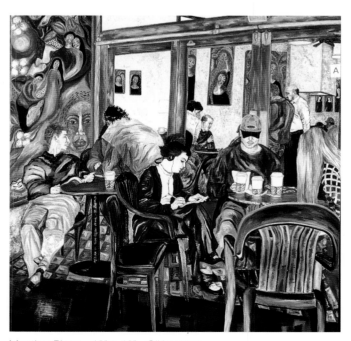

Meeting Place 48" x 48" Oil/canvas

Untitled (02.02) 36" X 50" Oil/canvas

Untitled (02.01) 39" X 42" Oil/canvas

Untitled (01.09) 39" X 42" Oil/canvas

PATRICK SCHMIDT

The remarkable and unexpected sensations to be derived from the stirring visual appositions of Patrick T. Schmidt bring attendant implications of a largely unfamiliar field of complexity in aesthetic response to shape and color. Assumptions of compatibilities and conflicts, intersubjective relationships and actualizations, open previously unseen patterns of expectation and reaction.

Currently Assistant Professor of Art at Washington & Jefferson College in Pennsylvania, Schmidt obtained his B.F.A. and M.F.A. from Central Michigan University, where he teaches painting, drawing, two-dimensional design, printmaking and digital imaging. Among sites of exhibition have been Neo-Futurarium of Chicago, Illinois; Second Street Gallery of Charlottesville, Virginia; The Painting Center in New York City; Schomburg Gallery of Santa Monica, California; Craig Flinner Contemporary Gallery of Baltimore, Maryland and many others. His paintings have been twice featured in *New American Paintings*.

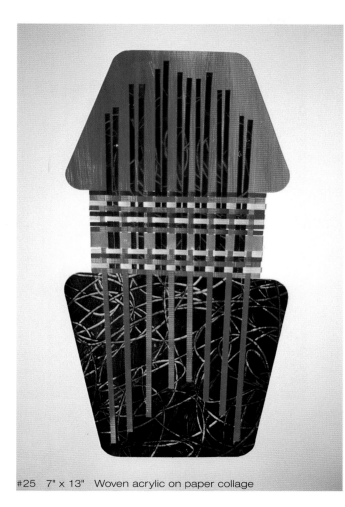

#25 7" x 13" Woven acrylic on paper collage

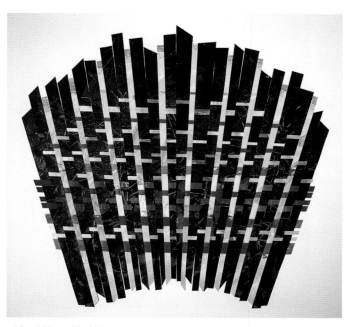

#12 12" x 12" Woven acrylic on paper collage

LAURA WIECEK

Laura Wieck's collages are startling not only in the vibration of her colors but in the way her selected interplay of images seem to echo that vibration. Her work suggests objects and interactions which imply feelings of things familiar —the ocean breakwater, the mystical fan, the odd reflected dwelling joined by earth locking pylons. These strong contrasting arrangements in her small works make definite statements whose meanings though serious and complex are pleasingly available.

While a student at Sonoma State University, working on drawings with classmates, Wiecek developed an interactive process of collage which has evolved along a unique trajectory into collaged weavings of color and design. Having mastered multiple-harness weaving, she engaged her affinity for mathematical equation and puzzle solution into a sum greater than its parts by incorporating these skills into an eclectic assortment of materials to produce dynamic and dramatic unities.

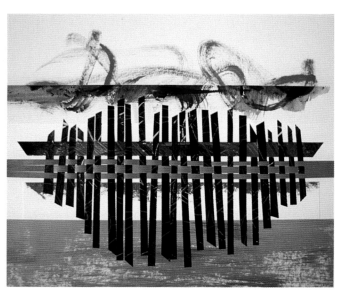

#30 9" x 8" Woven acrylic on paper collage

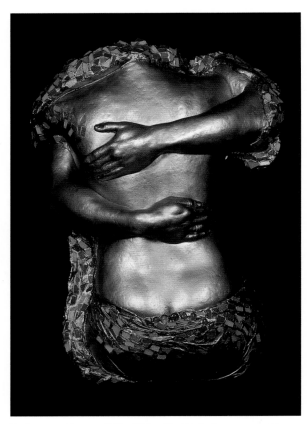

Embrace of Love　31" x 23" x 6"　Wall - hung mosaic
and cast gypsum- metallic patina

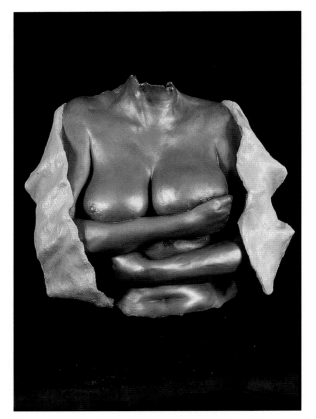

Home Comfort　19" x 19" x 7"　Wall - hung cast
gypsum - painted

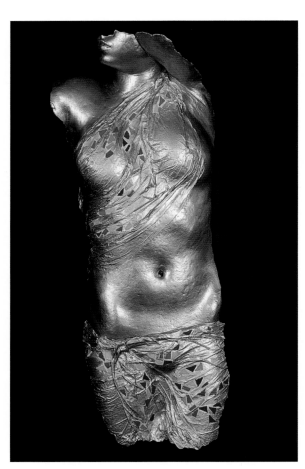

Discovered　14" x 38" x 7"　Wall - hung mosaic
cast gypsum

VICTORIA ANDREA DORIA

Born in New York City, Victoria Andrea Doria thrived in the creative community. The museums, galleries, theaters, performance centers and ethnic diversity were powerful dynamics for her to experience.

Ms. Doria's education is grounded in the traditional elements of painting which allows her a command of several media: painting in oil, watercolor, acrylic and silk painting. She aquired her education from Pratt Institute, New York; Art Student's League, New York; Artist's Apprentice, Ulivetto, Italy; UCLA, Los Angeles, Califorina, as well as additional workshops and study programs at a variety of locations.

She has created murals for the City of Cottage Grove, Oregon; City of Eugene, Oregon; Department of Parks and Recreation, Eugene, Oregon, as well as murals for businesses and private homes.

Visual expression is my passion. This is my voice to unlock my soul. Sharing with others is deeply satisfying and is my important contribution. My subject matter is carefully chosen to explore space and to communicate love. Art is a proven common ground between cultures ideologies and age.

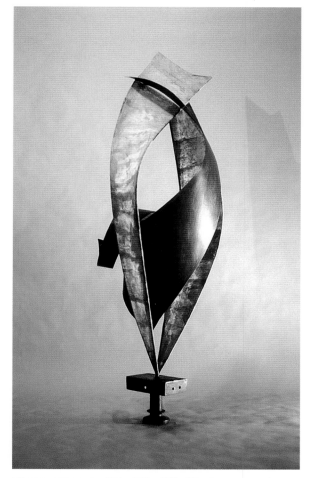

Vitruvian Dream 56" x 26" x 29" Steel, paper, resin

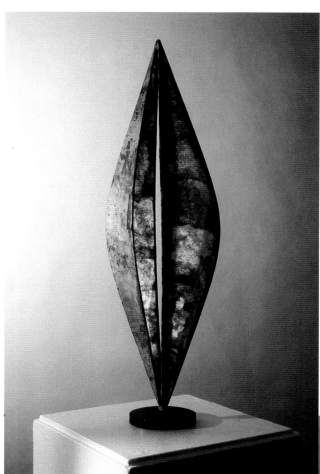

Sanctity 3½' x 14" x 6" Steel, paper, resin

DOUGLAS ALEXANDER TRUJILLO

A sleek opulence of line, aggregated with a visionary affability of tone, distinguishes the enticing sculptures of Douglas Alexander Trujillo with the slanting charisma of activity and purpose. His delicately wrought equilibriums appear gracefully but resolutely supported by substance, motive and momentum.

Born in Boulder, Colorado, Trujillo received his B.F.A. in Sculpture and Drawing from the Rocky Mountain College of Art and Design. His sculpture has appeared in exhibitions at the Fresh Art Gallery and Space Gallery in Denver; the Museum of Contemporary Art and Improv Gallery in Fort Collins, Colorado and other venues throughout the Colorado area.

In a sense, I see my art as a type of biographical exploration. Investigating life's experiences and translating them into a visual event, I explore the elements which make those objects what they are, so that I capture the very essence of light and movement in my work.

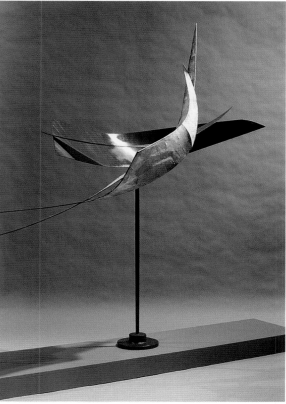

San-Pan 5' x 22" x 49" Steel, paper, resin

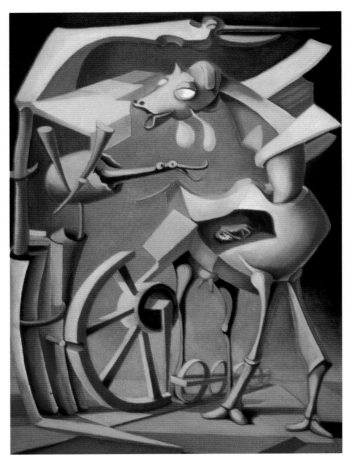

Revolution　36" x 48"　Oil

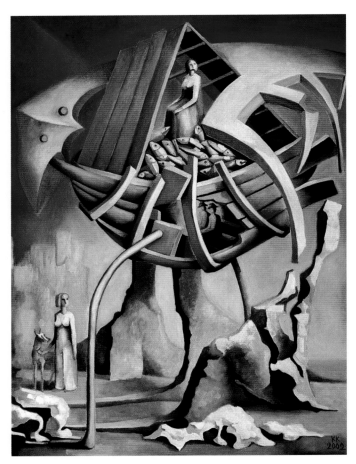

Fishing Boat　36" x 48"　Oil

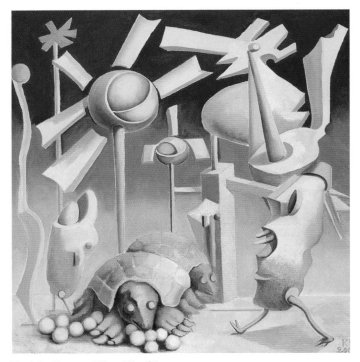

Turtle's Shore　36" x 48"　Oil

KONSTANTIN PETROV KONSTANTINOV

Though Konstantin Konstantinov stresses the narrative connection in his work he employs forms which also bear a strong relation to surreal landscapes. Highly imaginative and arranged using clean and delicately controlled color changes, he attempts to involve poetic metaphors and symbols in association with his own personal idiom. His forms and colors have a dream imagery redesigned intellectually so that they interchange between the familiar and the abstract , the representational and the non figurative, familiar reality existing in the context of edgily macabre private shapes.

The diverse cultural traditions of Bulgaria where Kontantinov was born influenced his imagination and sense of artistic purpose. He completed his Master's degree at the Fine Arts Institute in Sophia, Bulgaria and initially became known for his woodcuts, taking part in numerous juried shows at the National Gallery, Sophia, and in 1982 a solo show of book illustrations for children. He came to the US in the year 2000 and made the change from woodcuts to oil painting while retaining many of his original forms and ideas. He is a member of various organizations, among them the fine art division of UNESCO, and his woodcuts are in many collections in Europe.

I search for that perfect balance between color and shape. It is important that my art is accessible to the viewer in such a way that form does not dominate content nor content form. To interact with reality, I create imagery which must tell some type of story . These stories are my interpretations of nature and the social world around me.

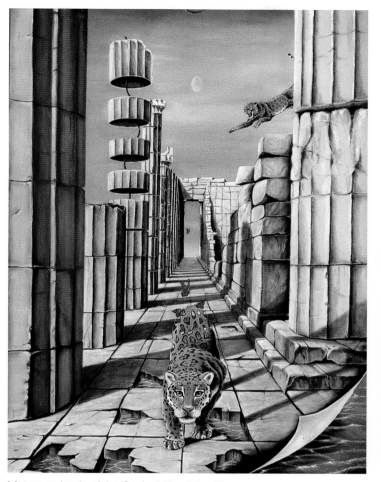

Metamorphosis of the Soul 36" x 48" Oil on canvas

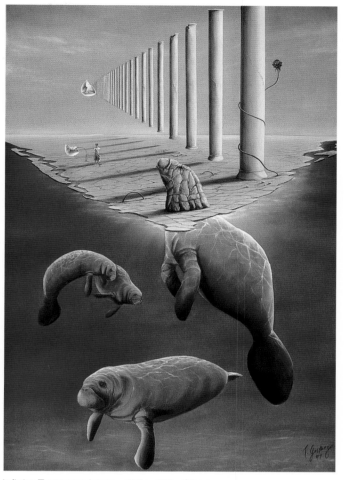

Infinite Transcendance 32" x 46" Oil on canvas

TERESA GOSTANZA

Images of surrealism comes to mind at once when viewing Gostanza's work. The creatures she creates seem comfortably free of gravity while other odd beasts swim or play in incomprehensible environments bearing perplexing relationships to traditional imagery or geometry. Contrasts of gold and blue empower the volumes and the classical imperatives, creating startling juxtapositions designed to manipulate the viewer's eye.

Teresa Gostanza is a Spanish surrealist who studied in Australia and England. She has shown her work and accepted commissions in the three countries of her connection as well as in the US. Currently she lives in Colorado and is represented by the Royce galleries.

I work primarily with oils on canvas. My subject matter originates from fragmented dreams which connect the images within the canvas. Most recently my works are based on my awakening to the true significance that exists within all life.

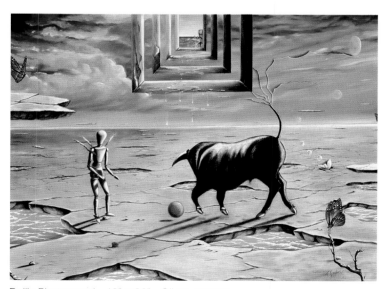

Bull's Playground 40" x 30" Oil on canvas

Warrior 35" x 27" Watercolor

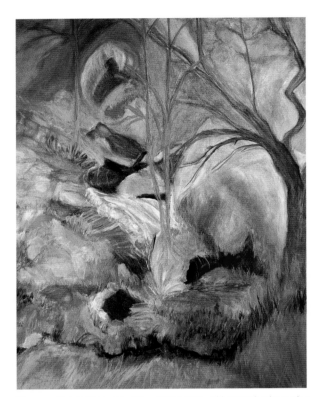

Stream-Palm Canyon, CA 34" x 28" Watercolor/gouche

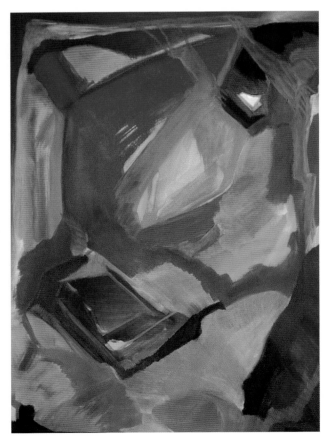

Golfing 36" x 29" Watercolor

JOAN L. GARFINKEL

The paintings of Joan L. Garfinkel present forms which are related to and derived from sensations produced by natural figuration and human emotional response to landscape and situation. Her responsive inner perceptions which evolve into expressive pictorial images. These forms seem to shift into and out of space through the use of allied patterns of color.

Benefiting from the tutelage of a wide variety of notable instructors in an equally wide range of artistic aspects, Garfinkel studied at the Rhode Island School of Design, the Newport Art Museum, Intensive Studies Workshops in Taos, New Mexico and with individual artists of note. Among the sites her work appeared in exhibition are the North Valley Art League of Redding, California, the Newport Art Museum, and both the Wickford South County Art Association in southern, Rhode Island.

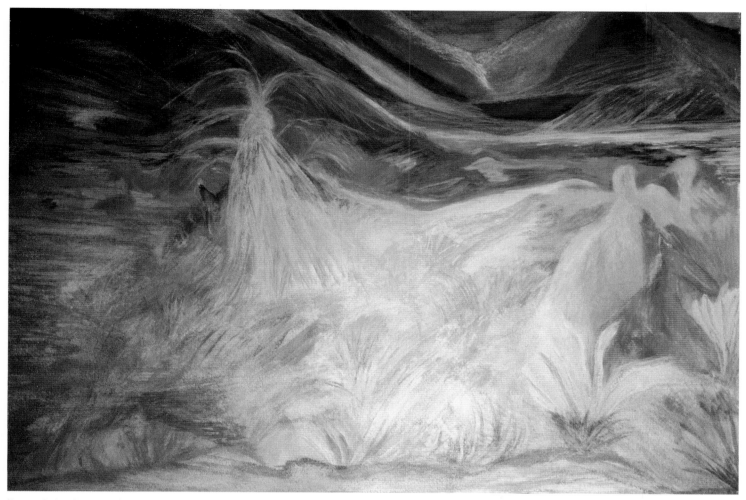

Peace-Palm Canyon, CA 37" x 29" Watercolor/acrylic

After studying voice, theatre and dance at Rhode Island College, painting was and is a natural way for me to continue expressing feelings about life through the arts; so "content" is what I strive for. Cezanne said it best when he said, "Paint your sensations."

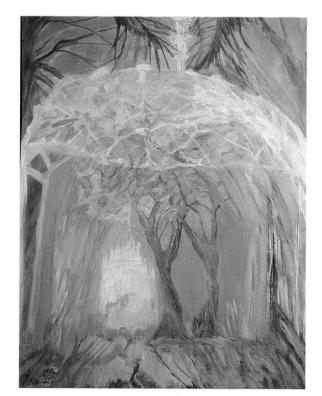

Gazebo in the Garden, CA 37" x 29½" Watercolor/acrylic

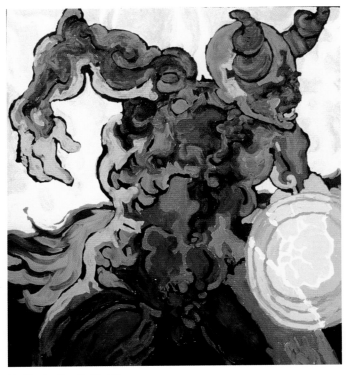

Untitled 6' x 5' 4" Oil

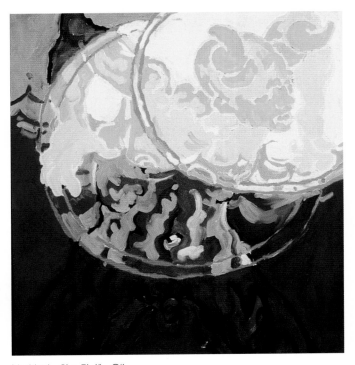

Untitled 6' x 5' 4" Oil

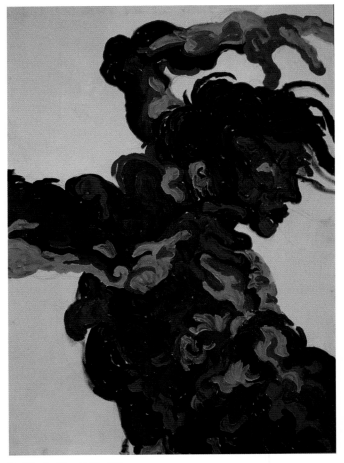

Untitled 6' x 4' 5" Oil

CHRISTOPHER JON SCHROEDER

The raw, organic connectiveness of Christopher Jon Schroeder's component figuratism, hinting of a refinement and simplification of objectives sought by a Vlaminck or Kokoschka, treats themes of popular contemporary imagination with a coagulating vigor. A leaning toward expressions of neomythic force in casual depths of current perception shapes his scenes and characters with an airy and unsuspected potency.

An early native of Indiana, Schroeder was raised in Michigan and graduated from the Kendall College of Art and Design. Currently a resident of Texas, he has exhibited his work at 10 Weston Gallery, The Urban Institute for Contemporary Arts, End Gallery and other sites in Grand Rapids, Michigan as well as West Third Gallery and Arts Complex, the Austin Visual Arts association, Halcyon Gallery and other sites in Austin, Texas.

Painting is really a form of poetry. Ideas change from one moment to the next. The strongest ideas are visions from the unknown universe. The painting process is rather simple, almost deceivingly so... I'm open to any artist's philosophical view and its application to the artist's work and I am always eager to contrast the two... (Art critique can) fail to properly weight the absolute necessity of originality in the total assessment... Of course, I have influences: VanGogh, Michelangelo, Pollack, Byrne... I strive to be as great as the top shelf artist and grander than the flock...

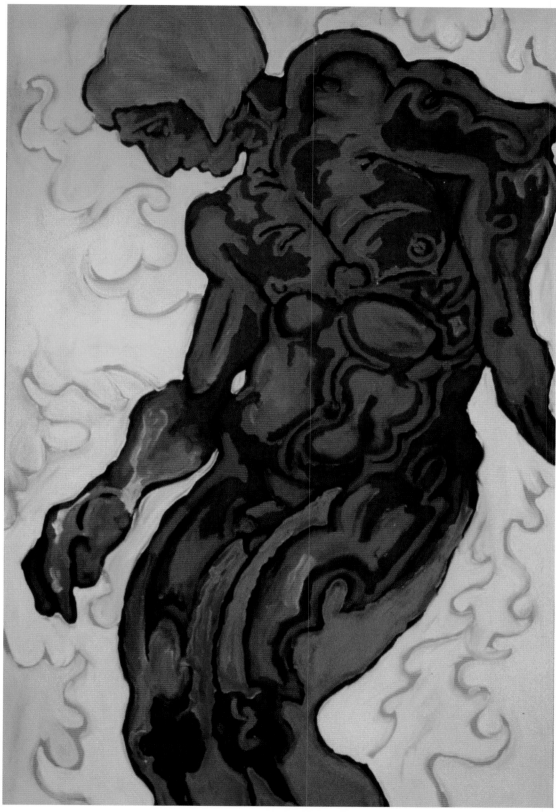

Untitled 7' 8" x 5' Oil

Dragon Limit III 16" x 12" Hand colored serigraph

ROBERT F KAUFFMANN

Though committed to the visual arts from an early age, Kauffmann chose to take a degree in Computer Science instead of art receiving his BA from Rutgers University in 1987. As an artist, however, he found himself attracted to the works of M.C. Escher which stimulated much of his conceptual thinking and contributed to his ideas so that his present style is a synthesis of art, computer science and mathematics.

Fractal geometry with its repetition and infinite complexity of mathematical forms became another influence and these concepts acted as unconscious stimuli for his creative ideas. Computers and mathematical imagery opened up new visual forms but he found he preferred to create his drawings, paintings and serigraphs by hand rather that through the use of computer algorithms. So despite the complexity of his designs which are ultimately dependent on his computer study, his works are produced completely by hand.

"I opted (he states) for hand drawing over programming as the more pleasant [artistic] alternative. My works typically portray visual paradox using mathematical structures as expressive tools. I name my work Mathematical Surrealism."

Developing his process Kauffmann creates complicated visual arrangements which seem to be in the act of spreading and growing like convoluted plants or living creatures. The intricate designs develop when he formulates a way to divide space so that he can manifest his shapes, then with multifaceted color arrangements, he creates an image which appears to have a complex mathematical precedent. but in fact portrays a new perspective of a familiar object..

Dragon Limit I 16" x 12" Hand colored serigraph

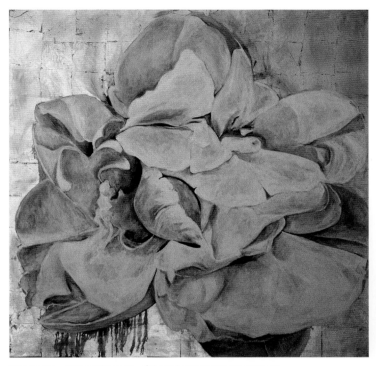

Gardenia 60" x 60" x 3" Oil and gold leaf on canvas

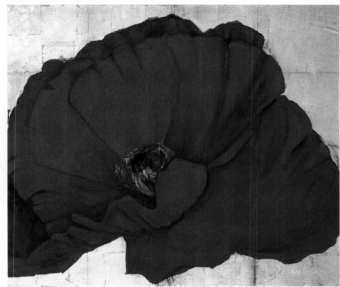

Poppy 42" x 48" x 3" Oil and gold leaf on canvas

ROSHAN HOUSHMAND

Roshan Houshmand is Iranian/American, raised in the Philippines and Iran, who spent most of her artistic life in Spain and the USA. She feels that she connects to the differing patterns of culture in her search for a universal truth. In her Installage Paintings she works to bring the formal traditions of art together with the " ethereal layers of life's fragments." She has been in a wide selection of solo and group exhibitions, ranging from Pennsylvania and New York through Denmark, Spain, Italy, New Orleans, and many other places. Her BA in Fine Arts comes from Bennington College Vermont and her MFA comes from Dominican University, Florence, Italy.

The most significant aspect of making art for me is the unique fulfillment of psychic, spiritual and emotional needs.

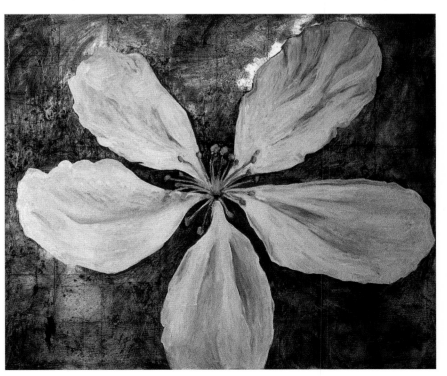

White Flower 34" x 40" x 3" Oil and gold leaf on canvas

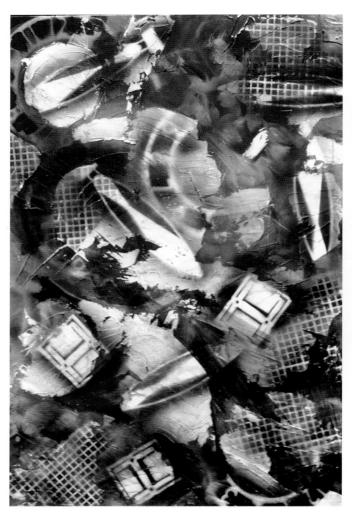

Time and Dogg I 36" x 24" Mixed media on board

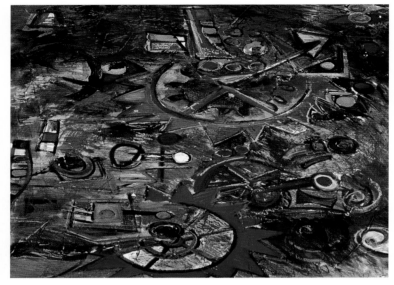

Cosmos I 28" x 36" Mixed media on board

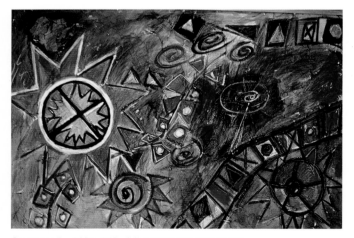

Cosmos II 28" x 36" Mixed media on board

ELIZABETH BABB

familiar shapes form a gratifying gibberish of images, interlocking, twisting, turning and reacting with each other, mesmeric in the excitement of their brilliant colors. The diverse parts of her work are also satisfying in their relation one to another so that their imagery and movement come together as a pleasing and stimulating whole.

Elizabeth Babb received her MFA from Tylee School of Art. Following an honors degree in Fine Arts at Kent State University, Ohio, Elizabeth Babb continued her studies in Rome and later at Temple University, Philadelphia. She has an extensive resume having exhibited widely in solo and group exhibititions, receiving prizes in Ohio, New York, New Jersey and many other well known venues.

I paint a fragmented reality. My work is inspired by bits and pieces of natural and man-made forms. These forms present themselves to me as I piece together the information from things I see around me. I use the logic of the dream world and gather images, tear them apart and then piece them together in ways which are new and different from their origins.

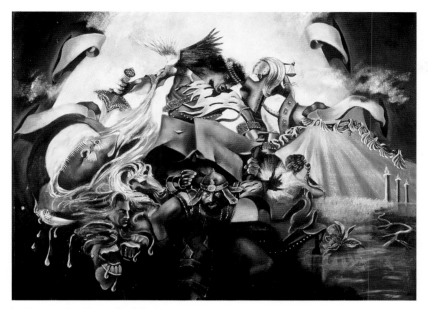

Mehregan 32" x 40" Oil/matboard

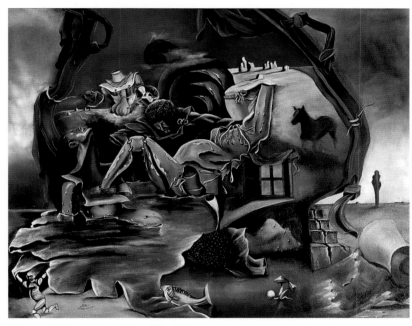

Climax of Thoughts 32" x 40" Oil/canvas

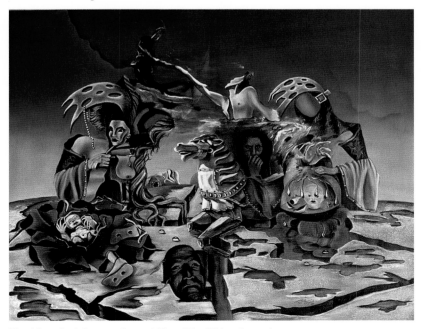

The Historical Connection 32" x 40" Oil/matboard

SHAHLA ROSA

Soaring and transcendent sweeps of surrealistic vista infuse the canvases of Shahla Rosa Beykaei with a haunted and velvety glide of mysterious scenario. Her liquid supplications of motive and shadow invoke formidable appeasements composed of the effulgence of hope winding itself into daylight apparitions of wonder.

Distinguished in fashion design, which she studied in California, and as a doctor of veterinary medicine, Beykaei received her B.F.A. from the Academy of Fine arts in Florence, Italy and Dusseldorf, Germany. Adept at set design for theater and opera, her award-winning paintings have exhibited at the Modern Art Museum, D'Unet, France; Artists Guild Museum of Modern Arts, San Diego, California and other venues.

I believe that the source of all creation is pure consciousness- going where it has not been to free the dream (unconscious) and present it in the moment (conscious). From this powerful source, at the wellsprings of life, springs the process through which the dreamer manifests the dream... I try to express a relationship between life itself and reality, so my work is an interpretation of its internal emotional reaction to the beauty and falsity of the external world....

I relish seeing and drawing creations in action because every action generates a force of energy that returns to us in kind- and there is nothing unfamiliar about this action. This implies an actively conscious choice-making which I enjoy presenting to my viewers. These movements and actions are eternal assertions of human freedom.

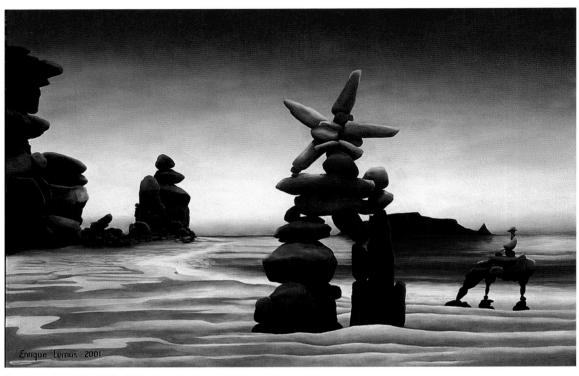

The Beach 24" x 30" Oil/canvas

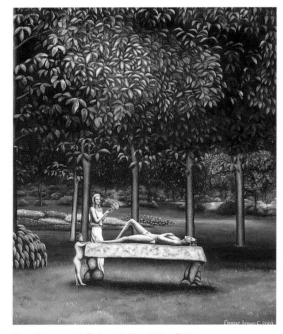

The Dream of Cain 24" x 30" Oil/canvas

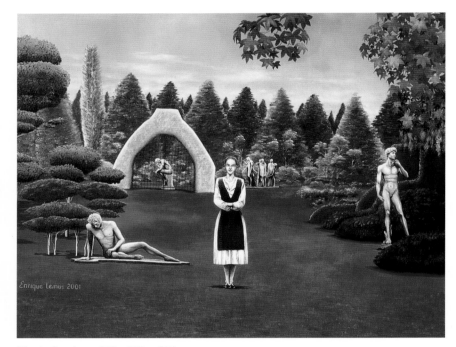

Elise's Garden 24" x 30" Oil/canvas

ENRIQUE LEMUS

Seeking a balance of morality and beauty on a planet of paradises and purgatories, Enrique Lemus peers curiously into the inky aphorisms of mankind's history and gazes unflinchingly toward the incandescent illusions of virtue in humanity's promise which seem to drift before his easel. His work presents surrealism's abandonment of logic in modes which are instructed by conscience and tempted by reality.

A resident of southern California, Lemus won scholarship in graphic design while earning his B.E.E. in Electrical Engineering in the Audio Visual Department at the University of Baja California. He is a member of the San Diego Museum of Art Artist Guild.

What should be the reason for a man to tear up his soul; break it, crumble and then redefine himself? ...to expose just a glimpse of his dreams? ...more probably to reach some other souls out there...

Morgen 20" x 16" Oil on canvas

Afrika 20" x 16" Oil/canvas

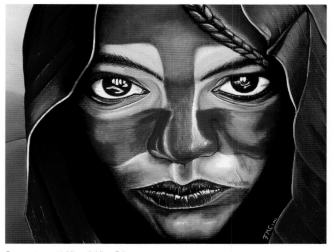

Sumatra 16" x 20" Oil on canvas

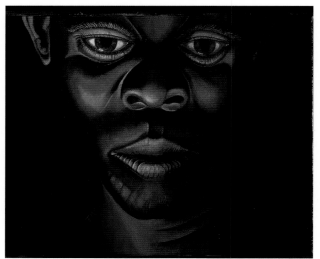

Macumba 20" x 16" Oil on canvas

FRANK MARCUS CZECKAY

Adorned, naked or fancified, the human face never ceases to provide a compelling source of fascination to artists and observers. Frank Marcus Czeckay finds telling nuance in facial expression as he orchestrates visually poetic isolations of countenance and personality in the visible features of the inward being.

Born in Hilden, Germany, Dr. Czeckay first studied art before entering Heinrich Heine Universitaet in Duesseldorf, where he would earn his doctorate degree in Medicine. Since moving to New Jersey in 2000 and serving residencies at Jersey City Medical Center and Beth Israel Medical Center in New York, he has exhibited his paintings at the Creative Eye in Guttenberg, New Jersey. Earlier sites include the Union Hill Arts and Crafts Building in Union City, New Jersey and Museum Ludwig in Leverkusen, Germany.

Faces manifest the vast range of human emotional experiences across ages, races and cultures. For me, a face is the most important part of the body. It reveals a person's inner life, which would otherwise be less apparent. Walking through life, as you observe others, their faces can be read as life maps. They can tell stories of an easy or difficult life, feelings of love or hatred, good health or illness and joy or despair. The eyes depite thier colour brown, blue or green are the windows to the soul. The nose in the center of the face is the bridge between eyes and mouth. The mouth, a point of sensuality and the gateway that allows the flow of words. A face captured on canvas will live forever and a day.

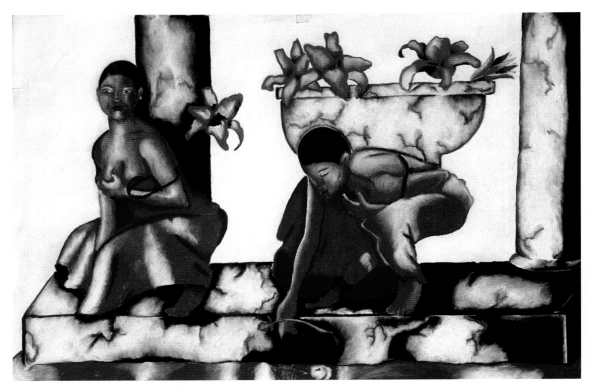

Beautiful 12" x 18" color pencil prisma

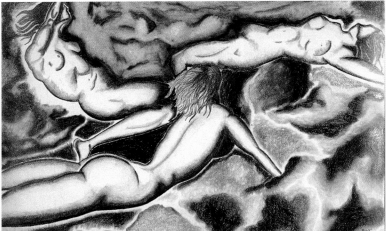

Heaven 15" x 24" charcoal pencils

KIMYARDA EDWARDS

A mystical authority in combination with imagery of contemporary hopelessness are shown in examples of work by Kimyarda Edwards. Hibiscus flowers collected by dark maidens attempt to fill a monumental bowl between marble pillars. Elsewhere the classical implications are deformed and in her imagination she describes a place of grime and despair yet alight with sunset colors. In this debris of modern poverty she offers hope as flower creatures search for common bond so that defined by the vibrancy of her colors she attempts to connect with a different form of classicism.

Edwards was born in Miami, and graduated from Jackson High school. In her final year she studied art under the tutelage of Erich Jenkins who worked with her particularly in the development of her creativity,

Art is something I love. To be able to create work as though from a dream is a gift from God. I feel blessed to have this gift.

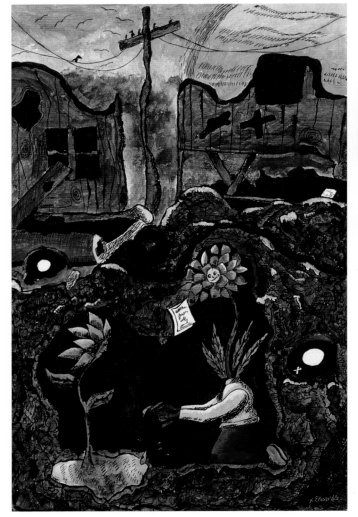

Life 18" x 12" watercolor, indian ink

Cradled in the Flag 13" x 16½" Watercolor

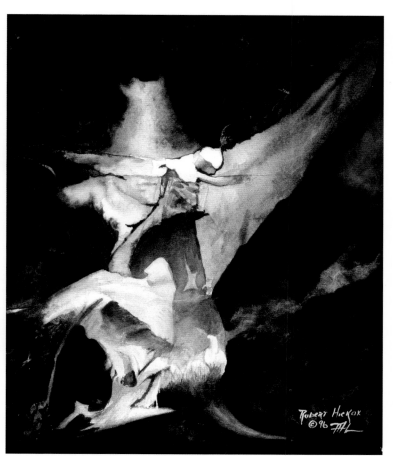

Imprisoned Soul 11½" x 10½" Watercolor

R. W. HICKOX

The imagery of Robert Hickox is diverse and strange. He works in watercolor, layering colors and shapes upon each other, a difficult and demanding technique. His forms hint of the works of Francis Bacon, though his coloring defines less brutal flesh. His constructions are apparently abstract yet seem to form into strange even macabre living creatures which in their variations of depth and tone draw out near familiar images, then change to obfuscate the mind.

Hickox was born in Jacksonville Florida, then lived in Raton New Mexico during his teen years. Living close to Taos, an active art center, he recalls a committment to art since the age of about five, where he absorbed a wide variety of expressive experiences. Introduced later to many techniques by artist Marvin Newton he was able to build the foundation of the his present skills. He has had many shows and is collected widely though choosing to call himself a self made artist. In 1986 Hickox moved to New Jersey, where he still resides today.

For me artwork is created with emotion and passion. That is the only way I know how to paint. We begin our lives with a blank canvas, and when our stay is done we sign our work, leaving a mark on the lives we've touched.

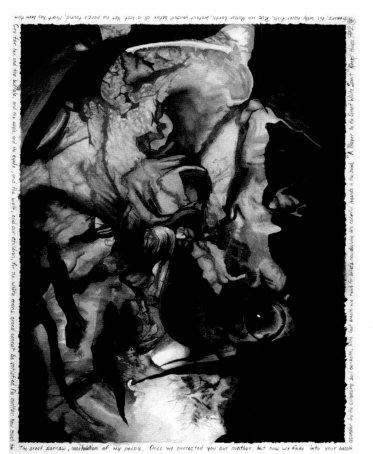

Indian Prayer 17" x 13" Watercolor

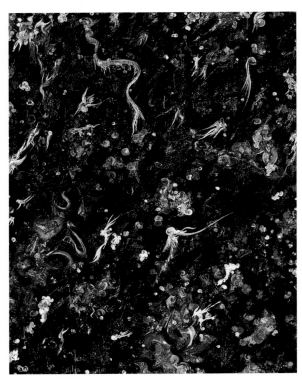

Fairy Tale Evening 42" x 54" Oil

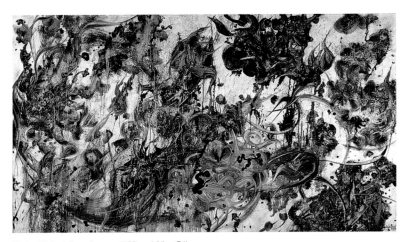

Fairy Tale Kingdom 78" x 48" Oil

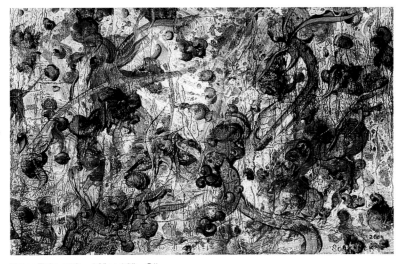

Fairy Tale #18 12" x 18" Oil

CHRISTOPHER J. SCHRANCK

The canvases of Chris Schranck frequently feature bursts and clusters of activity, creating dynamic tensions of shape which seek accord and appeasement in the tender mercies of color harmony, complement, contrast and relationship. Essentially bold, his designs avoid forcing gateways of conceptual perspective, challenging the viewer's individual creativity of association.

A resident of Lakewood, Colorado, Schranck earned his B.A. in Art at Western State College in Gunnison, Colorado and continued his studies of painting and drawing at Metropolitan State College in Denver. His work has been exhibited at Westmoreland Art Nationals in Youngwood, Pennsylvania; Limner Gallery in New York City and, in Denver, at the Lapis Gallery, Zook Gallery, Morph Gallery and other venues.

My imagery is derived from the imagination or by abstracting images I see. My works are either untitled or have vague titles in order to allow open interpretation. I want the viewer to see whatever they want without prejudice. Contrast in my paintings and drawings is derived from many aspects: textured surfaces versus smooth surfaces; warm versus cool colors or bright and vivid primary and secondary colors versus organic earth colors and geometric shapes versus organic shapes. Besides life experiences and my imagination, other artists have also been a means of influence and inspiration for me: Dale Chihuly's blown glass projects and installations; Marc Chagell and Pablo Picasso's cubism; Jackson Pollock's drip paintings and, finally, the surrealism of Salvador Dali.

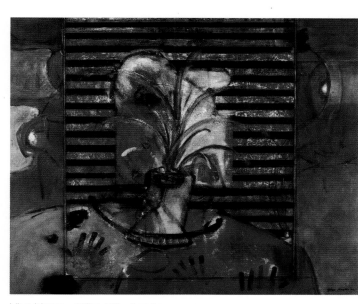

Vice Versa 40" x 48" Acrylic

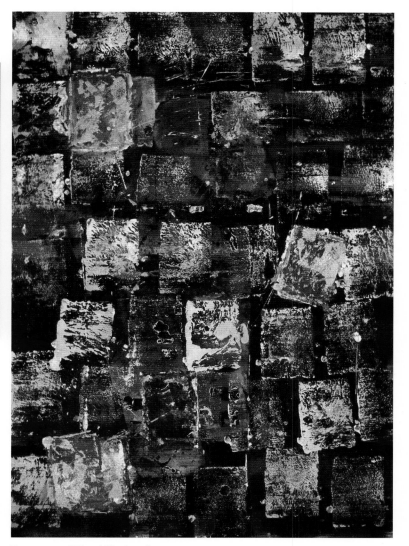

Recovery 55" x 43" Acrylic

GLORIA C. NEWTON

Reiteration and elaboration of bold form and rippling tonality are primary means in the striking ability of Gloria C. Newton to create rhythmically contained spatial poetry. Compliments of contrast and nuance, binding resonant colors and recapitulated motifs, bring a fluently cadenced dimension of secure unity to her compositions.

Born in northern Arkansas, Gloria worked in color photography for a decade and studied at Watkins Institute College of Art and Design as well as with Carol Mode at Belmont University and, privately, with expressionist Anton Weiss. She resides in Tennessee with her award-winning Nashville-songwriter husband, Wood Newton, whom she met while attending the University of Arkansas at Fayetteville.

My paintings begin with active black line. I'm stimulated by the extreme contrast between the black line and the white surface. I want references to the multitude of changes, decisions and traces of the process to show through the work, enhancing its underlying mysterious quality... I let the painting dictate what it wants to become while I'm searching for and incorporating my own convictions and their sources. It's this kind of interaction that attracts me to non-objective painting.

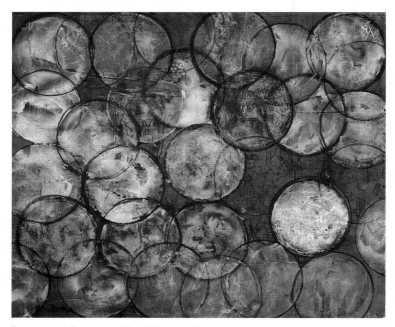

Round and Round 40" x 48" Acrylic/wood

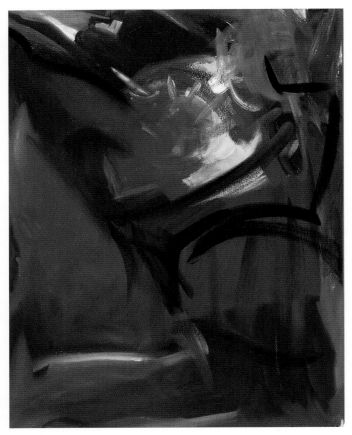

Bicycle Ride 48" X 36" Oil/canvas

SUSAN SOMMER

For more than three decades, Susan Sommer has been painting her insights and feelings, her observations and moods reguarding the familiar world of the Hudson Valley and the urban Manhattan center where she devotes muh of her time with the exotic places she loves to visit. Her work is finest and most appealing when she developes on paper or on canvas an improvisational treatment of gentle breezes, wild winds, dance rhythms, undulating currents, and warm eddies. Her restless but never breathless designs and colors strike a strong responce from viewers and collectors in the country and abroad. Her work is found in the Stanford University Museum and the Santa Clara Museum amoung other public places. Sommer graduated with honors from the Moore College of Art and Design in Philadelphia and the Art Students League with Macabi Greenfield, Nathan Hale, and Rudolf Baranick.

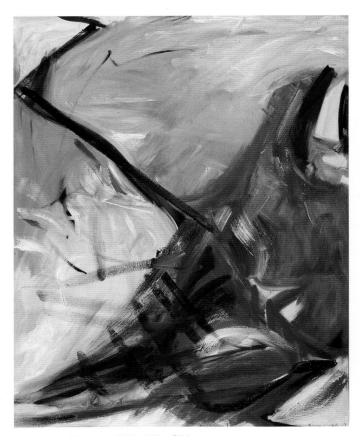

Caribbean Breeze 60" x 48" Oil/canvas

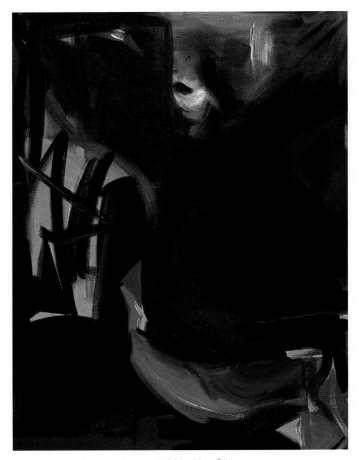

Train Ride To Amsterdam 60" X 46" Oil/canvas

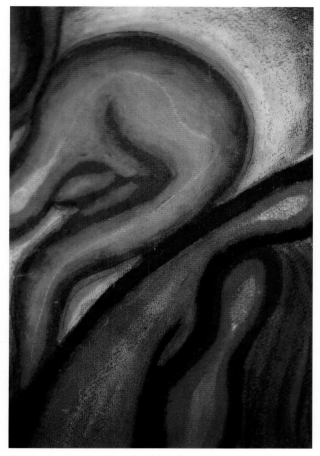

Awakening 14" x 9" Mixed Media

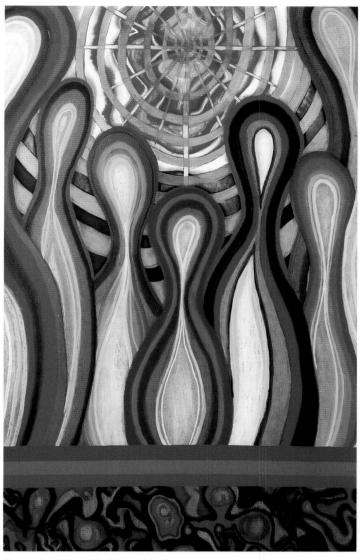

Carnival 60" x 40" Mixed Media

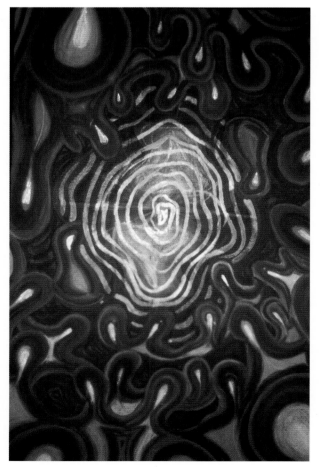

The Light 41" x 28" Mixed Media

JULIA KOIVUMAA

Mystically organic configurations nestle their rich colors within the lushly tender confines of scenes painted by Julia Koivumaa. Intimations and allusions to intrinsically cosmic and biological pattern provide sensual suggestions of universal motif in the physical manifestations of nature, social order and individual experience.

Currently a resident of northern Califorina, Koivumaa studied art at the University of Houston, where she received a BA in Communications, and expanded her art studies in Great Britain at the University of London and the Courtauld Institute.

Having traveled extensively and lived in a variety of places from Texas and California to London and Mexico, the one thing that I am certain of is the universality of human nature. We are all connected to one another by the same hopes, dreams, strengths, weaknesses and spirit. We are allmore alike than different. This feeling of connectiveness is the primary focus of my painting and consequently drives all of my imagery.

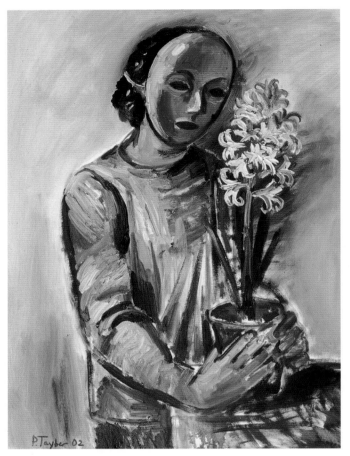

White Hyacinth 30" x 24" Oil/canvas

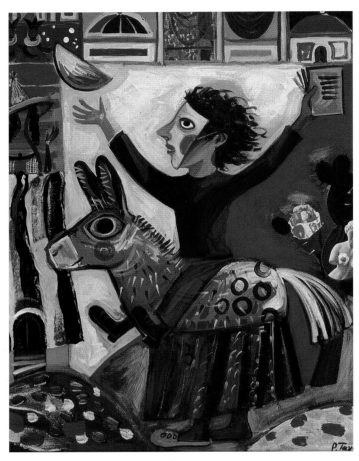

Carnival 24" x 22" Mixed media

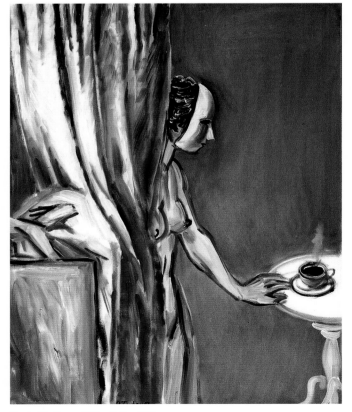

Early Coffee 30" x 24" Oil/canvas

PAVEL TAYBER

A measure of myth and a touch of satire entwine as binding fibers in the diversely styled compositions of Pavel Tayber. Using short, dynamic strokes and a palette rooted in primary colors, he ar re slant on complex and varied themes of life and identity against engrossing backgrounds of human culture.

Born in Kharkov, Ukraine, Tayber developed an early interest in art which prompted him to start painting at ten years of age. He was soon enrolled at a local art school and later studied classical painting formally at Kharkov Art Industrial College and received his M.F.A. from the Ukrainian Academy of Fine Arts. An internationally honored artist, whose works have been acquired by museums in numerous countries, Tayber moved to California in 1995. Recent sites of exhibition include the Gallery Europa of Palo Alto, California; Agora Gallery of New York City; Kunst Modern Gallery, Berlin, Germany; Central House of Artists, Moscow, Russia and the Boris Binder Gallery of Malmo, Sweden.

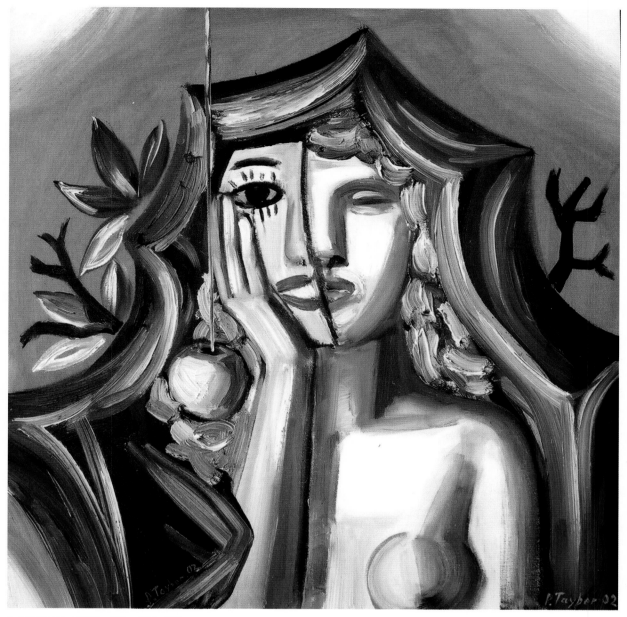

A Smile of a Mask 24" x 24" Oil/canvas

In modern life, and especially in America, most of us go through our lives repeating the same motions, but we never take time to stop and enjoy ourselves. There is motion, but there is no life... In life, everything is mixed—the beautiful and ugly. There is also the contrast between up (success) and down (failure)... When I moved from the Ukraine to Palo Alto, (my) inner clock changed and everything was mixed up. It feels like time flies much faster here. Life is more intensely filled with actions... When I come to a clean canvas, I am excited. I feel aesthetic pleasure looking [at it]. I am about to destroy this whiteness, to breathe a new life into it. I paint and feel how a fever pitch inside me grows, how ecstasy grips me while I see my ideas coming out on a canvas.

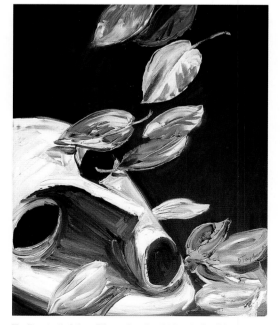

To Poets "of the Silver Age" 30" x 24" Oil/canvas

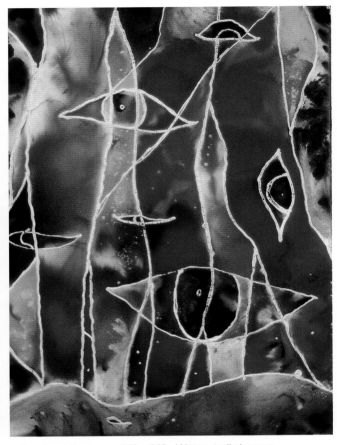

Parade of Dreams 30" x 22" Watermedia/paper

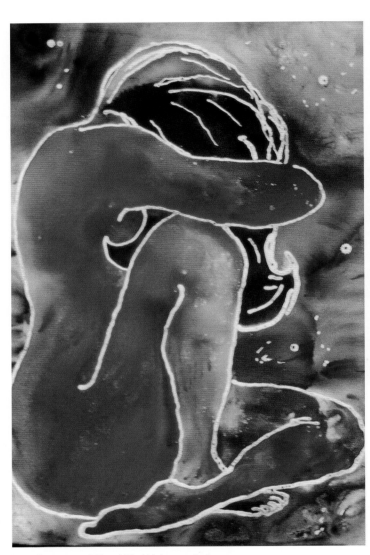

Lost Dreams 22" x 15" Watermedia/paper

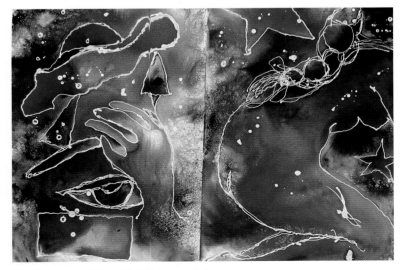

Star Catcher 22" x 30" Watermedia/paper

C.R. LANGE

A vibrantly shifting field of color blend and contrast brushed with flowingly imposed figures and symbols signal the stylistic approach of C. R. Lange. The artist's feel for finely moderated balances and compositional impact creates engaging combinations of effect.

A resident of Texas, Lange gathered art and journalism scholarship awards as well as an Associate of Arts degree with honors from Northeast Texas Community College. Beyond a B.F.A. added from the University of Texas, Lange studied extensively with independent instructors in oil, pastel, watercolor, design, acrylics, collage and printmaking. Among many sites of exhibition are the Limner and Agora galleries of New York City; the Texas Fine Arts Center at Breckenridge, the Regional Arts Center in Texarkana, Texas and numerous other sites.

My paintings portray the psychodynamics of the struggle with shadows past, ever with ambiguity influencing personal dreams. Eyes as portals to one's inner thoughts remain a personal obsession to seek ever elusive dreams... Yet my primal love of bold, brash color most readily depicts the duplicity of strong emotions experienced during one's lifespan. Hence, my love of the unexpected surprises found with Watermedia. It flows where it will, much as one's random thoughts meander, creating a vibrancy unmatched in other media.

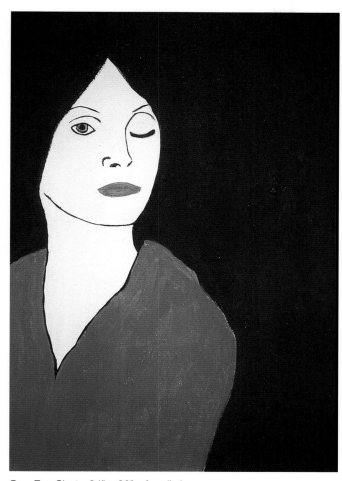

One Eye Shut 24" x 20" Acrylic/canvas

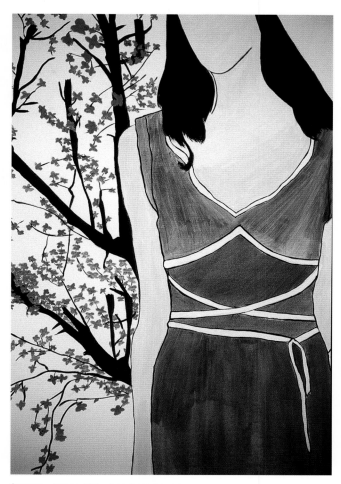

Spring 36" x 48" Acrylic/canvas

JILL BAYOR

An elegance of simplicity accentuates the statement in the psychologically cognitive paintings of Jill Bayor. Her direct and appealing images carry subtle undertones of emotion and thought with charming clarity and accessibility.

Currently a resident of Los Angeles, Bayor was born in New York and raised in the state of Georgia. She recently graduated from Harvard University, where she received her M.A. degree in Philosophy & Religion, as well as having taken numerouscourses highliting her strong ongoing interest in painting, critical theory, and modern art. She has worked for the Set Design Department at Saturday Night Live and exhibited her work at Havard's Carpenter Center Gallery in Cambridge, Massachusetts.

My paintings for the most part, revolve around aspects of identity. Stemming from a psychological, as well as philosophical background, I use the canvas and its colors to examine and portray the individual's struggle with self: to depict each person's need to overcome fragmentation and make themselves whole. To this end, the paintings are also a comment on how most people in our society get their cues for their identity, from the modern American culture that surrounds them- the idea that we are who other people tell us we are, or that we often admire the pretty aesthetics of being (i.e. "Spring") while not clearly seeing the emptiness and hollowness of that which often exists, underneath.

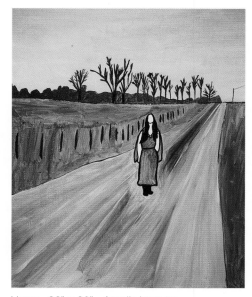

Hope 36" x 20" Acrylic/canvas

Inside Quercus 15½" x 19½" Silver Gelatin Print

Wall of Houses III 15½" x 19½" Silver Gelatin Print

Delete Tree 15½" x 19½" Silver Gelatin Print

STAN ZAWISTOWSKI

In this series of appreciations of the sturdily enduring *Quercus gambelii*, or scrub-oak, Stan Zawistowski artistically expands our regard for the essence of a hardy common species of plant and the harsh environment in which it thrives. Sensitive, poignant and humorously sidelong glimpses of territory, circumstance and encroachment underpin the aesthetic arrangements he finds in his lens.

An Environmental scientist with a B.S. from Upsala College and a M.S. in Geology from the University of Iowa, Zawistowski studied fine art photography at Colorado's Arapahoe Community College and, subsequently, art history, sculpture, watercolor and drawing in pursuit of his B.F.A. from the University of Colorado. His 'Neo-Expressionist' instincts are primed to demonstrate a "metaphorical fulcrum between art and science" in upcoming exhibitions.

OSB #3 30½" x 26¾" Mixed Media

OSB #2 30½" X 26¾" Mixed Media

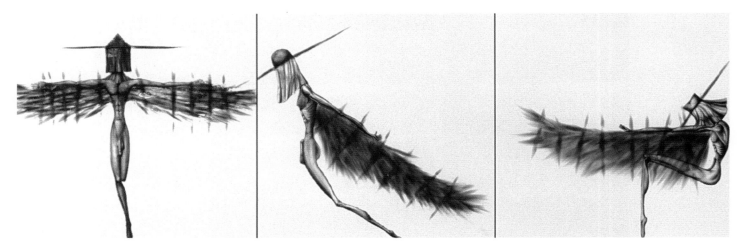

Landscape II Triptych 24" x 72" Acrylic, pastel, candle soot on canvas

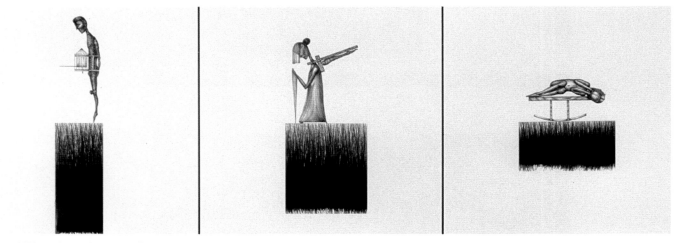

Landscape I Triptych 36" x 108" Graphite on board

XISCO PONCÉ, JR.

Reduction, in this series of triptychs by Xisco Poncé, Jr., brings our focus to an intimate language of posture and circumstance in environment and human juxtaposition. Isolated from myriad select distractions of perception in commodious and frugal circumscriptions, subtle signals are revealed in the artist's depictions; messages core to the inundated essences of his enigmatic restoration of factors.

Born in Magsingal, Ilocos Sur, Philippines, Poncé is a self-taught artist whose *cum laude* degree in Architecture is from California College of Arts and Crafts in San Francisco. A singer-songwriter as well as an artist and an architect, Ponce has exhibited his work in California at the Emeryville Art Exhibition, Berkeley Open Studios, the Chinese Culture Center of San Francisco, Mosconce Center West, and Somarts Gallery.

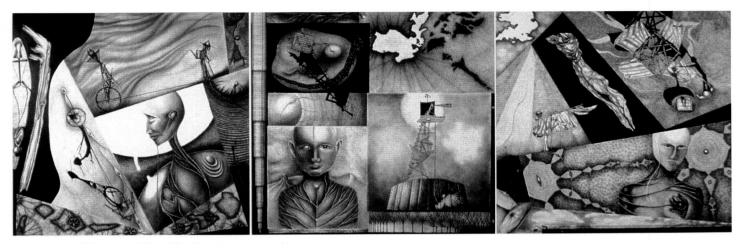

Landscape IV Triptych 30" x 90" Graphite on board

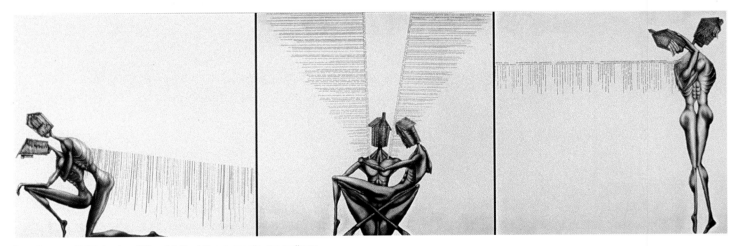

Landscape III Triptych 40" x 144" Mixed media on collage

I am a self-taught artist with an architectural training background. My work focuses directly on the human body and its connection to the outer landscape (surroundings, response), as well as the internal (body, emotions). Color itself is removed from my work due to its descriptive nature. Rather, I rely on the textures derived from the graphite, charcoal and collage that mix onto the canvas/board to define the mood. Also, my architectural training has helped me to engage the human existence in space (landscape) and reveal a story in the constructive vocabulary of plans, sections and elevations.

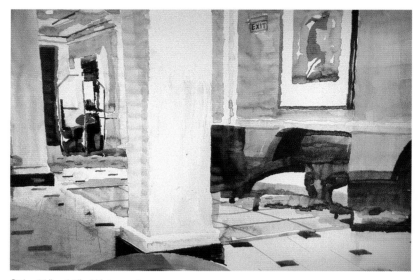

Sol 11" x 17" Water color

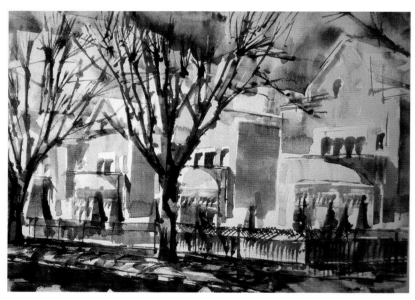

Farz 11" x 17" Water color

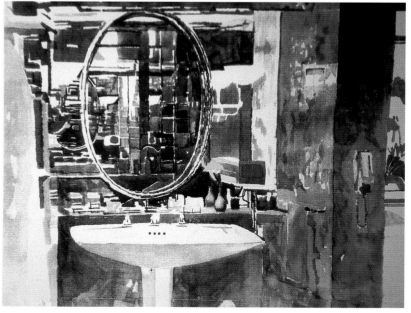

Ado 11" x 17" Water color

DAVID MCDERMOTT

The use of autumn tones combined with a clearly defined reaching toward the vertical, realize McDermott's world of color. He explores three closely drawn architecturally different subjects in which he moves from an indoor vista —an empty hotel foyer perhaps — through a shadowed skeletal, tree lined street to a tightly constrained arrangement involving reflections in a mirrored boudoir. In each work he depicts an unusual mastery of his medium, combining dark and complex colors with a purity of form and line while holding firm precise control of the many variables in his imagery and brushwork

A Canadian who recently has moved from Vancouver to San Francisco, David McDermott finds his current work to be strongly influenced by the ambience of the city and the Bay area.. Experienced in travel having visited Spain, Morocco, Mexico, England and parts of Asia, he finds his artistic expression through the diversity of the region in which he resides, his unique stimulus developing from within the architectural structures and the various national representations with which he merges.

My drawings depict various forms, environments, colors, textures and concepts. They represent my individual experimentation as it relates within the spatial organization of its 3-D context. I enjoy an architectonic approach with my work which often acts as a theme which seem to resonate between form and people. Cultural differences and economic factors such as language and custom can be discovered from the attributes of the drawing.

Winter is Coming 21½" x 12" Pastel

Sunflowers #2 15" x 21½ Pastel

HELEN ISSACKEDES

Working in pastel, Helen Issackedes displays a skill and delicacy of form and shape. Her enthusiasm for the imagery of plants or landscape is readily expressed in a vibrant fashion through her detailed study of this medium. Her pleasure in the use of color is articulated through her strong contrasts, as well as as the softness and mystery associated with her chosen metaphors.

While studying for her BFA in Arcadia University, Issackedes made the decision to explore as many media as she could, finally choosing to work in pastel as her main interest and study. She has exhibited in solo, juried and group shows in New Jersey and Vermont, while working full time as a graphic designer.

"It is the beauty of color which pushes me to create the most usual vibrant images possible. I continually seek to push the limits of color with one brushstroke or one pastel stroke. I feel my works are alive with enthusiasm and excitement."

The Red Tree 17" x 11" Pastel

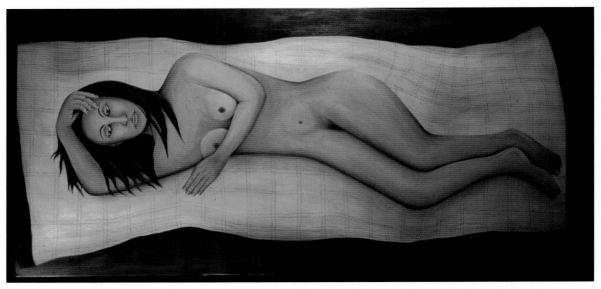

Within My Soul 30" x 60" Acrylic

KAI JARUSANKUNAKUN

The images produced by the self-taught artistry of
Kai Jarusankunakun convey direct and dramatic
views of the human dilemma. Her pensive,
introspective subjects, often portrayed in situations
of vulnerability and reflection, transmit a stirring
sense of intimacy and isolation.

Born in Thailand, Jarusankunakun was educated at
a boarding school in her native land before

coming to the United States on a student visa at the
age of seventeen. Although art was not a focus of her
attention in college, when she married and decided
to settle in the Midwestern U.S., she began her self-
guided exploration of artistic expression by painting
on walls. Intrigued by the result, she has shifted her
brush to the more portable medium of canvas.

*I paint from my soul. I try to capture the
moments or feelings in my life either from the
past or present and put them on canvas.*

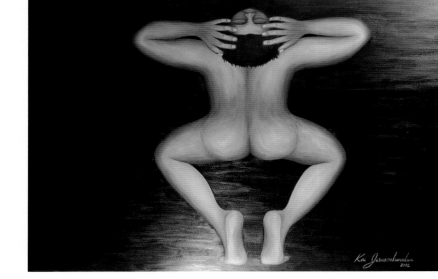

The Frustration 42" X 56" Acrylic

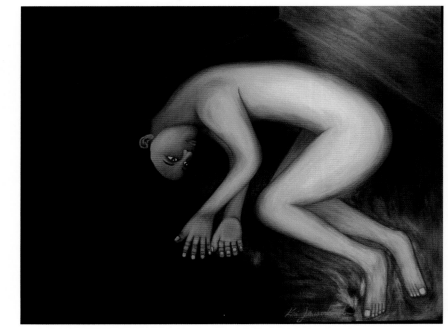

Untitled 42" x 42" Acrylic

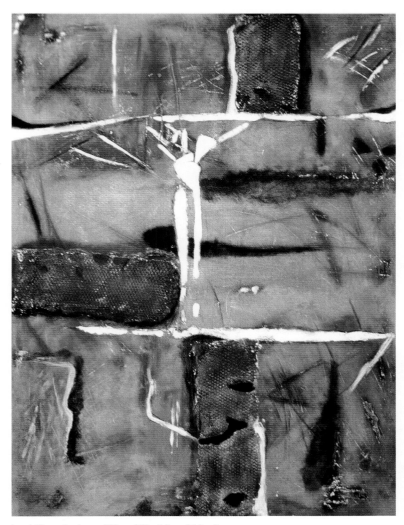

Lost Knowledge 36" x 48" Mixed Media

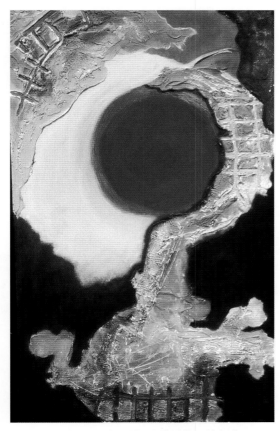

Transmogrification II 22" x 36" Mixed Media

JENNIFER LANZA-LINN

Earthy hues and a strong dynamic of form and position distinguish the textured paintings of Jennifer Lanza-Linn. Her conjured visions summon lovely sensations of precious antiquity and cryptically wanting messages that beckon a concluding imagination.

Born in Nevada and raised in Northeastern Ohio, Lanza-Linn earned her B.A. at Kent State University, where she studied under ceramic artist Kirk Mangus. Her work has been exhibited at the Butler Institute of American Art in Salem and Youngstown, Ohio and at other venues.

My work on canvas is different from my work on paper. On canvas, I prefer to explore my love of texture. I was primarily educated in ceramics and I like to translate my interest in those materials onto a two-dimensional surface in unique and innovative ways. I am heavily process-oriented and only feel like I am working when I can actively build up, tear down or manipulate the materials to make them appear mysterious and/or archaic. My work on paper is a straightforward exploration of color and shape. I work spontaneously and use colors that appeal to me at the time. The manner in which I work is nearly always abstract but, at times, I am directly influenced by something that appeals to me in nature. Ultimately, I know a piece is finished when I feel that the relationship between my mood and the materials have created at that moment, for me, an expression of personal truth.

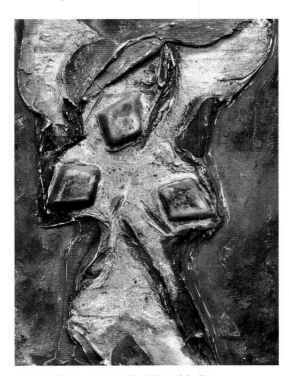

Strange Fruit 16" x 20" Mixed Media

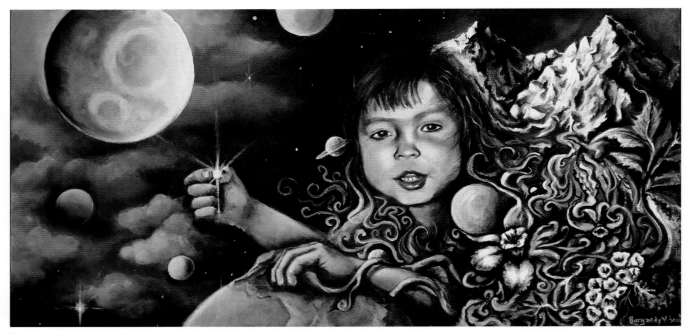

I Caught One 1½ x 3' Acrylic

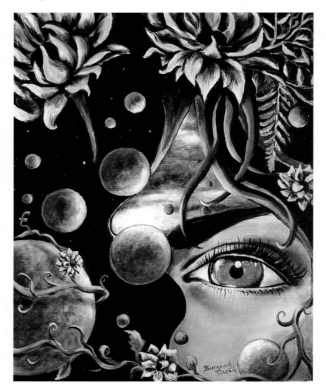

Behind the Mind's Eye 2'3" x 1'3" Acrylic

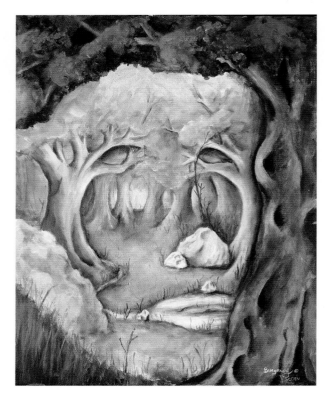

Bark Like a Man 2' x 1½ Acrylic

BURGANDY VISCOSI

Influenced by an early and serious illness, Viscosi's paintings reach into the surrealism of the human experience. She describes a face which lies dormant and pale in the depths of a hidden forest; or an eye glowing with curiosity looking at the viewer through moving leaves and a floating spread of fantastic planets; or most strikingly, a child enveloped by strange pale fauna, holding up the glowing jewel to discover for her watchers the light of hope. Viscosi presents such paintings as these which are deeply thought provoking even disturbing yet extremely beautiful, opening her world of fantasy, drama and perhaps, memory.

In 1999 Burgandy Viscosi, recovering from a serious car accident where she almost died, discovered art as a means of renewing and loving life. She "embraced the wondrous reality of having the world at her fingertips" and was so consumed she began to study art. Currently to support herslf she works as a portrait painter. Her personal works are very unusual, images of other worlds and the evolution of the human spirit.

Art is human reminder not to let happiness be at society's convenience, but to make it your own. Art within itself has a rhythm which knows no limitations. I believe that visual art in no way has to be limited to visual intake, but rather is allowed to intoxicate all your senses.

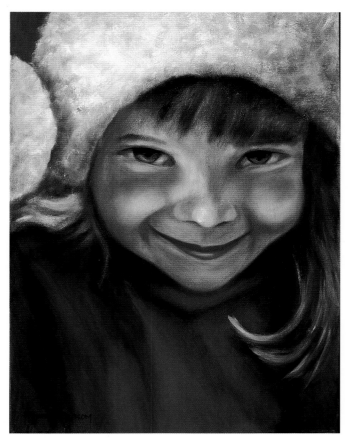

Kaysie 20" x 16" Oil 16" Oil

Big Nick 36" x 18" Oil

SHANNON GRISSOM

Be it portraiture or still life, the paintings of Shannon Grissom convey a warmth and sincerity of observation achieved through a fine sense of color evaluation and execution. Nuances of expression conduct transfers of trait and persona in bold presentations of physical features.

A native Californian, Grissom pursued an interest in music from her childhood years and it wasn't until later in life that a serious preoccupation with visual arts took hold. Her early efforts in this direction were guided by a series of group studies, workshops and the instruction of Los Gatos artist, Michael Linstrom, whose own influences include Perceptual Impressionism and Charles Hawthorne's 'Color and Light' movement. Among sites of exhibition for her work are Galeria Tonantzin, San Juan Bautista, California; Multicultural Art Faire of San Jose; the Los Gatos Museum of Fine Art and Natural History and other venues.

I simply must paint. Each morning, I rise early and eager to paint. I may not be awake but my body is propelled to the studio. I love painting early. I don't have to contend with the influences of the day. It's pure. It's so quiet. Well, pretty quiet. You see every morning I rise with a song lyric or melody that can stay in my head all day. Sometimes the relevance is applicable for the day. Other times, the message applies over a longer period. Always, the music has relevance to my work, my life; so I pay attention.

Emma Ruth 24" x 18" Oil

Bathroom 18" x 14" Acrylic on canvas panel

Recurrent Image 62 9" x 7" Acrylic on canvas panel

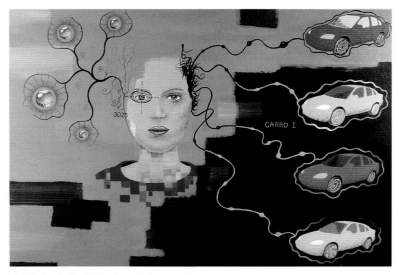

Untitled 14" x 11" Acrylic/masonite

MIGUEL ANGEL AVILA

Miguel Angel Avila captures provocatively mysterious images from interior spaces and guides them into a continually intriguing exterior existence. Mythic elements entwine with common contemporary vistas, technological snares, and timelessly effective human concerns in colorful blendings of nightmare and daydream.

Currently a resident of Houston, Texas, Avila was born in California and raised in Monterrey, Mexico. He began painting in a self-instructed style before taking part in fine art ateliers and became involved in graphic design projects as he studied International Relations and Architecture at Instituto Tecnológico y de Estudios Superiores de Monterrey. He has exhibited in Texas, New York and Mexico..

My artistic work is created out of the need to materialize images and events that take shape in my mind. The painting is never finished there, though, and I cannot completely see it beforehand... That is probably why I start looking for it right away with brushes and hands. I only have to snatch something out of my head. Then I let myself go, let the paint flow and let the piece start coming together. It is the best way that I have found for myself, to express and ease out whatever is lodged inside. At the same time the very act of painting feeds my soul.

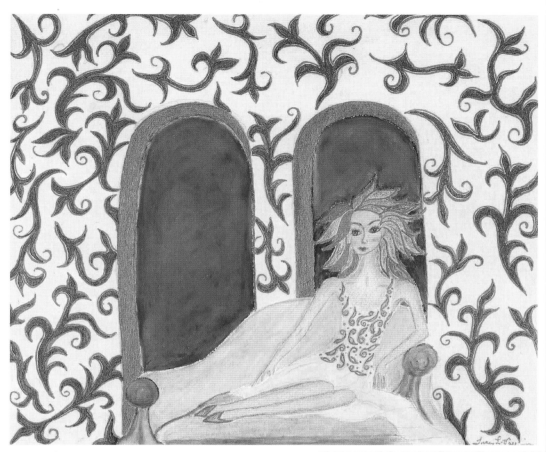

Evening Serenade I Pastels and pens

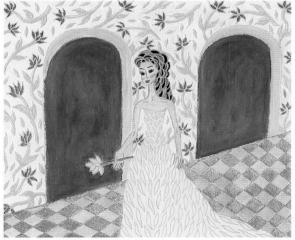

Evening Serenade III Pastels and pens

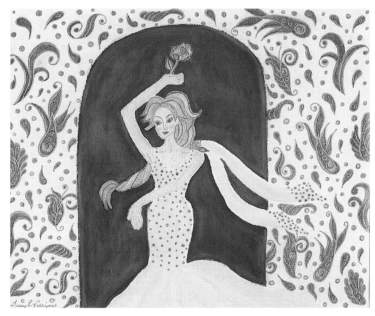

Evening Serenade II Pastels and pens

TRACY LYNN VALLEJOS

Amidst of all the turmoil and goodness experienced in
the past few years, perhaps a light might emerge from
the darkness. This perception can be viewed analolous
to Ella Wheeler Wilcox's Solitude: *Laugh and the
world laughs with you; weep and you weep alone.*

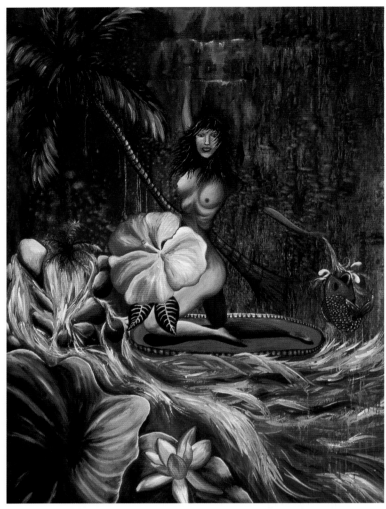

Fallacy of Flowerhood 30" x 40" Oil

MARILEE MAST

Self taught artist, born in Michigan now living in
Florida, Mast has exhibited in Galleries across that
country, some of which include;Limmer Galleries of
New york, Berkeley Arts Center, Icebox Gallery in
Minneapolis, along with a solo exhibition in Space
Gallery of New Orleans. Mast is currently being
represented by Amsterdam Whitney International Fine
Arts Gallery of Chelsea New York.

*My work is a reflection of the beauty I see all
around me. It amazes me how many wondrous
things there are in the world. There is the beauty of
joy and of sadness, of innocence and of sin,
laughter and tears….. In my paintings I use
various angles, emotions and space to convey what
my eyes have seen as beautiful*

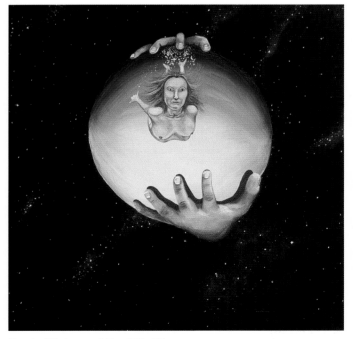

Survival Sphere 24" x 24" Oil

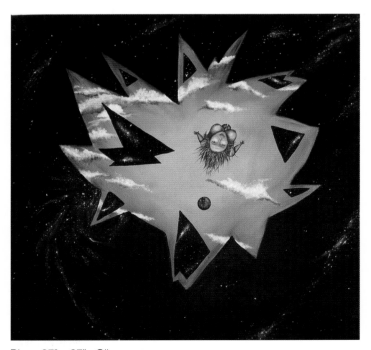

Dive 37" x 37" Oil

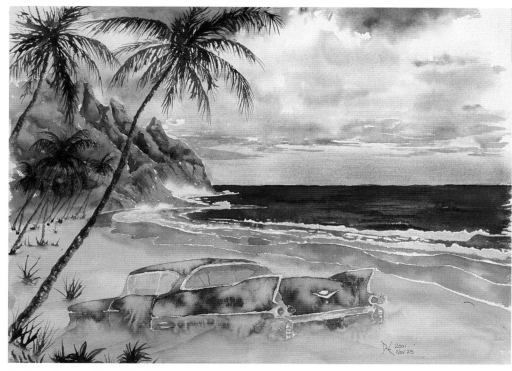

Cadillac Coast 16" x 20" Watercolor

Coconut Palm 12 x 16 Watercolor

Kukuiula Bay 12 x 16 Watercolor

DAVID ECHTERNACH

The eternally soothing lure of open coastlines sets the temper in many of the watercolor scenes painted by David Echternach. Often, we find his exquisite sense of space nudged by the amusing ironies of civilization's wreckage, poised in a balance of tribute and scorn.

A native of Southern California and primarily a self-informed artist, Echternach began to focus earnestly on painting in rural Arkansas after living in Hawaii for twelve years and carrying some of the beaches with him in his mind, if not his shoes. A musician as well as an avid surfer and windsurfer, he has thusfar exhibited his work in the Fort Smith region of Arkansas.

I am constantly experimenting with the (watercolor) medium's intrinsic desire to create on its own. Watercolors allow me to keep an unstructured perspective of my original sketches or ideas and I am often pleased with the spontaneous results...I'm intrigued by other artists who display true individualism in their artwork rather than rigid perfectionism and their distinct methods influence my development.

Lollygag 48" x 36" Acrylic

Enigma 52" x 32" Acrylic

KIRSTIN L. BRUNER

Celebrating bilateral symmetry with a rationale of harmonic colors and a crystalline logic of space, the paintings of Kristin L. Bruner create mesmerizing atmospheres of aesthetic organization. A serene decorative affinity to ancient stained glass technique, systematical tones of musical modality and even sacred architecture are echoed in the orderly precision of her designs.

Raised in Florida, Bruner's interests emphasized painting and mixed media as she attended high school in Connecticut. She minored in psychology while acquiring her B.A. in Humanistic Area Studies at John Hopkins University and she is currently pursuing a Masters degree in Public Policy at American University's College of Law. Currently a Professor of Communications, Humanistic Studies, Law and Business for Strayer University Online, Bruner interned in Art Therapy and Play at John Hopkins Children's Hospital. Among many sites of exhibition are the Gora Gallery of Montreal, Canada; Gallery West of Alexandria, Virginia; Masur Museum of Art in Monroe, Louisiana; Dishman Art Gallery of Beaumont, Texas and other locations.

My work focuses on bringing the study of language to life on canvas through abstract painting; in essence, defining words through art. I explore this relationship through the balance of color and symmetry to evoke emotion through repetition of lines and patterns.

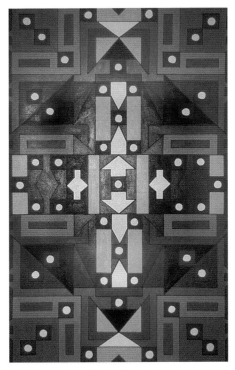

Zoe's Mishap 50" x 30" Acrylic

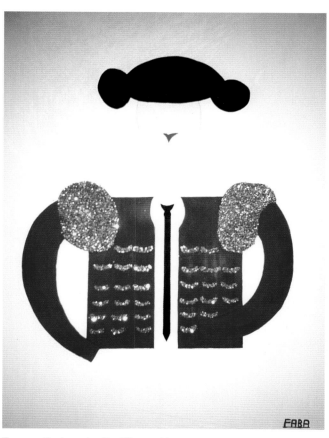

Torero - Pedro 4 x 3 Oil, sparkles on canvas

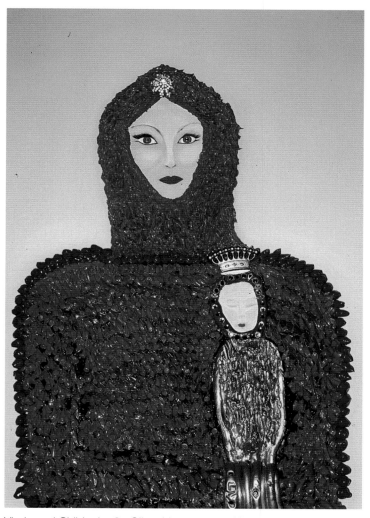

Virgin and Child 4 x 3 Oil, gold crown, sparkles on canvas

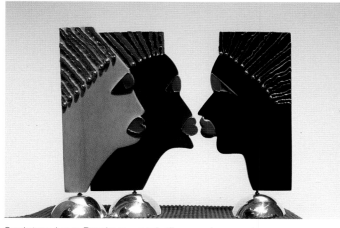

Sculpture Love Precious wood, silver and enamel

FABA

Sly and quaint, the witty juxtapositions of traditional and contemporary sensibilities presented by the images of Faba, glitter on canvas and confront in three dimensions. Their probings into the resources of conditioned reflex and expectation edge along neo-dada concepts and ingrained genuflections of sincere conventional regard.

An interest in mosaics during early life in Seville and Madrid widened to include drawing and painting prior to Faba's move to the United States at 18. Subsequent studies at the Corcoran Art School in Washington, D.C. followed and a personal devotion to the needs of children in poverty led to the foundation of the Faba Millennium Kids Foundation for sponsorship of schools in developing Third World countries, largely funded by proceeds from Faba's art.

Raised in a country known for its masters–Picasso, Dali, Goya–and drawn to art early on, the emotions evoked by an image, the juxtaposition of colors, textures, mosaics, drawing, I am drawn to painting, as a sculptural element, and to a variety of tools, like sparkles or wood, to create a new dimensional texture that draws not only the eyes to an image but also creates a desire to touch.

Acknowledging everything that has been done, the goal is to address a variety of subjects, from the lighter side of life to the darker side of one's emotions, and combine elements from the past and present in a single image. I present a vision of the world using not only ideas from the past but combinations of them with updated materials.

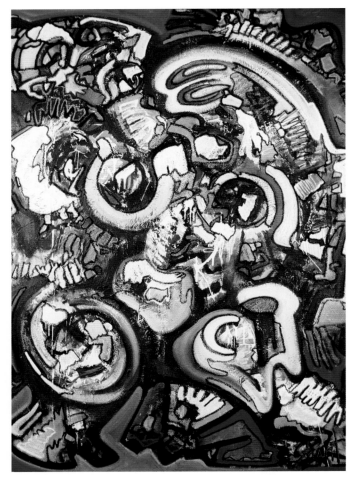

The Behemoth 48" x 60" Oil

SHANT BEUDJEKIAN

Born in Beirut and growing up in Geneva Shant
Beudjekian currently works in California. He
completed his Bachelor's degree at Otis College
and later an internship in the Rhode Island
School of Design. His particular interest in form
and space as associated with landscape has
produced work where strong contrasts between
light and dark connect various abstract images
which come to life as individual moving shapes,
then combine to create a single massive abstract
or semi-abstract form. "The Behemoth" for
example, initially seems to consist of a flurry of
activity by small separate creatures linked to
diverse life symbols. When studied they
combine, absorbing the viewer, to become a
massive image with glowing eyes: the behemoth!

OVIDIU LEBEJOARA

LeBejoara is fascinated by surrealism and its
relationship to dreaming. However in spite of a
deep early interest and study of the Surrealistic
masters he is not a follower of traditional
surrealistic ideas. In the sense that they deal with
mythical or dreamlike figures his works have a
surreal quality but he does not invoke those
elements which he believes are fundamental to
traditional surrealism.. Instead, his paintings
represent a reorientation of figurative and
personal symbols based on mythology and
explored through an array of illusory questions
only he can answer. His colors relate to the mood
of this form of personal imagery and so complete
his interpretations.

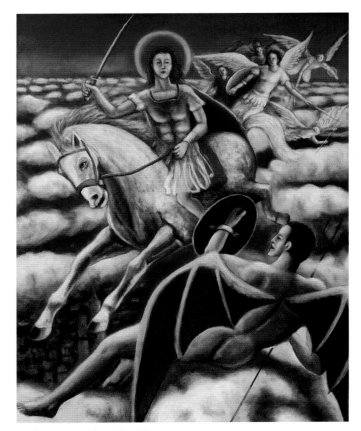

St. George 48" x 40" Oil

The Blue Madonna 24"x 30" Oil

ALFRED GOLDMAN

A combination of interests which include abstract expressionism, cubism and portrait painting come together in recent works by Alfred Goldman. Having explored cubist imaging in a lighthearted and whimsical way and created fiercely figurative distortions which he relates to a carnival, he has developed his interest in realism. An example of this recent direction unconsciously brings together much of his previous imagery. It shows a portrait of a woman holding a rose to her breast. The arching curve of her head and of her shoulders bears relation to many of his cubist figures while at the same time her expression, a delicate mixture of sadness and surprise, redefines his role as painter of realistic portraits.

Goldman studied at the California School of Fine Arts and at the San Francisco Art Institute. He has exhibited at the San Francisco Museum of Modern Art, The Montgomery Gallery, San Francisco and the San Francisco Civic Art Festival. He is also a former member of the Society of Western Artists and his primary interests relate to Abstract Expressionism, Cubism, Cartooning and Portraiture.

BECKY R. BARKER

The exceptional portraiture of Becky R. Barker brims with character and warmth. Her communicable compassion for her subjects captures an inner essence of personal charm.

Educated at the Kachina School of Art in Phoenix, Arizona and the Famous Artists School of Westport, Connecticut, Barker tended to some additional study at the Krannert Art Center in Champaign, Illinois. Her portraits are available by commission only and have won numerous awards, including the Illinois Heartland Artists Best of Show.

PeeWee 14" X 18" Oil

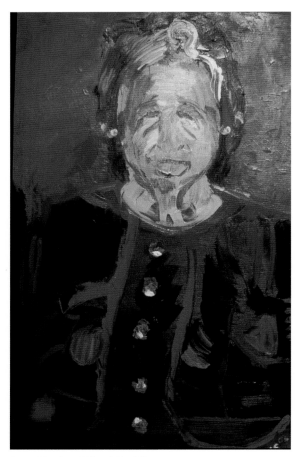

Sweet Lady 15" x 24" Oil

ANDREA STIGDON

Stigdon's art is primarily about communication. Her special interest is the human form and through this she expresses her need to connect. Her work shows an affinity with the German Expressionists relating through her use of heavy impasto and bright color to many artists of that period. Born in Austin Texas, she received her degree in studio art at Southwestern University, Georgetown, and has exhibited in a wide selection of juried exhibitions throughout the U.S.

I respond most strongly to the human form. After all what is more fascinating than the human face, that summation of all generations prior who lived through the ravages of civil wars and famines, empires and dark ages, religions and famines? To me a face or a figure conveys my own thoughts and feelings more than landscape ever could.

EMIL LAZAREVICH

After spending many years as a sculptor Emil Lazarevich changed to painting. Reminiscent of Klee or Stuart Davis, but using simple more ordinary color

his strange alien shapes interact with ganglion-like splashes of paint: full of life they march silently across the clouded spaces of his background field.

Lazarevich was born in San Francisco in 1910. He states: *My slides speak more clearly than my words can*

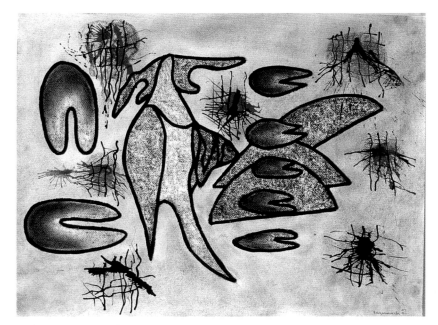

Untitled 20" x 26" Pastel

YOLANDA MONCAYO

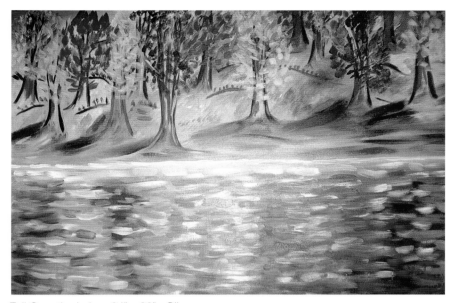

Fall Over the Lake 24" x 36" Oils

The art of Yolanda Moncaya suggests a connection to post impressionism. She implies an influence with pointillism but her work has developed a more distant or dreamlike texture. Floating from her canvas her delicate landscapes seemingly attempt to cultivate new statements in mystical abbreviation

Moncayo studied painting in Ecuador, beginning when she wa five years old. In the last thirty years, however, she has lived in Athens, Ohio, where she studied art at Ohio University. She works in oils and also creates prints and ceramics finding the stimulus for images mainly from in the local countryside.

Color is for me the most important element in artistic creation, in painting as well as prints and ceramics.

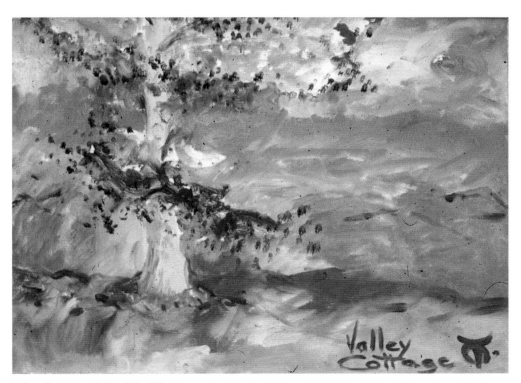

Valley Cottage 24" x 28" Oil

MARGARET ANNE THOMSEN-GRASSO

An innate affection for the natural environment is evident in the paintings of Margaret Anne Thomsen-Grasso. A poetic sense of form is complemented by an appreciation for spatial dynamics in her painterly approach.

A resident of the New York area, Thomsen-Grasso acquired her B.F.A. in Communication Arts and Design from Virginia Commonwealth University and her M.F.A. in Painting in Art History from the Parsons School of Design. Among numerous sites of exhibition are Amsterdam-Whitney International Fine Arts of New York City; Rockland Center for the Arts in West Nyack, N.Y.; Anderson Gallery of Richmond, Virginia; Thomsen & Hoyt Gallery of Tappan, N.Y. and many others.

A. SHARAFY

Relating his art to the concept of insubstansiality in the everyday world, Sharafy creates images that are not easily caught in concrete form - smoke, clouds, and such. Much moved by 911 he began to explore new media and serendipitously discovered steel wool with which he found he could produce works relating to his Taoist and Indian beliefs in reality, soft-edged colored amorphous arrangements which materialize from a background of dark, empty space. Sharafy who is Assistant Professor of Art in Washburn University, Topeka, Kansas teaches 3D animation and multimedia. He has exhibited widely in U.S. and abroad.

Dealing with things that cannot be captured in concrete form, I am also trying to connect with the flow of energy in life, the flux of reality.

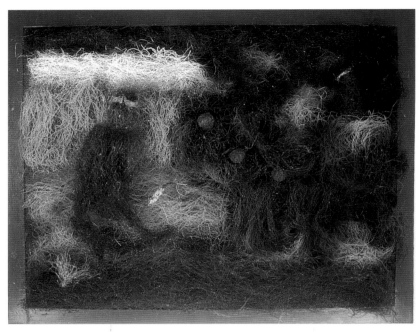

Memories of Indian Miniature 20" x 16" Steel wool and enamel paint

ANTUCO CHICAIZA

Chicaiza's composition is an expressive grouping of semi abstract forms and figures, the action of a band of musicians bound together as one in an ecstasy of creation. Their beat hangs on the balance of their strong interactive shapes, bright earth colors and frenzied textures which open a window to understanding the performers' exciting rhythm. Luminously created in pastel, in the foreground is a massive curled lead guitar hand, a foundation for the structure and action of the group, so that a vivid visual interaction becomes a living moving description of their total rhythm. Color bound with shape bring to aural life the memory of an overwhelming musical beat.

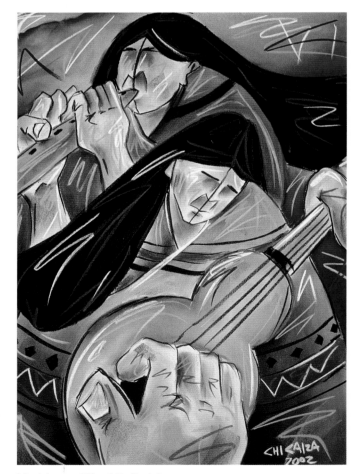

Musicians 18" x 24" Pastel

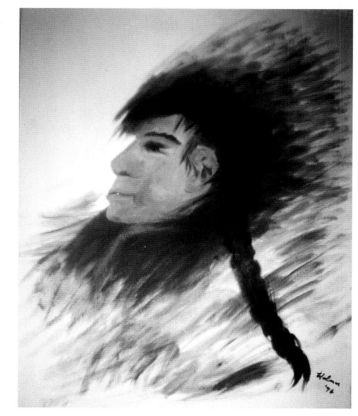

Indian Chief 24" x 30" Oil on canvas

HELMER

In subdued color and active texture, Helmer's imagery is of a northern Native American chief. The portrait in traditional headdress shows the chief's power and authority and his expression of time-honored remoteness. A ritual rope of hair is balanced against the rush of his cloak emphasizing the full weight of his command, like the rushing movement of a winter storm closing against the stillness and chill of a lowering sky.

BARBARA WESKOT

Like a cave prepped and illuminated as a studio, shadow shapes lock in jigsaw interlocking tones so that distance has description only by the edging of the forms and perspective of the essential images....

Such is the simplicity captured by Barbara Weskot using as her view the artist in an abstract studio trapped within a maze of shapes and shadows exposed by light. She expresses this in color - reds, purples, blues, black, pink and white to bring to life the chiaroscuro where the complex imagery of interlocking shapes retain familiarity by their positioning and precision of their constant line. To resolve the image of the studio the figure of an artist sketching on a yellow board forms closure to the composition.

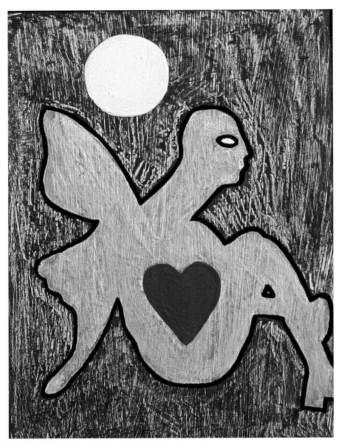

Transformation 16" x 20" Mixed media

RICHARD FORAND

"Ria's angel has come!" is a line by Richard Forand in a poem honoring his seriously ill wife. The poem forms a description for a series of his visual statements and he explains his work as a reflection of his journey with her. In one example he shows a simple abstract figure in golden yellow floating in a field of blue, his image perhaps of a female angel of spiritual and earthly love. The image, shown beneath a pale full moon, is part of what he calls spiritual conceptualism which, in his words: *allows the expression of those archetypical and mythical concepts…necessary for growth and wholeness.* Forand studied at Massachusetts College of Art in Boston where he received his MFA, and Pratt Institute, New York.

Burnt Horizon 4' X 8' Oil

DANNY AUGUSTINE

The contemporary Neo-Expressionistic style of Danny Augustine employs thick mixtures of pigments and chemicals applied and removed repeatedly to achieve a layered effect. Intuitive transfers of color rapidly build subject allusions and sympathetic ardors of form and varying texture.

A Pennsylvania resident, Augustine looks to nature for emotive direction in his paintings. He earned his B.A. in Visual Arts at Alderson-Broaddus College in Philippi, West Virginia. When not painting or exhibiting his own work, Augustine assists in the direction of the Third Street Gallery in Carnegie, Pennsylvania.

Sausage Eater Series #4 48" x 36" Rust-o-leum/board

The Sunflower 48" x 48" Rust-o-leum/board

The Daisies 48" x 48" Rust-o-leum/board

RYAN E. CRONIN

Cutting to the chase, Ryan E. Cronin produces bright, colorful and straightforward images aimed at direct and immediate impact. Mastering the deceptively difficult art of effective simplicity, his vibrant and vital messages deliver the essential core delight of communicative visual experience.

Based currently in upstate New York, Cronin's sites of study, prior to earning a B.F.A. from the State University of New York, include the Maine Photographic Workshop, the Rhode Island School of Photography and the School of Visual Arts in New York City. When his guerilla art isn't reaching viewers from unexpected locations, he has exhibited upstate at the Barrett Art Center in Poughkeepsie; Open Studio in New Paltz; the Ulster Performing Arts Center in Kingston; Northern Westchester Center for the Arts in Mt. Kisco and the Hammond Museum in North Salem as well as sites such as the Ellen Elizabeth Gallery in Harwich Port, Massachusetts and the New York Film Festival in New York City.

Painting with a sense of humor and a value for entertainment, the sometimes raw appearance of my work comes as the result of quick and instinctual markings with my paintbrush. I encourage the element of chance in the process and feel that I produce my best work when the painting takes on a life of its own.

Abrahams, Alayue 130
(301) 933-5233 abrahaa@wyeth.com

Ameen, Tracy 86
Man Unleashed - $4,000
Something Like a Break Down – $3,000
Untitled – $1,100
The Way I See It – $4,500

Augustine, Danny 190
Burnt Horizon – $2,000
Mother – $2,000
Prophesy – $1,500
Riverside – $1,000

Avila, Miguel Angel 178
(713) 278-8259 miguel@maavilam.com
www.maavilam.com
Bathroom – $200
Recurrent Image 62 – $125
Untitled – $180

Babb, Elizabeth A. 154
(845) 679-4959 info@bookart.com
(330) 337-6537 eababb@neo.rr.com
eababb.com
Cosmos I – $725
Cosmos II – $725
Time and Dogg I – $725

Balenko, Tamara 98
(845) 679-4959 info@bookart.com
(818) 343-1301 vladimir231@msn.com
Flower – $1,500
Olden Times #1 – $800
Olden Times #2 – $1,000
Snailman – $1,500
Soul's Flight in the Temple – $2,000

Barker, Becky R. 185
(845) 679-4959 info@bookart.com
(815) 635-3772
Prairie Art Gallery (217) 394-2243
Pee Wee – $204

Bayor, Jill 167
(845) 679-4959 info@bookart.com
(818) 345-1603
One Eye Shut – $1,200
Spring – $3,800
Hope – $1,400

Bender, May 122
(845) 679-4959 info@bookart.com
(732) 545-9853
Terrain III – $7,400
Seated Woman Abstract – $5,500

Beudjekian, Shant 184
(845) 679-4959 info@bookart.com
(212) 988-8763 shant1971@yahoo.com
The Behemoth – $1,200

Beykaei, Shahla Rose 155
(949) 412-1659
The Historical Connection – $5,000
Mehregan – $5,000
Climax of Thoughts – $5,000

Bonassi, Jodi 141
(845) 679-4959 info@bookart.com
(818) 882-2079
Latte Laughs –$3,500
Meeting Place – $3,500
The Frustration – $4,200
Holding on to the Ground – $3,600
Untitled – $4,200

Bowen, Susan 34
(918) 965-4217 mail@susanbowenphoto.com
www.susanbowenphoto.com
Graffiti – $400
Chelsea w/Bush – $400
8th Avenue Street Fair – $400
Reflections To Go – $400
42nd Street – $400
Times Square – $400

Bown, Ryan 40
(801) 830-4274 ryan@bownstudios.com
Bown Studios International, Ryan Bown (self)
Mitosis I – $7,000
Mitosis II – $10,000
Mitosis III – $15,000

Brodsky, Alex 126
(845) 679-4959 info@bookart.com
(570) 426-1146
Muse – $2,200
No Trespassing – $1,300
Anxiety Cloud – $3,000

Bruner, Kristin L. 182
(202) 319-9069 awne@aol.com
Zoe's Mishap – $1,200

Carafelli, Robert J. 88
(845) 679-4959 info@bookart.com
(330) 264-2803
The Gallery In The Vault (330) 262-3599
View From The Bridge – $2,600
Italian Hospitality – $2,710
The Story Teller – $3,00
Charm, Holmes Country, Ohio – $2,450
Heading For Shelter – $950

Chicaiza, Antuco 188
Musicians – $500

Christy, Bonnie 124
(845) 679-4959 info@bookart.com
(415) 385-9058
Morning Light – $2,000
Buddha – $2,000
California Dream – $2,500
Early Spring – $2,000
Wisteria in Spring – $3,000

Clements, Kirby 137
(845) 679-4959 info@bookart.com
(503) 244-2248 kpc@laughingshadow.com
Right Angle Series #1 – $1,100
Untitled 5 – $1,100
Pod – $1,100

Coffey, Michelle 129
(310) 452-4000 michellecoffey@aol.com
Sylvia White Gallery
Nature Reclaimed #4 – $1,100
Bois De Bambou – $800

Cronin, Ryan E. 191
(845) 255-2713
The Sunflower – $2,000
Sausage Eater Series – $1,800
The Daisies – $2,000

Czeckay, Frank Marcus 157
(845) 679-4959 info@bookart.com

Deleuze, Margarita 105
(845) 679-4959 info@bookart.com
(954) 389-3918 margarita@deleuze.com
Margarita Deleuze Fine Arts
Love Never Fails – por
Le Grand Mango – por
Fruit Stand – por

Deng-Thompson, Christine 140
(845) 679-4959 info@bookart.com
(386) 362-2565 dusty@atlantic.net
All Natural Ingredients – $1,500
The Watcher – $1,200
Star Light – $1,000

DePodesta, Karen Deicas 136
(415) 613-1319 www.deicas.com
Deicas Art
Formal Attire Suggested IV – $2,800
Formal Attire Suggested I – $2,900
Formal Attire Suggested III – $3,400

Diatlikova, Irina V. 131
(845) 679-4959 info@bookart.com
(610) 775-9138
The Space Dragonfly – $463
The Space Orchid – $463

Dobbelaar, Ien 42
(845) 679-4959 info@bookart.com
+ 31 79 3310550 (Netherlands)
iendobbelaar@hotmail.com

Doria, Victoria Andrea 144
(831) 566-8080 v@vadoria.com
www.victoriaandreadoria.com
Home Comfort – $1,750
Embrace of Love – $1,850
Discovery – $1,850

Drayer, Ruth Abrams 114
(505) 527-8688
www.zianet.com/ruthdrayer/paintings
Abode of the Immortals – $1,800
Burnt Topaz Morning – $2,500
Place of Golden Peace – $2,000

Duffek, Jeannine 115
(845) 679-4959 info@bookart.com
(715) 627-4519 (WI) (863) 325-8032 (FL)
duffekdd@dwave.net
Affairs of the Heart – $995
Blue Wedge – $995
External Expectations – $995

Echternach, David 181
(845) 679-4959 info@bookart.com
(479)638-8036
Coconut Palm – $400
Kukuiula Bay – $400
Cadillac Coast – $2,800

Edwards, Kimyarda 158
(706) 837-923
Heaven – $250
Beautiful – $300
Life – $475

Faba 183
(332) 48585875 (France)
mfaba13@aol.com

Fairchild, Jason 44
(845) 679-4959 info@bookart.com
(312) 455-1255
Fire Eye – $6,500
Omniscient – $5,000
One Aspect of Self I – $5,500
Three Sister Rings – $5,000

Fedorov, Lena 84
(845) 679-4959 info@bookart.com
(323) 667-2083 eefedorov@earthlink.net
www.fedorovgallery.com
Harlequin – $4,000
Cachely – $4,000
Circus – $3,800
Two Clowns – $5,000
Harlequib and a Girl – $5,000

Forand, Richard 190
(845) 679-4959 info@bookart.com
(401) 726-6989
AS220 Gallery
Transformation – $1,500

Frankel, Rosalie A. 92
(845) 679-4959 info@bookart.com
(212) 866-4130 rfrankel@buckleyschoolnyc.org
Strong Star – $375
I Was 4 But Turned 400 Maybe – $375
One Step, Another Step, I Come Up – $350
Cute Little Teddy Bear Face – $2,500

Garfinkel, Joan L. 148
(845) 679-4959 info@bookart.com
(401) 783-9062
Stream-Plam Canyon, CA –
Warrior – nfs
Golfing – nfs
Peace-Palm Canyon, CA – nfs
Gazebo in the Garden, CA – nfs

Garro, Mark 26
(845) 439-3329 mgarro@hvc.rr.com
markgarro.com
Purgatory – $2,800
Buttercrucifly – $2,800

Goldman, Alfred 185
(845) 679-4959 info@bookart.com
(510) 763-2293
Nasse Gallery
The Blue Madonna – $20,000

Gostanza, 147
(845) 679-4959 info@bookart.com
(303) 369-4023 gostanza@yahoo.com
www.gostanza.com
Metamorphsis of the Soul – $5,000
Infinite Transcendance – 4,500
Bull's Playground – $3,200

Grimm, Calvin 6
(845) 679-4959 info@bookart.com
(845) 679-7183 www.calvingrimm.com
Horses, Chauvet Cave - in private collection
Drowning Ass – $2,800
Shaped Cave Panel – $9,000
Bison, Chauvet Cave – $2,500
Buster, 30,000 B.C. II – in private collection
Engraved Feline, Chauvet – in private collection
Bison, 30,000 B.C., Chauvet – $4,500

Grissom, Shannon 177
(845) 679-4959 info@bookart.com
(831) 638-4928 shannon@shannongrissom.com
Kaysie – nfs
Big Nick – nfs
Emma Ruth – nfs

Groffman, Martin 120
(845) 679-4959 info@bookart.com
(305) 743-2516
Alien Landscape – $150
Ion Storm On Alien Sea – $150
Psychdelicious – $200
Euclidean Geometric #6 – $150
Euclidean Geometric #1 – $150

Helmer 189
(845) 679-4959 info@bookart.com
Indian Chief – n/a

Hickox, R. W. 159
(845) 679-4959 info@bookart.com
(856) 691-6303 rwhickox@artist01.com
Cradled in the Flag – $1,200
Inprisoned Soul – $610
Indian Prayer – $950

Houshmand, Roshan 153
(845) 676-3895 roshanhoushmand@hotmail.com
www.roshanhoushmand.com

Inwood, Bart A. 24
(845) 679-4959 info@bookart.com
(513) 533-3572

Issackedes, Helen 173
(845) 679-4959 info@bookart.com
(201) 384-8998 h_issackedes@hotmail.com
hipaintingsplus.com
Sunflowers #2 – $550
The Red Tree – $450

J.T. 106
(845) 679-4959 info@bookart.com
Judy Tanibajeva(917) 592-7825
info@artjt.com www.artjt.com
JT # 1 – $2,000
JT # 2 – $2,000
JT # 3 – $2,000

Jarusankunakun, Kai 174
(847) 926-0968 paintwkai.com
The Frustration – por
Untitled – por

Jenik 133
(845) 679-4959 info@bookart.com
(818) 779-0311 jeniksart@msn.com
www.jeniksart.com
ABS No. 23 – por
ABS No. 24 – por
ABS No. 9 – por

Jordan, Herb 116
(856) 309-5567

Kaelin, D.C. 94
(845) 679-4959 info@bookart.com
www.dckaelin.com
Bandages – $800

Kaufmann, Robert F. 152
(215) 781-8600 www.arxpub.com
Arx Publishing
Dragon Limit III – $550

Kaye, Anna 138
(845) 679-4959 info@bookart.com
(314) 367-2914 annalouisekaye@hotmail.com
Embrace Your Irritations – $1,500
Reverie – $2,000
Impermeable – $2,000

Kilian-Tan, Ilse 108
(845) 679-4959 info@bookart.com
(509) 244-6350
The Green Planet – $4,000
Greening of the Earth – n/a
Palouse Harvest – $5,000

Klappert, Yolanda 66
(845) 679-4959 info@bookart.com
(310) 455-2470 yolandakl@aya.yale.edu
Ansel's Trees – $2,000
Les Agrements – $1,600
Grand Canyon in Perpetual Motion – $1,400
Southwest Cloudscape – $2,000

Koivumaa, Julia 163
(845) 679-4959 info@bookart.com
jkoivumaa@hotmail.com
Awakening – $1,500
The Light – $5,000

Konstantinov, Konstantin Petrov 146
(845) 679-4959 info@bookart.com
(909) 682-2157
Fishing Boat – $1,500
Revolution – $1,500
Turtle's Shore – $1,200

Kossiba, Marek 52
(845) 679-4959 info@bookart.com
(608) 361-0321
Brenda – $4,000
Green Waves Mirage – $6,000
Red Passion Windmill – $7,000
Waves Exaltation – $6,000
Windmills Morning Dance – $7,000

Krauss, Anthony 76
(845) 679-4959 info@bookart.com
(845) 679-6360 anthonykrauss@aol.com
www.fletchergallery.com
Three II – por
Arrow I – por
Intersecting II – por.
Sails III – por
Angled Illusions – por
Tinted Reflections III – por
Storm Over Krabill – por
Twelve I – por

Laliberte, Robert 14
(845) 679-4959 info@bookart.com
(719) 339-7170
(posters & giclees available for sale prices on request)

Lange, C.R. 166
(903) 645-7014
Lost Dreams – $300
Parade of Dreams – $600
Star Catcher – $600

Lanza-Linn, Jennifer 175
(845) 679-4959 info@bookart.com
(330) 337-1423 jlanzalinn@aol.com
Strange Fruit – $500
Transmogrification #2 – $900

Latych, Raissa 18
(818) 343-6643 joeelena@pacbell.net
www.raissasart.com
The Blue Bird of Happiness – $3,000
The Crack – $3,500
My Home-My Castle – $5,000
The Straw Hat – $5,000

Lazarevich, Emil 186
(845) 679-4959 info@bookart.com
(805) 964-9486
Untitled – $2,500

Lebejoara, Ovidiu 184
(310) 434-9659
St. George – $9,900

Lemus, Enrique 156
(845) 679-4959 info@bookart.com
(619) 460-3450 elemus@nethere.com
www.enriquelemus.com
The Beach – por
The Dream of Cain – por
Elise's Garden – por

Lombardi, Stephen J. 54
(508) 476-8986 kimlombardi@charter.net
All the Worlds a Stage – $4,000
The Arrival of the Colored Man – $3,000
Garden of Eden – $3,500
Putting Together the Pieces of a Child – $3,000

Mast, Marilee 180
(845) 679-4959 info@bookart.com
(727) 858-9420 bluedeanie@msn.com
www.marileemast.com
Dive – $7,000
Fallacy of Flowerhood – $7,000
Survival Sphere – $5,000

McDermott, David 172
(415) 614-2475 info@simply-ora.com
Ado – $157
Farz – $137
Sol – $144

McGoff, Mike 139
(845) 679-4959 info@bookart.com
(570) 848-5158
www.creationsstudiogallery.com
Creations Studio Gallery

Mitchev, Peter 48
(845) 679-4959 info@bookart.com
(813) 453 2464 mitchevart@lycos.com
Reverie with a Fairy Horse – por
Tails fo Children and Adults – por
Tails of Children and Adults I – por
Red Haired Mermaid with a Horse – por
Magin of Love III – por

Mizonova, Olga 127
Awaiting – $1,800
Sleep – $1,000
Waltz – $1,000

Moncayo, Yolanda 187
(845) 679-4959 info@bookart.com
(740) 594-5469
Butterfly Over Daffodil - $600
Dancing Trees - $800
Fall Over the Lake – $600

Moore, Hal P. 134
(843) 527-6159
Cadillac Series X – $3,000
Grosdorf Series I – $750

Motyl-Palffy, Viola 117
(352) 489-9902
001-41-41-711-4439 (Europe)
View of 2003 III – $5,000

Nelson, Basha Ruth 36
(845) 679-2941 exrc.aol.com
Crush – por
Jazz – por
Cascade Firenze – por
Bot – por
Drum Beat – por
Dazzle – por

Newton, Gloria C. 161
(845) 679-4959 info@bookart.com
Recovery – $2,600
Round and Round – $2,400
Vice Versa – nfs

Nielson, Derek K. 72
(801) 870-9993 derek@daementia.com
www.daementia.com
Daementia Studios
Draylorius' Technique – $2,500
The Draytor Confrontation – $1,800
A Moment of Inspiration – $1,800
Noramius – $5,000

Oilar, John R. 95
(845) 679-4959 info@bookart.com
(765) 362-3436
Drawing – $250
Krakow Sukiennice, Poland – por
Venice II – por
Villi Estate, Como, Italy – por

Overby, David 100
(845) 679-4959 info@bookart.com
(480) 551-8462 doverby@earthlink.net
www.doverbyfinearts.com
Floating World – $4,000
Meditation – $3,000
Search for Tranquility – $4,800
Sisters – $3,800

Parkyurin, Markcy 102
(845) 679-4959 info@bookart.com
(856) 783-8784
unification-love@sbcglobal.net
Included Music Sheet No. 1 – $10,000
Included Music Sheet No. 2 – $10,000

Poncé Jr, Xisco 170
www.xisco.com
Landscape I – $900
Landscape II – $500
Landscape III – $3,000
Landscape IV – nfs

Rath, Perry 107
(845) 679-4959 info@bookart.com
www.perryrath.com
RIshi – $1,400
Uncovering Urban Creeks – $1,900
Thiruvannamalai – $1,400

Ruddy, Sally 110
(845) 679-4959 info@bookart.com
(209) 874-9523 sallylamar@aol.com
Dove – (print) $200
Eternity – (print) $200
Honoring Those Who Serve – (print) $200
Morning – (print) $200
Together – (print) $200

Santos Soloman, Julia 28
(845) 679-4959 info@bookart.com
(845) 679-1133 yvesansol@aol.com
Sunburnt – $1,000
Torso – $900
Thinking of Michigan – $900
Caribbean Thoughts – $1,500
Gabina – $2,000
Four Year Old Dominican Girl – $1,800

Schmid, Eliza Maria 118
(845) 679-4959 info@bookart.com
Masks and Shadows – $500·

Schmidt, Patrick 142
(845) 679-4959 info@bookart.com
(724) 229-9195 pschmidt@washjeff.edu
Untitled (02-02) – por
Untitled (01-09) – por
Untitled (01-04) – por.

Schranck, Christopher J. 160
(845) 679-4959 info@bookart.com
(303) 995-2039
Fairy Tale #18 – $600
Fairy Tale Evening – $1,200
Fairy Tale Kingdom – $5,000

Schroeder, Chris 150
(512) 636-7558
Untitled – $2,000
Untitled – $1,500
Untitled – $2,000
Preumatic Man – $2,000

Sharafy, A. 188
(845) 679-4959 info@bookart.com
Memories of Indian Miniature – $3,001

Sherrod, Philip Lawrence 20
(845) 679-4959 info@bookart.com
(212) 989-3174
bigdaddyhotssherrod@spaceboy.com
Allen Stone Gallery
100% Brushless – $9,000
Time Square – n/a
Delancey St. – $10,000
Open (24 Hrs) – $13,000
Kelly's Freckles – n/a
Kitty Kat – n/a
La Dolce Rossa – n/a

Singerman, Irene 113
(845) 679-4959 info@bookart.com

Sipho, Ella 70
(816) 767-0641 patricia1@kc.rr.com
The Black Pot - $2,500
Gases - $1,000

Smith, Mary I.D. 128
(845) 679-4959 info@bookart.com
Sisley – $1,250
Guillaumin – $1,250
Pissarro – $1,250

Sommer, Susan 162
(845) 687-4221
Bicycle Ride – $4,000
Caribbean Breeze – $6,500
Train Ride to Amsterdam – $6,500

Stamatiou, Olga 56
(845) 679-4959 info@bookart.com
(843) 838-1122
Rocco Zappia
Breakfast at Tiffany's – $5,000
The Governor – $4,000
Wakup Caw – $5,000

Starnes, Lynn B. 96
(845) 679-4959 info@bookart.com
Eye of the Beholder – $60
Nature's Ballet – $180
Oh Say Can You See – $60
Stealthy Mountain Lion – $60

Stigdon, Andrea 186
(845) 679-4959 info@bookart.com
Sweet Lady – $750

Tarasiewicz, Tamara 46
Oak Trees – $24,000
Live the Dream – $26,000
Trees in Landscape – $25,000
Drawn From Life – $20,000

Tayber, Pavel 164
(650) 566-1758 paveltaybor@aol.com
Carnival – $3,000
Early Coffee – $4,000
A Smile of a Mask – $3,000
To Poets of the Silver Age – $3,000
White Hyacinth – $4,000

Terry, Laura J. 132
(845) 679-4959 info@bookart.com
Energies of Our Universe – $250
Changes of Consciousness – $80

Thayer Jr, Thomas M. 87
(360) 387-7305 thommythomas@yahoo.com

Thomsen, Margaret A. 187
(845) 679-4959 info@bookart.com
Valley Cottage – $1,500

Trujillo, Douglas Alexander 145
(720) 220-1552
Navigation Studio, Douglas A. Trujillo
San-Pan – $4,000
Saretity – $1,500
Vitruvian Dream – $3,500

Vallejos, Tracy Lynn 179
(845) 679-4959 info@bookart.com
(909) 444-9011

Vasylyev, Vladimir 12
(845) 679-4959 info@bookart.com
(818) 343-1301 vlasimir231@msn.com
September 11, 10:28 a.m. –
September 11, 9:00 a.m. –
Songs of an Old Forest, Melody #1 – $1,200
Songs of an Old Forest, Melody #2 – $1,000
Songs of an Old Forest, Melody #4 – $1,000

Viscosi, Burgandy 176
(206) 310-1339 burgandyviscosi@hotmail.com
Bark Like a Man – $800
Behind the Mind's Eye – $500
I Caught One – $1,000

Weskot, Barbara 189
Boy in the Studio – $1,500
Girl in the Studio – $1,500

Wiecek, Laura 143
(845) 679-4959 info@bookart.com
#12 – $400
#25 – $400
#30 – $350

Wolf, Cheryl 112
(401) 884-0953
Persephone – por
9/11 – por
Life's Ponderences – por

Xela 82
(516) 621-1538 xela@xelaart.com
Budapest 1944 – por
A Dog Too Can Dream – por
Aftermath 1 - $30,000
Prarie Noon – por

Yvelisse 62
(845) 679-4959 info@bookart.com
(845) 679-1133 yvesansol@aol.com
Playa Bayahibe – por
Homage to Yorgie Morel – por
Internal Island – por
Wind and Tenderness – por
Rio Dulce – por
Enredadera – por
My Heart Looks Up to the Sky – por
Crocues Waking Up –por

Zahavy-Mittelman, Yael 32
(845) 679-4959 info@bookart.com
Little Pinkas –por
Birth – $3,000

Zaikine, Zak 104
(707) 523-8523 zaksartnadsoul@yahoo.com
www.zakzaikine.com
Birds of a Feather – $1,650
The Lilly Collection – por
New Spirit – $2,000

Zawistowski, Stan 168
(845) 679-4959 info@bookart.com
Inside Quercus – $700
Wall of Houses III – $700
Delete Tree – $700

Key:
nfs: not for sale
por: price on request
n/a: not available